VISUAL & PERFORMING ARTS

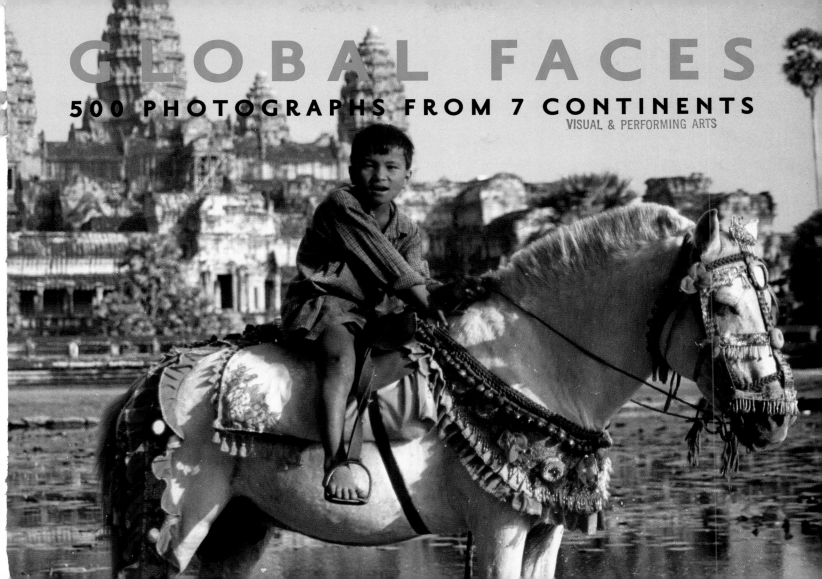

GLOBAL FACES
500 PHOTOGRAPHS FROM 7 CONTINENTS
VISUAL & PERFORMING ARTS

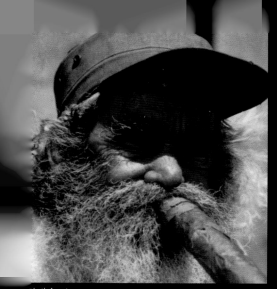
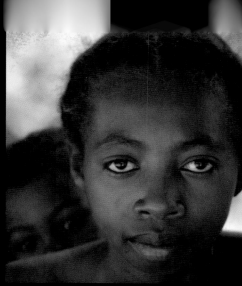
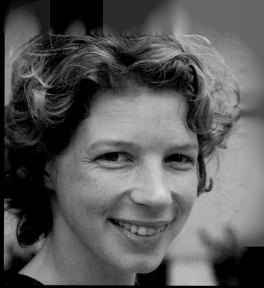
North America
Africa
Europe
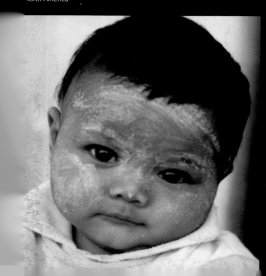
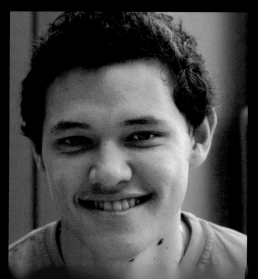
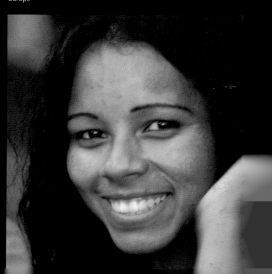

GLOBAL FACES

500 PHOTOGRAPHS FROM 7 CONTINENTS

MICHAEL CLINTON

FOREWORD BY DAVID GRANGER

Glitterati
INCORPORATED
NEW YORK, NEW YORK

First published in the United States of America
in 2007 by Glitterati Incorporated

Glitterati
INCORPORATED

225 Central Park West, New York, New York 10024
www.GlitteratiIncorporated.com

First edition, 2007
Library of Congress Cataloging-in-Publication Data
is available from the Publisher.

Every attempt has been made to contact the subjects in the
book. For further information, please contact the Publisher.

Hardcover ISBN 0-9777531-0-7
ISBN 13 978-0-9777531-0-9

Design: Karen Engelmann, Luminary Books & Design
www.karenengelmann.com

Printed and bound in China by
Hong Kong Graphics & Printing Ltd.

10 9 8 7 6 5 4 3 2 1

For Tom, Kate, Matt,
Chris, Joe, and Peg...
some of my favorite
global faces.

On the cover and title page: Angkor Wat, Cambodia

Right: Dubai, United Arab Emirates

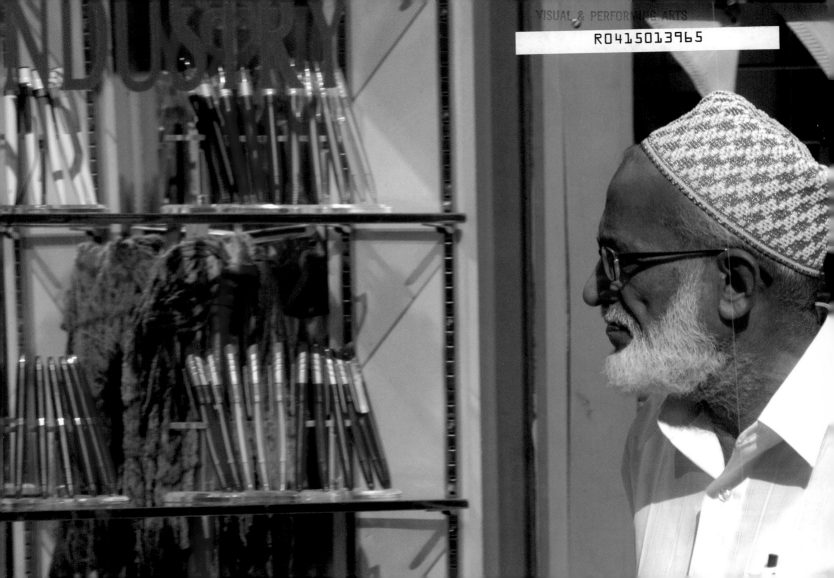

VISUAL & PERFORMING ARTS

CONTENTS

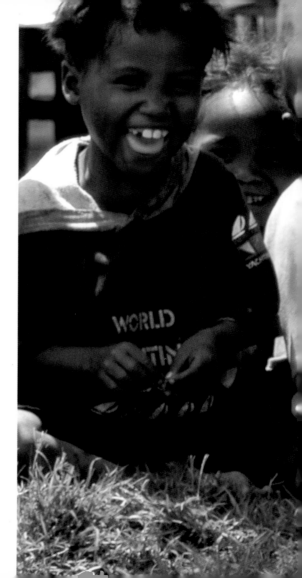

Right: Antananarivo, Madagascar

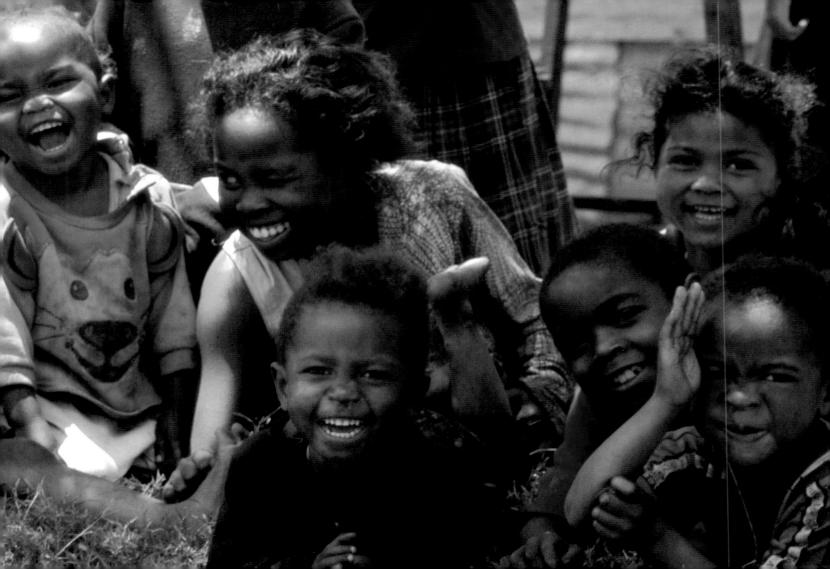

FOREWORD

There was an element of Michael Clinton's first two books that was out of character to some of us who have known him professionally for a long time. Michael, as you may know, is one of the most influential executives in publishing. He's guided some of the biggest brands in the magazine business to positions of dominance and has been, for the last ten years, a senior executive at the largest publisher of monthly magazines in the United States.

Michael knows everybody. He is, by necessity and, possibly by inclination, a social person. He knows people in every defining industry—entertainment, letters, automotive, advertising, information, fashion, philanthropy, the arts... you get the picture. A significant part of his life is the relationships he creates and cultivates. And no one is better at the cultivation of relationships than Michael. He's *interested* in people. He wants to know about them. And people seem to want to *tell* Michael. Tell him their stories, their aspirations, their plans, their passions. I always feel like a bit of a social retard around Michael—a curmudgeon, a wallflower, an introvert. He is good at people.

I'd seen Michael's photography for years before his first book was published—at exhibitions or gallery shows. But it wasn't until *Wanderlust*—a collection of photographs Michael had taken over the course of 35 years of traveling the world—was being published that something odd struck me. At the book party celebrating *Wanderlust*, held at the International Center of Photography in New York, I wandered through examples of his work and I saw a facet of Michael that I had never noticed before. It was this: There were no people in his photographs.

Look through his first two books, both *Wanderlust* and then *Global Snaps*. There is the evidence, of course, of humanity—architecture, cityscapes, markets, street scenes, not to mention photos that could only have been taken via the elevation afforded by an airplane—but precious few actual humans.

What did this mean? A consummate man of people was about to publish his first major book of photographs almost entirely lacking, you know, people. It could have been that his photography represented to him what his semi-annual trips to the most exotic places in the world—Antarctica, Madagascar, Papua New Guinea and the rest—represented: a break from the life he lives the other 48 weeks of the year.

But looking at Michael's life, I can't but wonder if it's all of a piece, that is, if the life he's created for himself first through work and then by fleeing work to visit countries on seven continents isn't the fulfillment of the aspirations of a small-town Pennsylvania kid who longed as much as anything to escape. Life in the center of the media universe in New York is no farther psychologically than are the dunes of Namibia—at least to a high school kid from outside Pittsburgh who's taken his first photo. They both represent an opportunity to become more than anyone could have expected.

Apparently, I asked him why there were no people in his photos on that evening when we were celebrating his first book, most likely with my characteristic lack of tact. And then I forgot about it. Some years later, as he was publishing his second book, Michael told me I'd given him the idea with my offhand remark for a new book—this book.

And so, GLOBAL FACES. It's the perfect companion to his first two collections. On every page, you see a different country, a different experience of life in this world, but instead of seeing it reflected in natural wonders or in ancient structures, we see life in the images of the people who've lived it. The experience of going through this book is amazing—amazing in that you see *countries* in these faces. It's unsettling how so often the portraits match your preconceptions of the countries they turn out to represent; and how often those preconceptions are exploded on the very next page. Like the photographer, these subjects constantly surprise you.

Michael had these people in his camera and in his heart all along. It just took him a little while to share them with us.

DAVID GRANGER
EDITOR IN CHIEF
Esquire

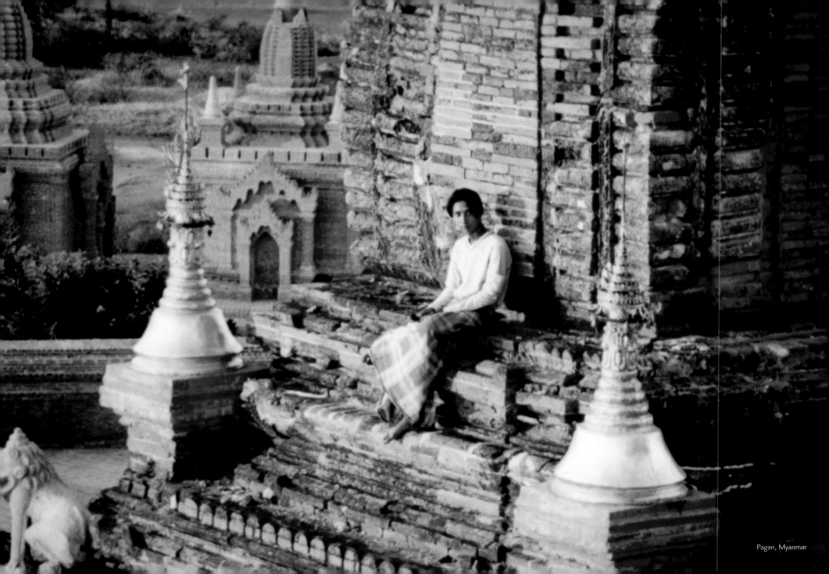

Pagan, Myanmar

INTRODUCTION

Most of us know the answer to the question, "What is your favorite thing to do?" or at least could mention a couple of options. When I am asked that question, I always have the same response—to roam the world, to see its wonder, and to meet its people. To date, I've been to 115 countries, so it is pretty obvious that I am devoted to my favorite pastime. From an early age, airplanes, trains, and boats have been a part of my life, as I have visited 47 states (and counting), as well as all seven continents—a feat accomplished in 2003, when I set foot in Antarctica!

An important part of my travels has been to keep journals and to photograph my experiences and what I've seen. In a small room at home, countless cameras and lenses that I've used throughout the years are stored along with boxes and boxes of photos, negatives, and digital chips. While I have managed to put countless leather bound albums together labeled "Nepal" or "Patagonia," thousands of these images have been tucked away in storage, waiting for me when I have wanted to reminisce about the climb to the top of Mt. Kilimanjaro or the idyllic days on Nukubati, an island in Fiji.

About seven years ago, my friend Mary Rolland, a painter, and I were spending an evening in her Soho studio when she suggested that with the thousands of photographs that I have taken in my years of globetrotting, that I should mount a photography collection to show at a gallery. At first the idea seemed daunting, if not intimidating. To start with, how could I begin the process of editing the images that were worthy to show—not to mention that I was not a full-time photographer by profession. Putting my work "out there" also seemed a bit scary, especially with art-savvy New Yorkers viewing them.

I spent months agonizing over the shots, and eventually called upon my lifelong friend, Tom DeVincentis to be my critic and to help me select the right images. My culled collection was finally complete with 50 images from places like Namibia, Argentina, Cuba, Morocco, as well as many other countries. On the night of the opening, friends, family, and colleagues came to support me at the gallery, and I was both nervous and unnerved. Soon after the crowd assembled, I was given positive feedback and I began to enjoy myself and relax.

Since then, I've had shows in New York, Southampton, Miami, and New Orleans. I am also the author/photographer of two recent books, WANDERLUST: 100 COUNTRIES AND GLOBAL SNAPS, and I have sold photos to individual and corporate collections. But there was a particular moment during that first show that made me realize that I had a lot more work to do in order to call myself an established photographer. I was speaking with my friend and colleague, David Granger, the editor in chief of *Esquire* magazine when he said, "Michael, I really like your work, but you have no photos of people!"

I looked at the walls. While it was true that I had a shot of some tango dancers in Buenos Aires, and a colorful street vendor in Khatmandu, the majority of the images were landscapes, architecture, and animals. That night, I began to sort through all of my photos and realized that in the multitude of years of travel and photography, there just weren't a lot of faces in the shots. David was right, and it set me on a new course to focus on the world's faces as I continued my travels. GLOBAL FACES is a result of that idea, and of course, the first person that I turned to contribute the foreword to the book was David, reminding him that it was his comment that initiated my quest.

As I thought about this new direction, it became apparent to me that my approach might be to do some portrait shots, but ultimately I decided that I really wanted to concentrate on everyday people in everyday settings. In my search, I roamed the streets of Oslo, the markets of Antananarivo, the villages of India, and more. It was on the Ramblas in Barcelona that I discovered the varied expressions of the city's street performers, and in a village in Fiji that I met the locals dressed in their celebratory garb. On a visit to Dubai, I sat with a Jordanian family in Creek Park, photographing them amidst their conversations about world politics, and laughed with Yemeni shopkeepers as they described how they could identify different nationalities as they walked through the *souks*.

But during my search, I would also photograph great faces in statues, mannequins, and on billboards that reflected both the past and present of a country's culture. At times I'm sure I bothered my fellow travelers, as in the case of my friend Frank Valentini, who was pointing out the height of a mountain that we were about to climb in Bhutan, while I was focused on a young monk walking toward us with my camera ready. Or the time that a fellow photographer, Cap Sparling was marveling at the architecture in Riga, Latvia, and I was preoccupied with the people passing me on the street.

It was through my family and friends and their facial expressions that I began to see how our environment evokes myriad emotions. Peggy had a look of awe when I told her about the history and intrigue of Bandolier in Northern New Mexico and I

could see that Tom was visibly moved by the excitement of the children in an African village when he shared his candy with them. I was fascinated by Dan's expression of "Can you believe it?" as we awoke in our sleeping bags at daybreak after slumbering in the open air on an ice shelf in Antarctica and discovering two large seals sleeping only yards away, and Mary's expression of awe, as she saw the antiquities of Rome for the first time. These experiences made me realize how our faces change a hundred times a day based on how we absorb the world and people around us.

I learned on my journey to find and photograph faces that no matter where people live, we all have similar reactions as we all share in the human experience. Seeing the sheer delight of a group observing the painted elephant faces in Jaipur, India, can easily be matched with the expressions of another group watching a mother leopard and her cub pass by a Land Rover in the bush in Africa. A mother in a village in Mozambique looks at her child with the same adoring look as a stylish woman on the streets of Paris. Each morning, regardless if you live in a big city in America, a sleepy fishing village in Mexico, or the highlands of Nepal, we all wake up with the same sleepiness in our faces, and at the end of the day, we can all look tired from a hard day at work and ready to rest again.

It would amaze me how so many people would light up and smile when I asked them if I could take their picture. When I learned to look at people with a trained eye, I could find the nuance of their culture in their faces. A Muslim woman, who might cover her entire face with only her eyes showing, might avoid looking back at me, and a less traditional Arab woman might wear a head wrap and pose in modern make-up and designer sunglasses. Smiling Bhutanese women think nothing of showing their betel-juice stained teeth, while European men and women would be horrified at the idea of presenting anything in their teeth.

It was interesting to see how people reacted to me. When I was in a small village on Benguerra Island in Mozambique, a young child burst into tears at the mere sight of me, while another wanted to touch my blue eyes, which were a novelty to him. Upon meeting and communicating with the children and the families of the village, we established an ease with one other that crossed our cultures. With my digital camera in tow, I was able to experience their joy and excitement when I showed them the images that I had just taken. Spending a couple of hours in that village was as rich an experience as one could hope for when traveling the world and meeting its people.

GLOBAL FACES shows the many different kinds of faces that live on Planet Earth. There are parts of the world that I have yet to explore—I hope to get to the tribal ceremonies of Papua New Guinea, to hike in the highlands of Scotland and to explore the streets of Ljubljana, Slovenia. What I think I'll find are friendly people, who want to hear about life in another part of the world. Their eyes will widen, as I try to explain what life is like in New York City, and my eyes will widen in return, when they tell me about their everyday life.

In those moments together, I'll hope to capture their expressions of joy and curiosity, and I'll marvel at the new friendships that I make, so that I can continue to tell everyone that there is one family of people who walk our world, and that we are all connected to that family through our shared humanity. My only wish is that as I meet them, I will be able to bring their faces home to you, so that we can all learn the lesson that we all share this world together. No matter where you live, we all have the same need to smile, to laugh, and to dream of a better future.

MICHAEL CLINTON
NEW YORK

11

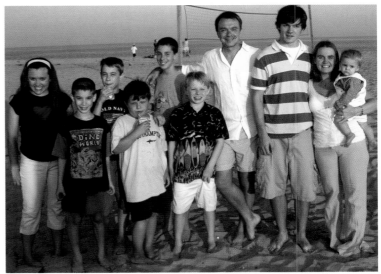

The author with family, Bridgehampton, NY, 2003

Paris, France

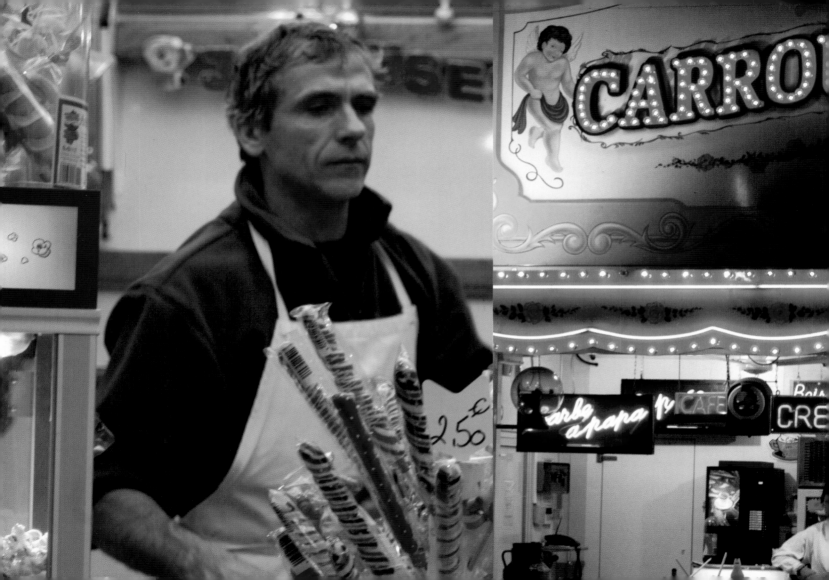

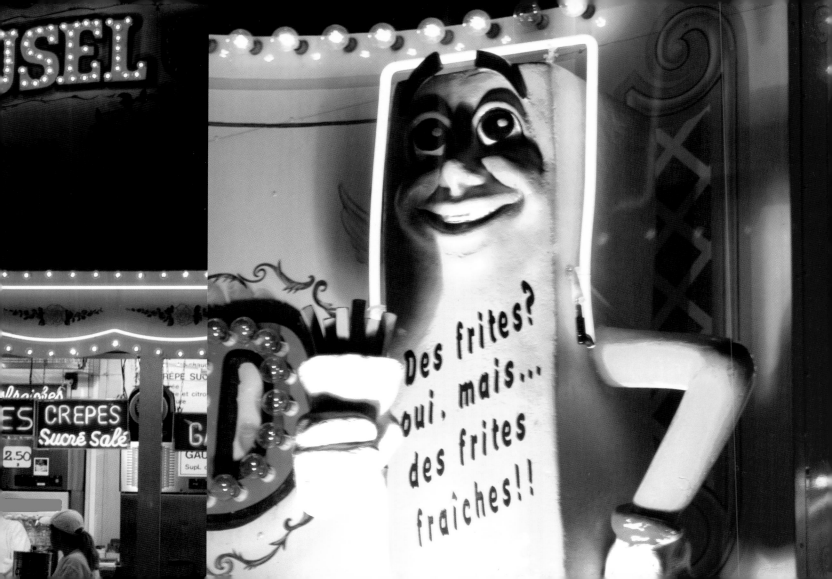

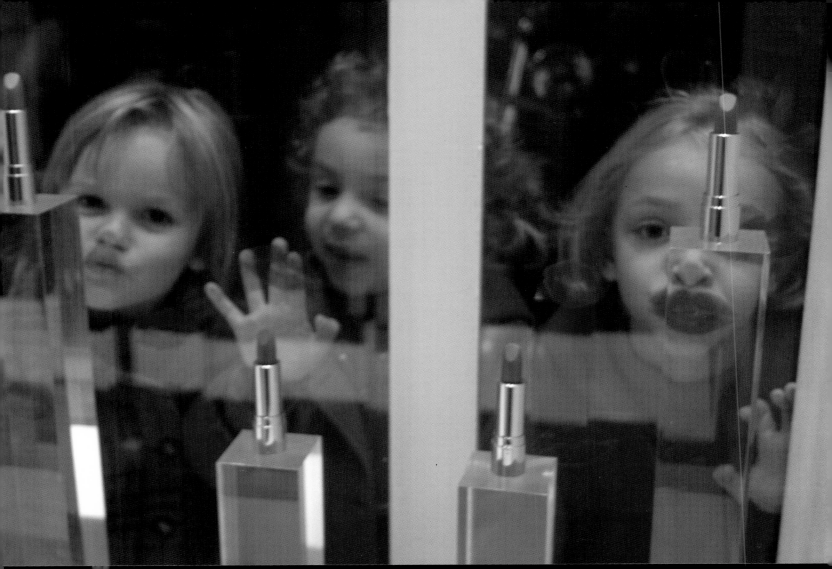

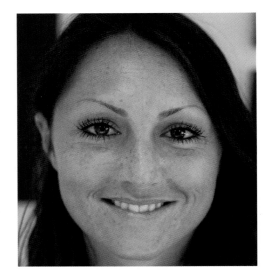
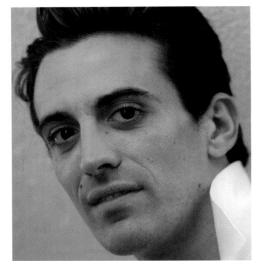
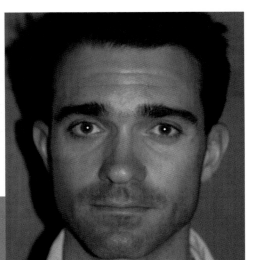

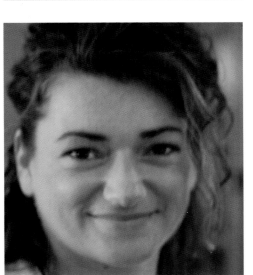

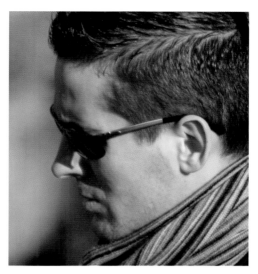
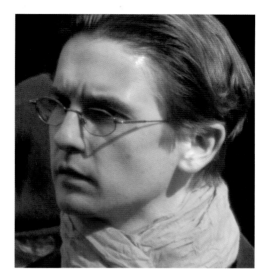
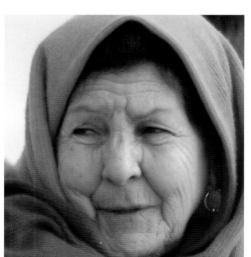
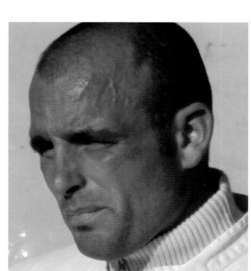

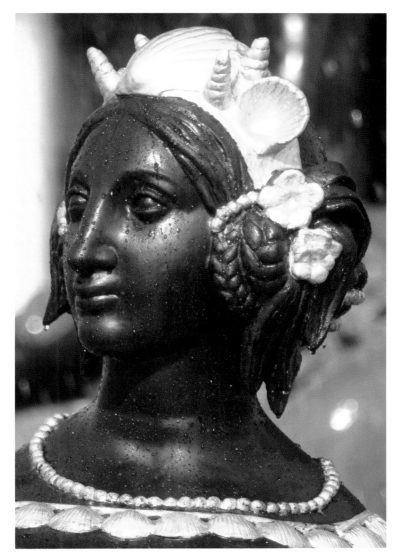
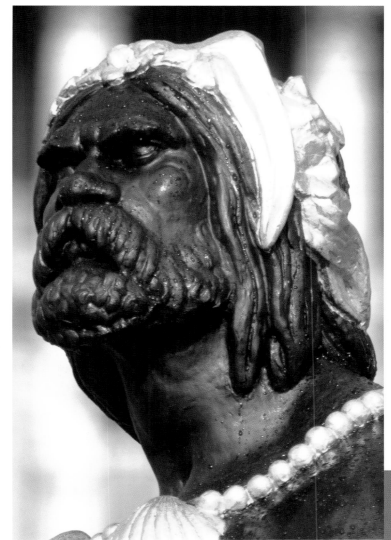

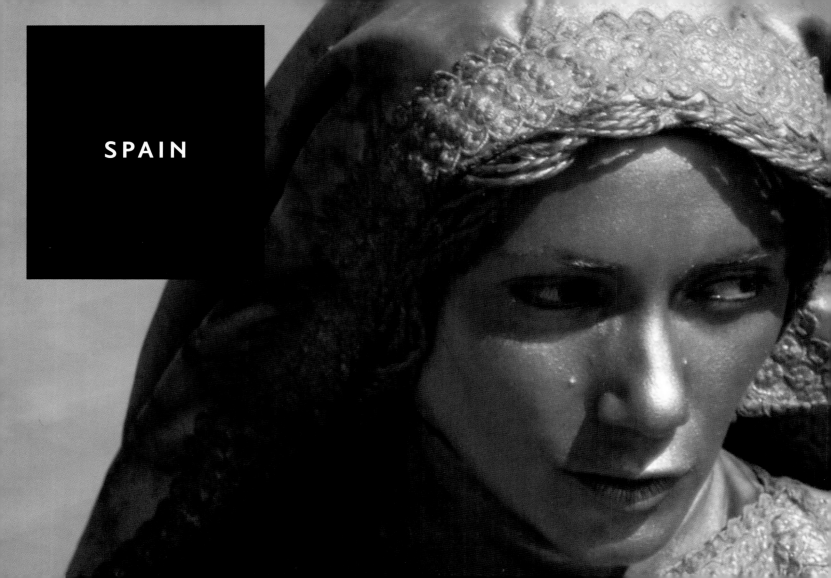

SPAIN

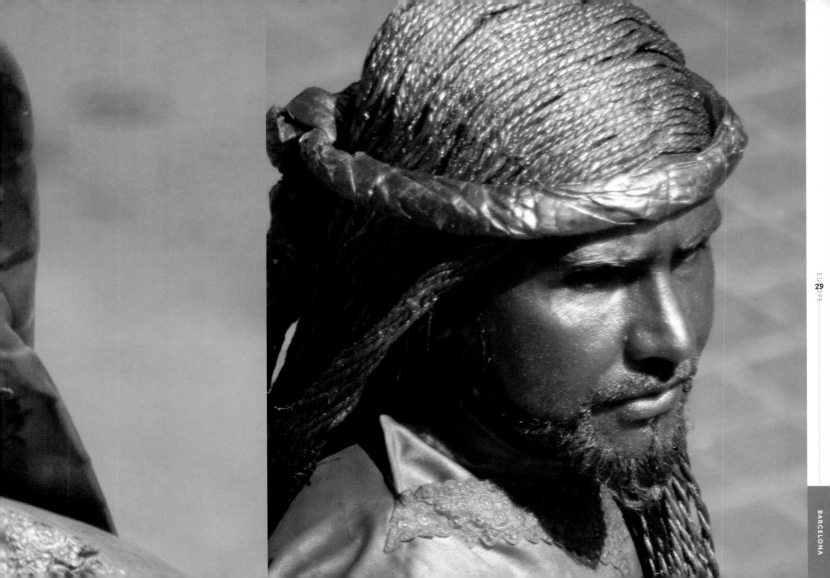

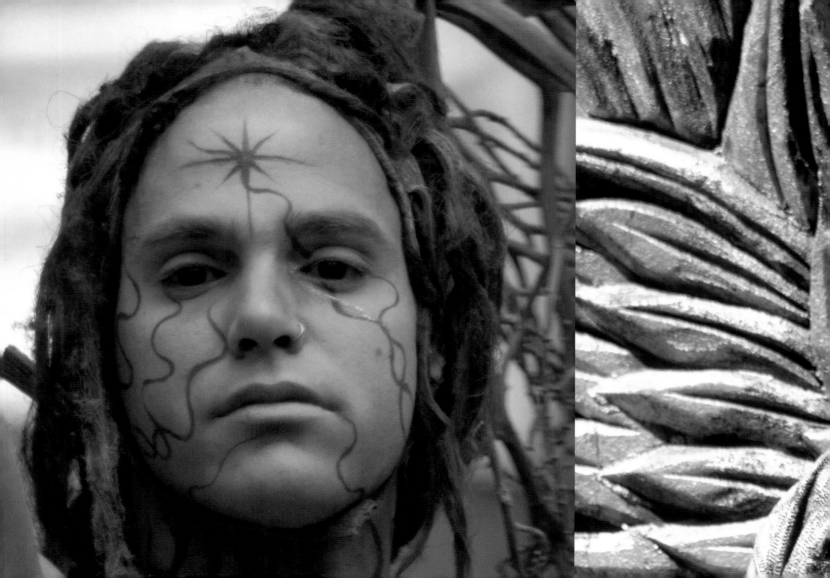

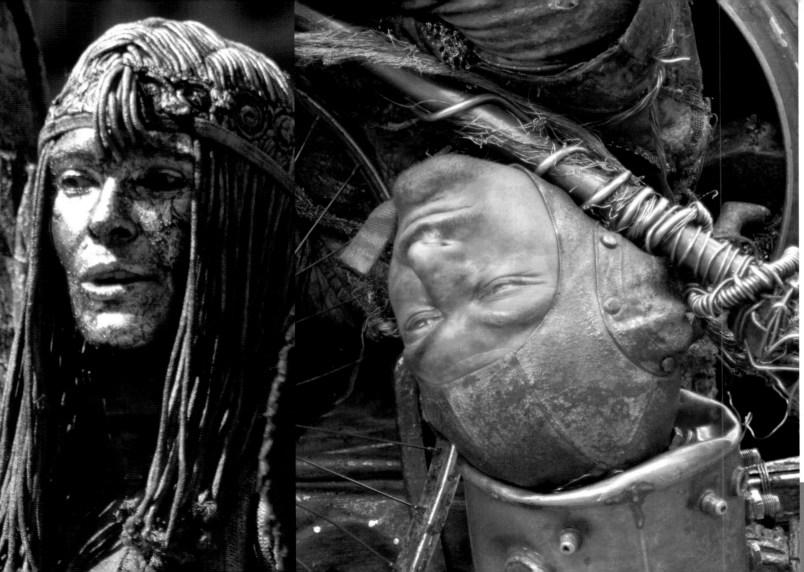

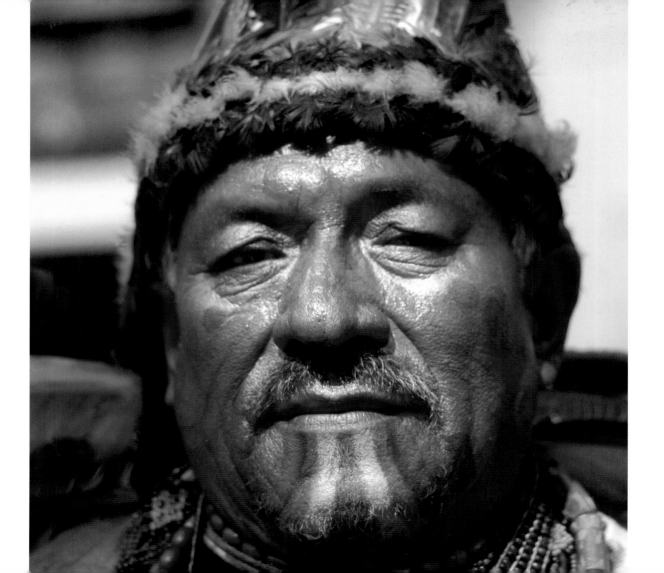

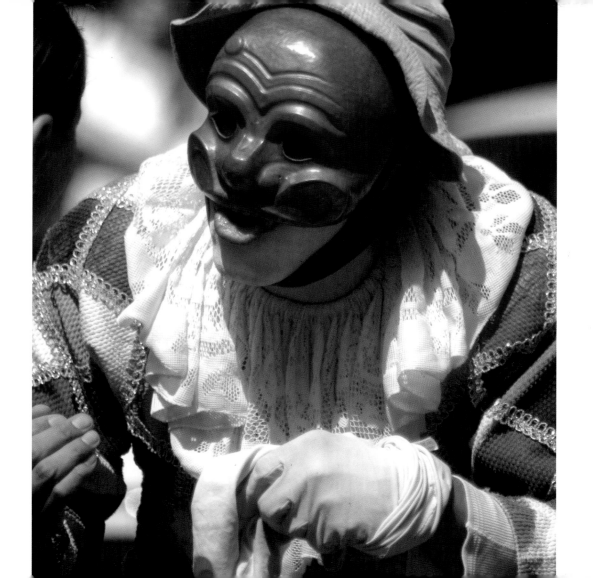

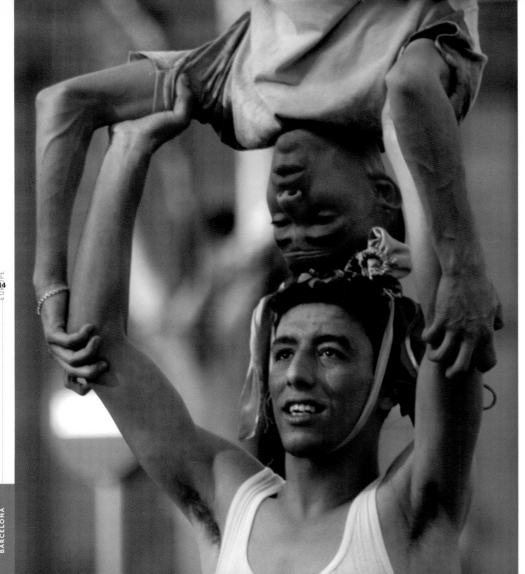

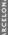

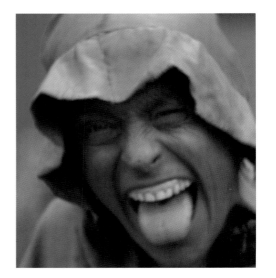

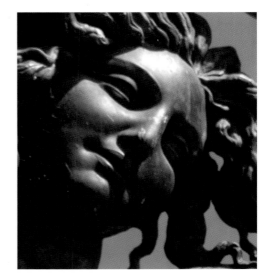

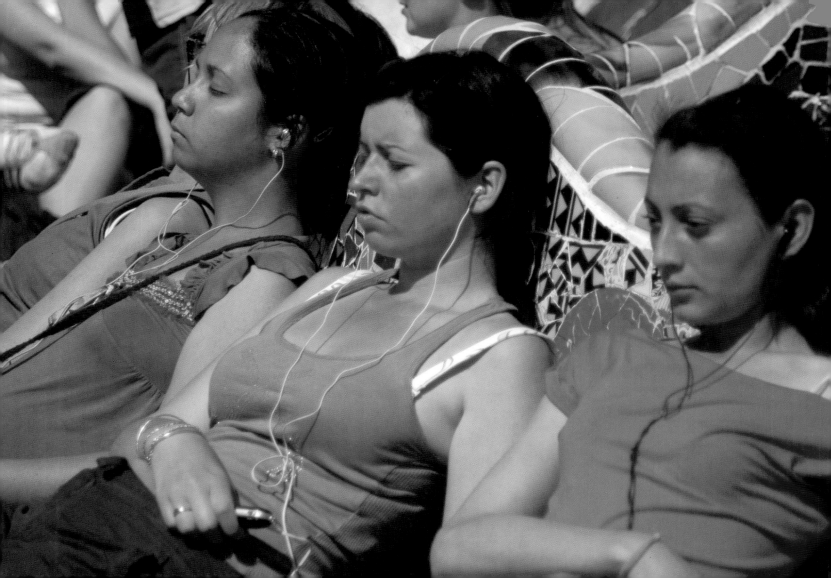

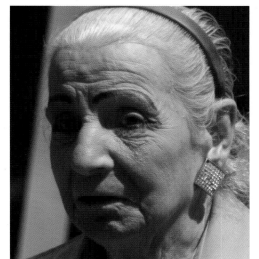
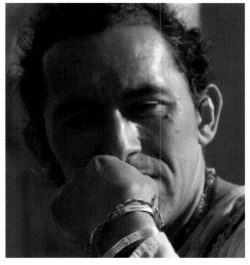
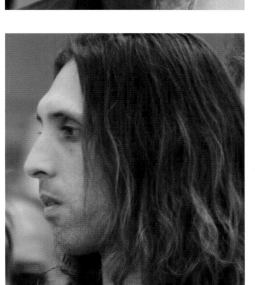
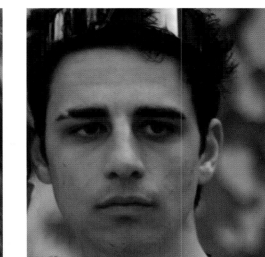

TURKEY

44

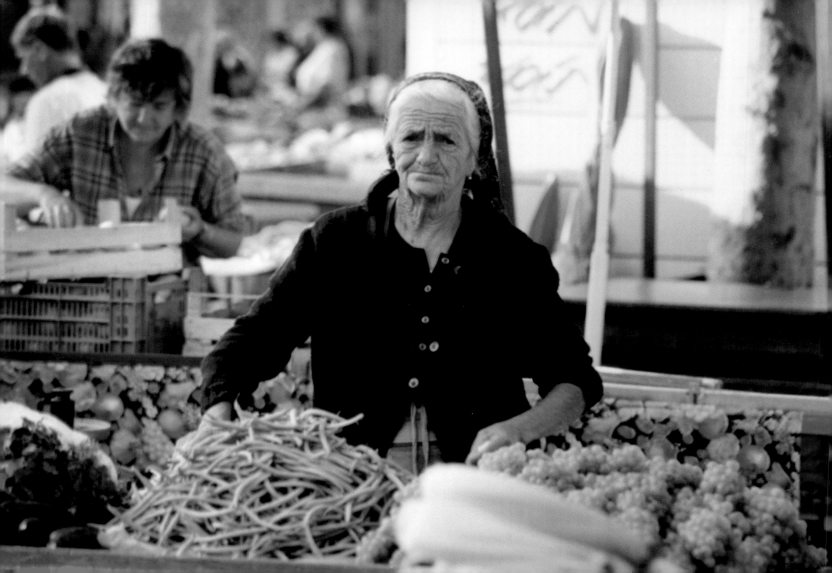

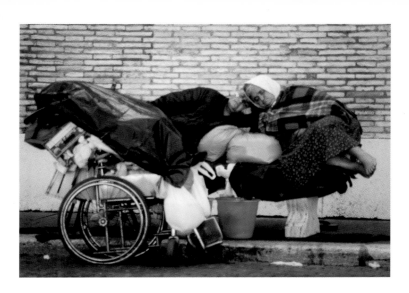

CROATIA

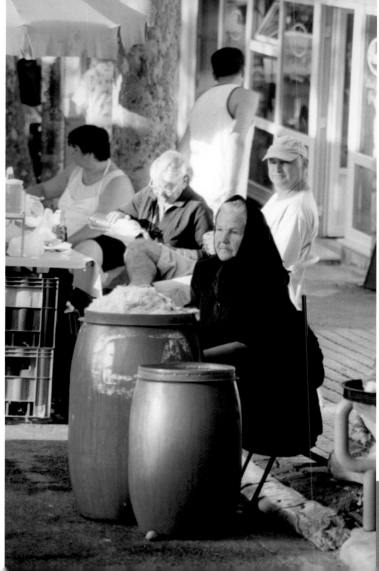

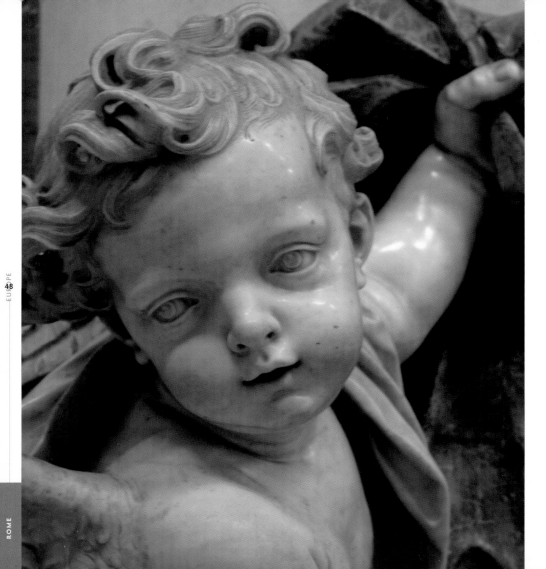

ITALY

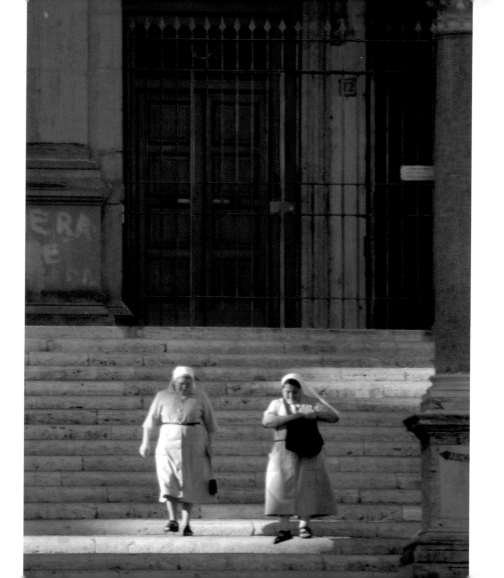

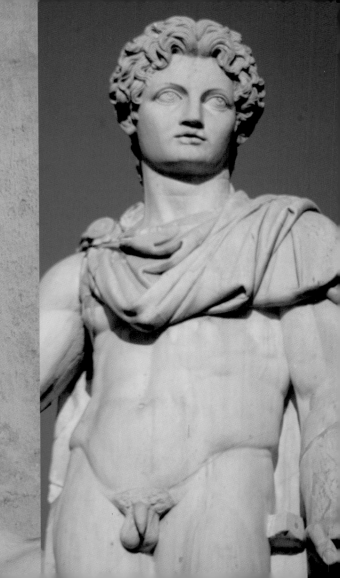

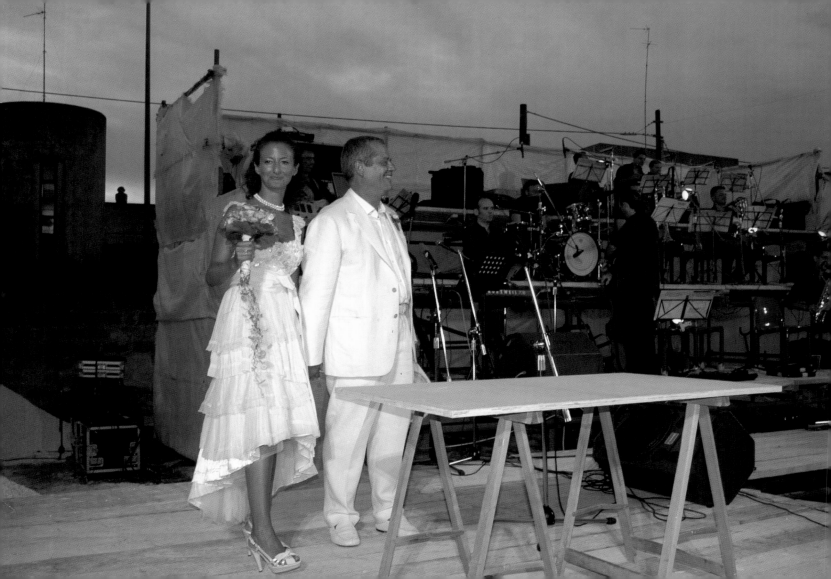

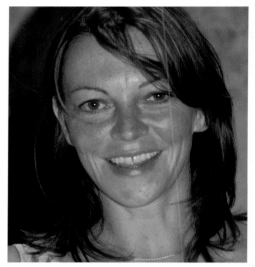

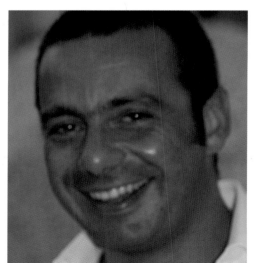
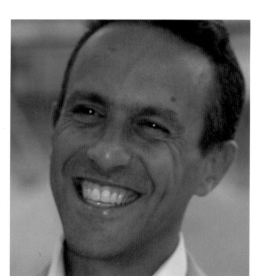

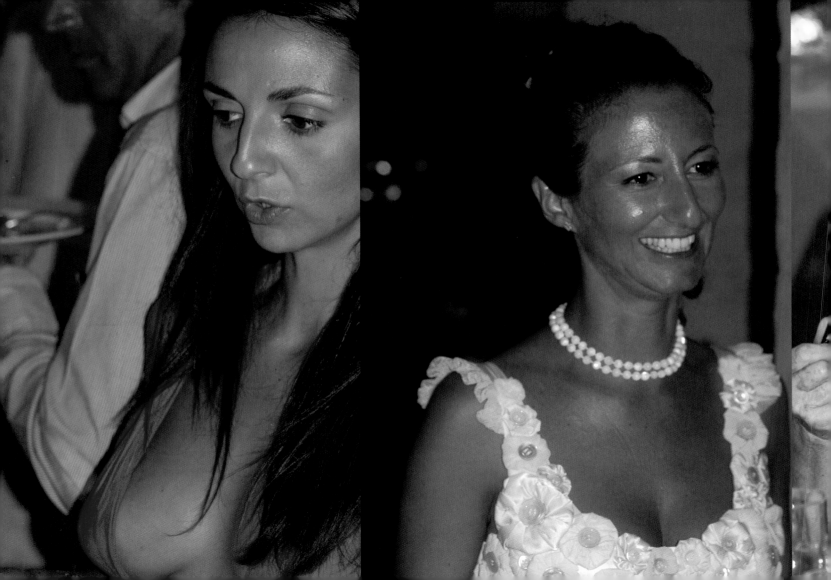

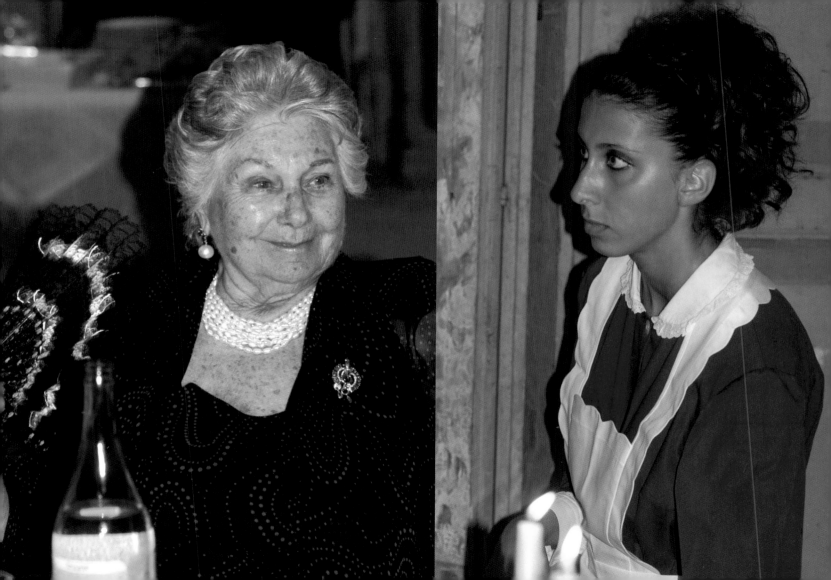

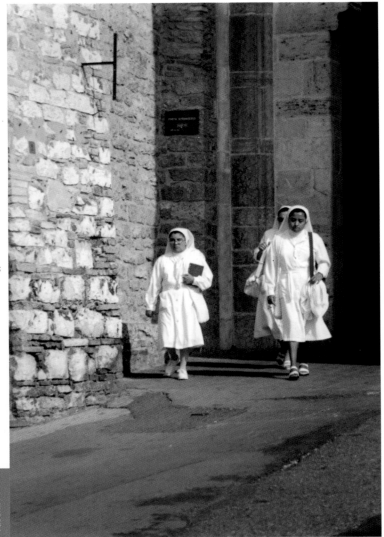

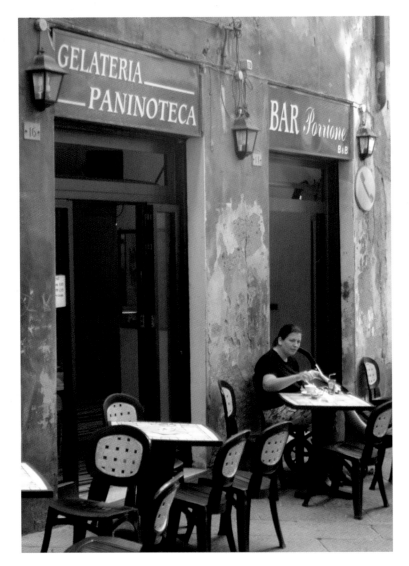

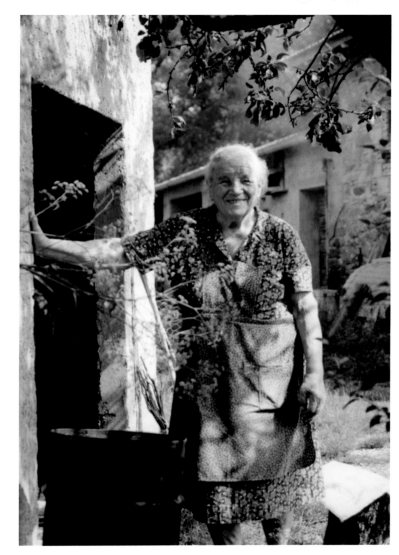

THE BALTICS
ESTONIA
LATVIA
LITHUANIA

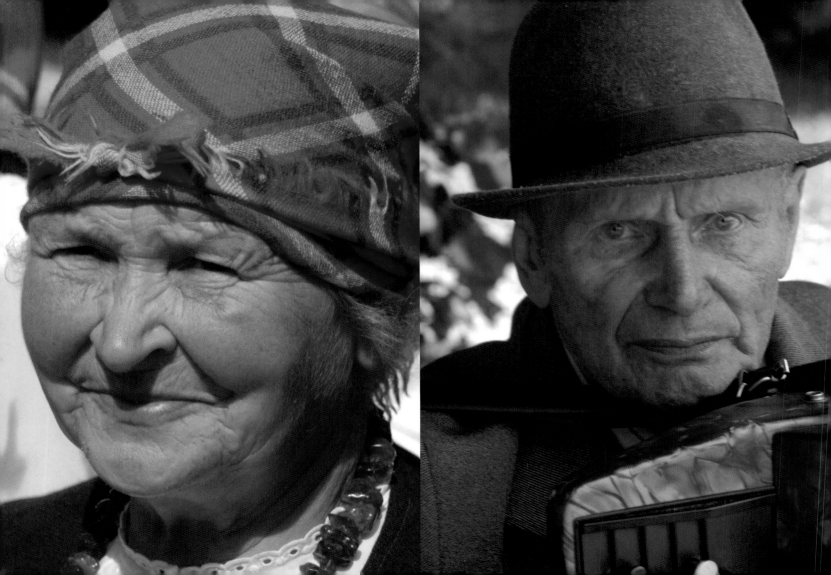

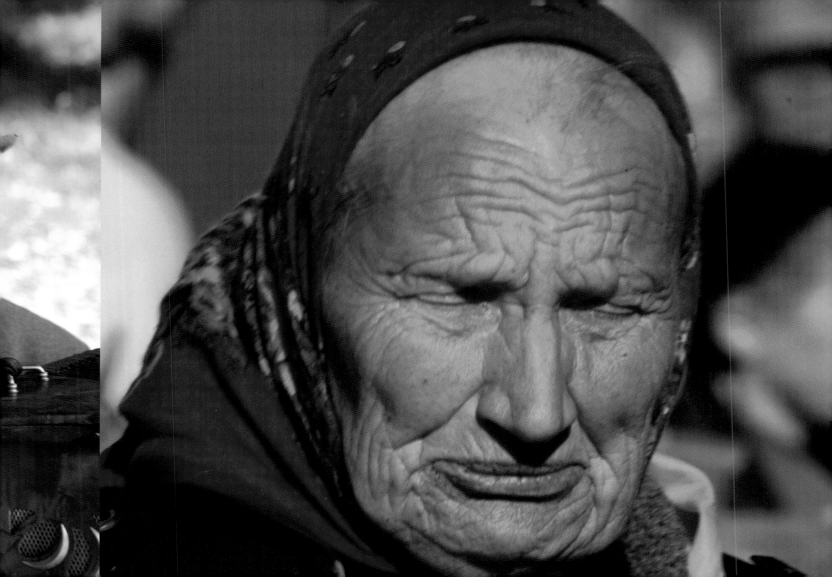

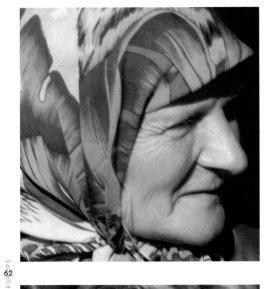

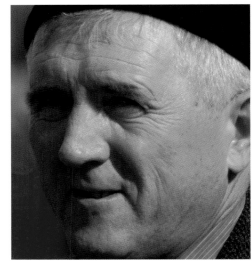
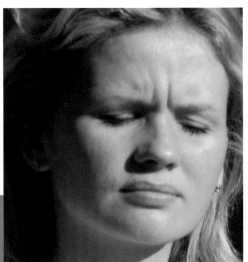
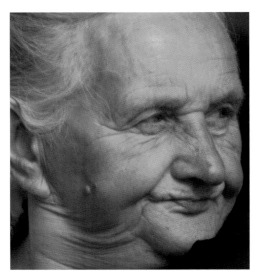
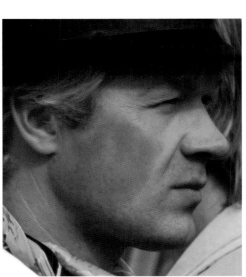

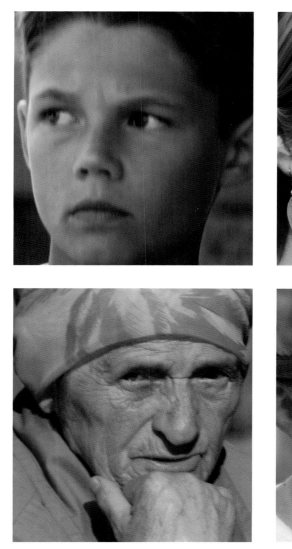
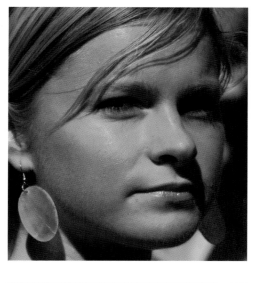
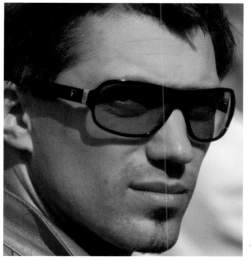
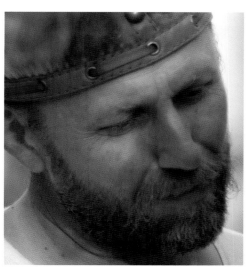
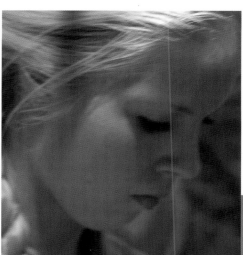

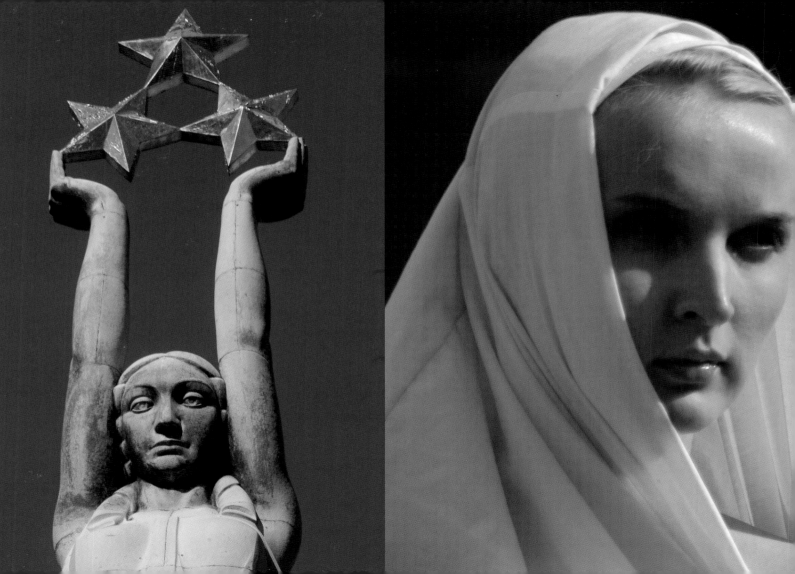

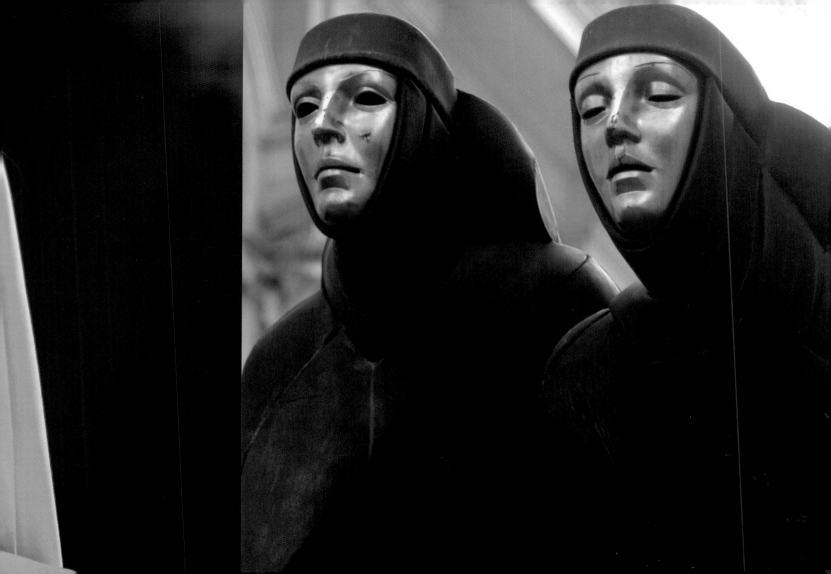

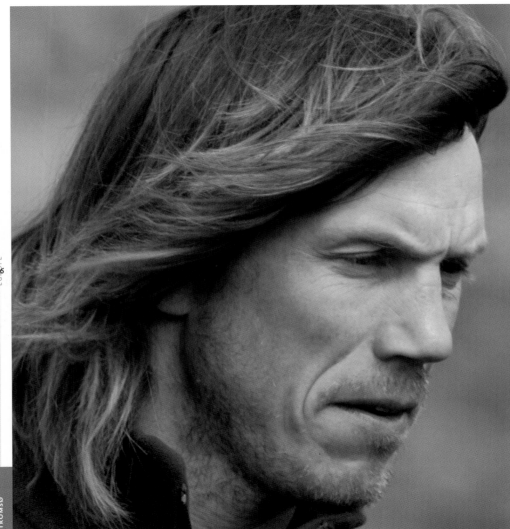

NORWAY

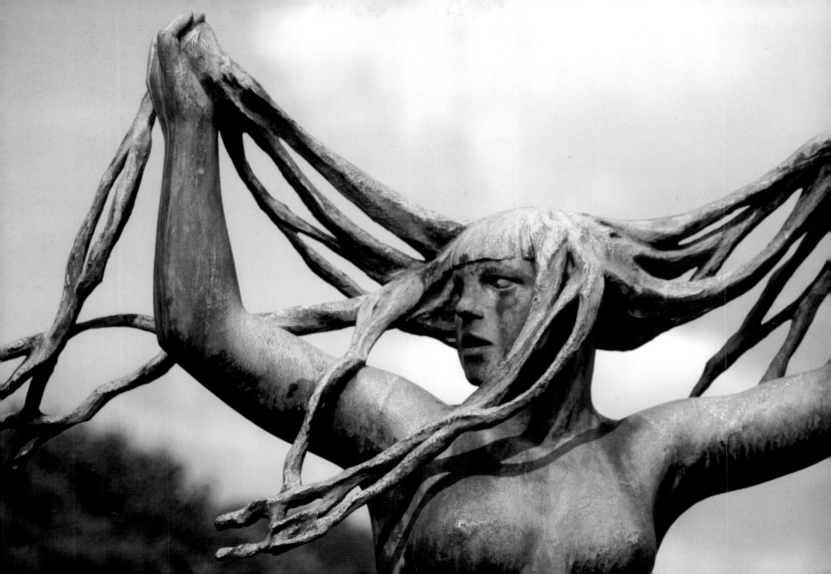

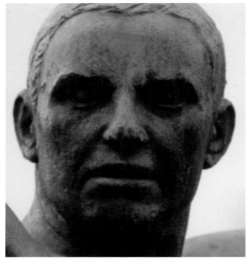
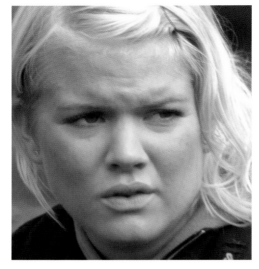
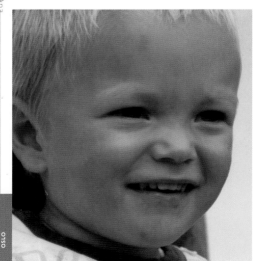
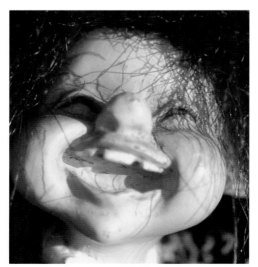
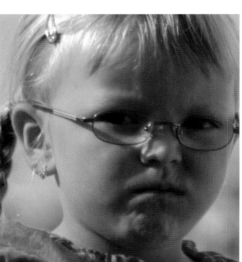

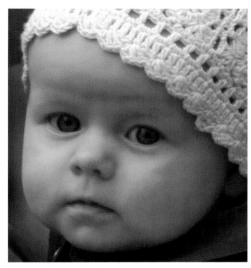
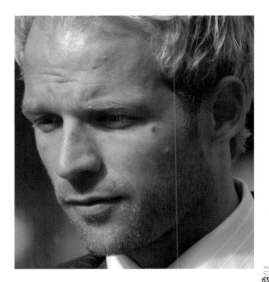
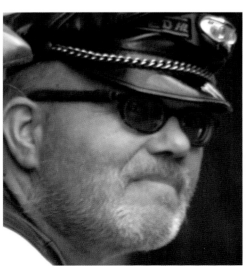
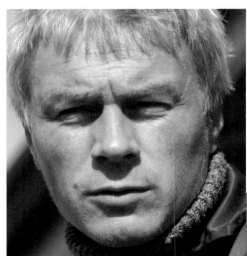

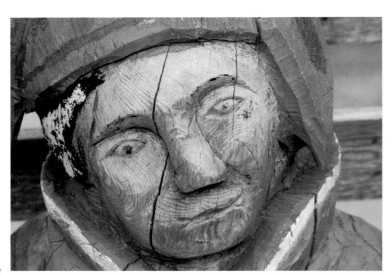

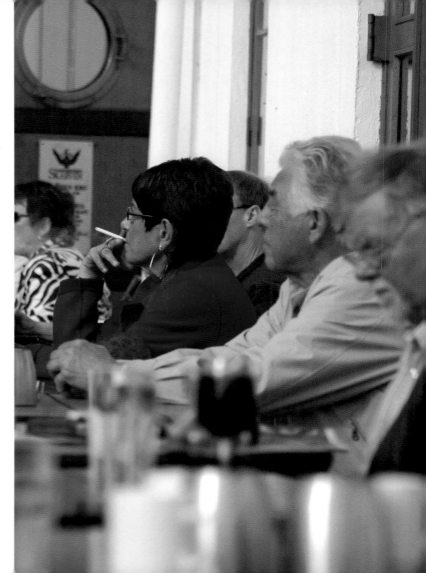

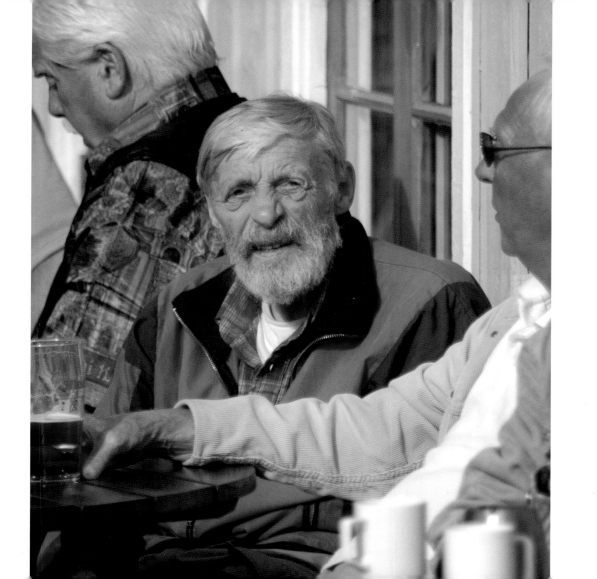

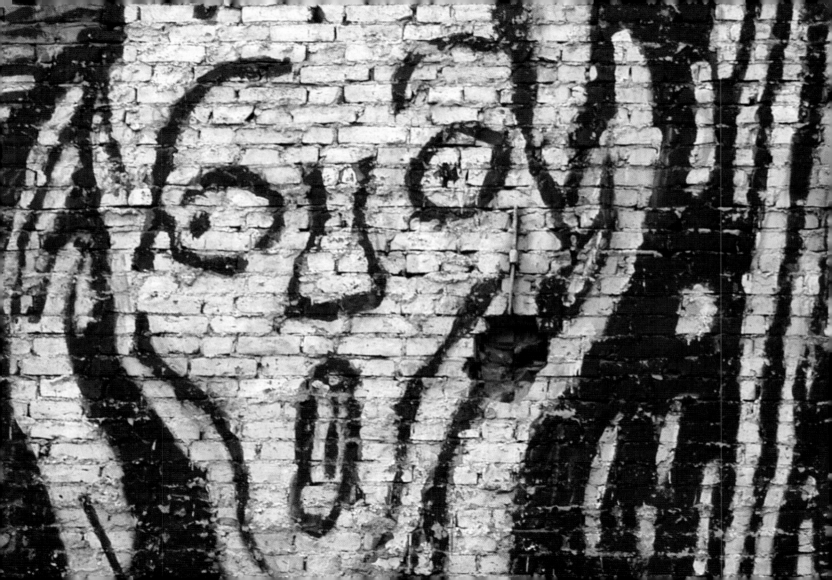

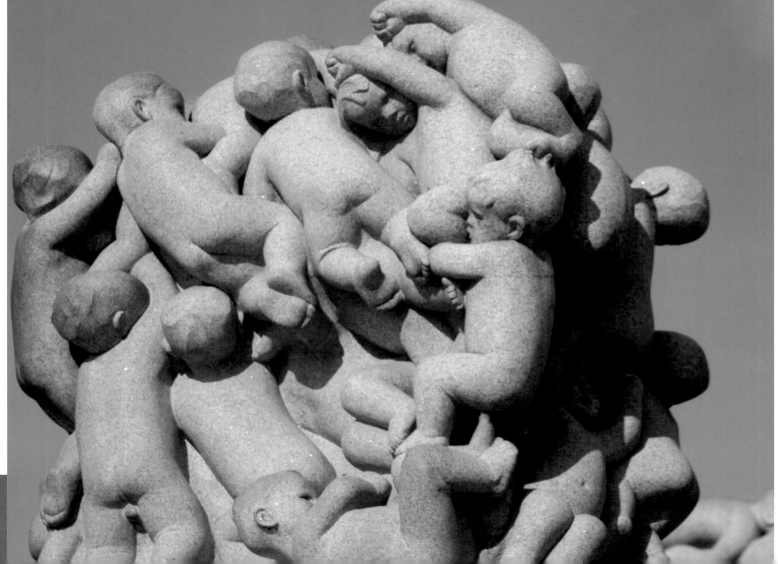

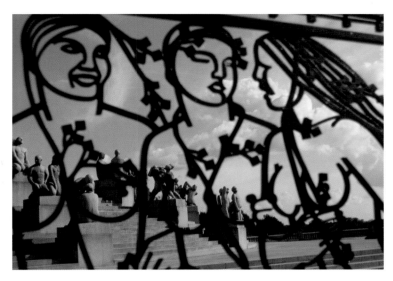

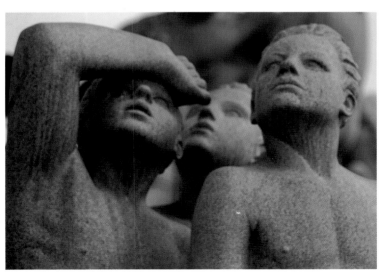

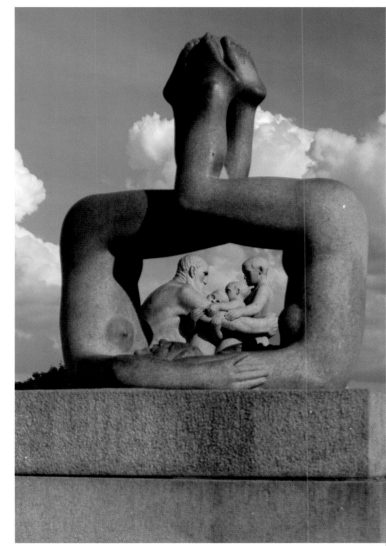

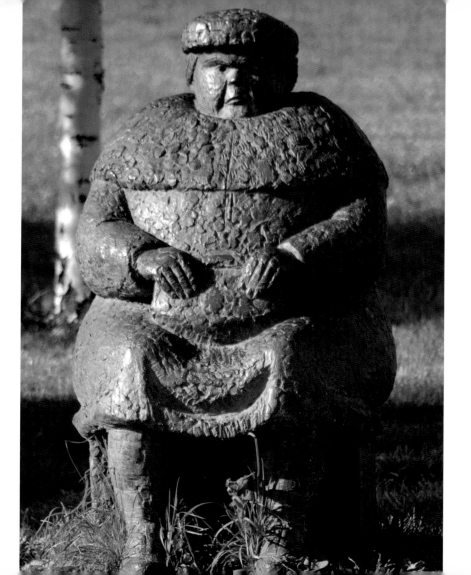

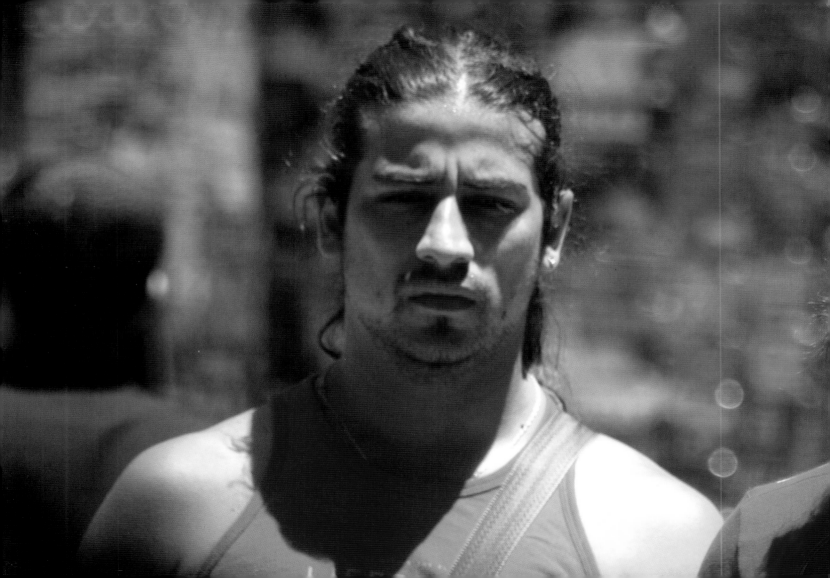

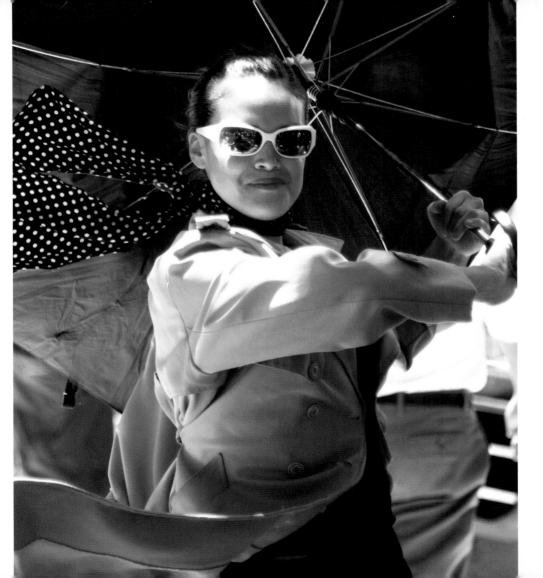

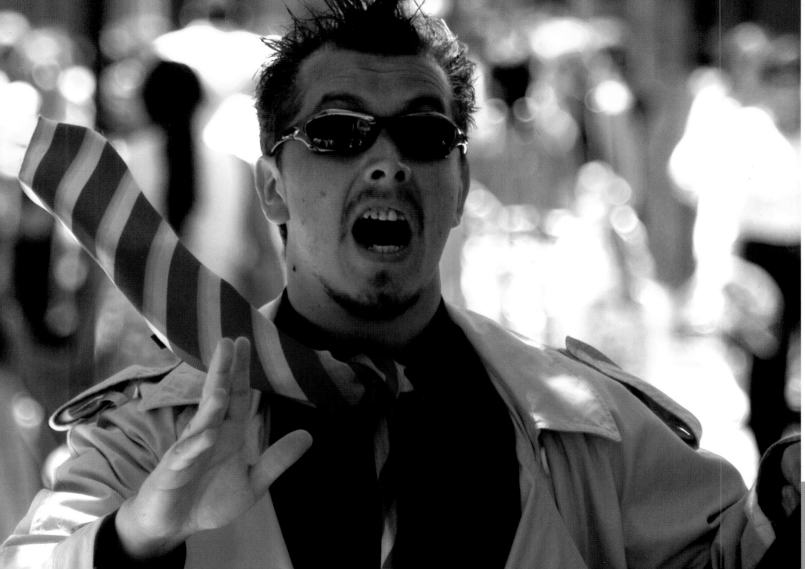

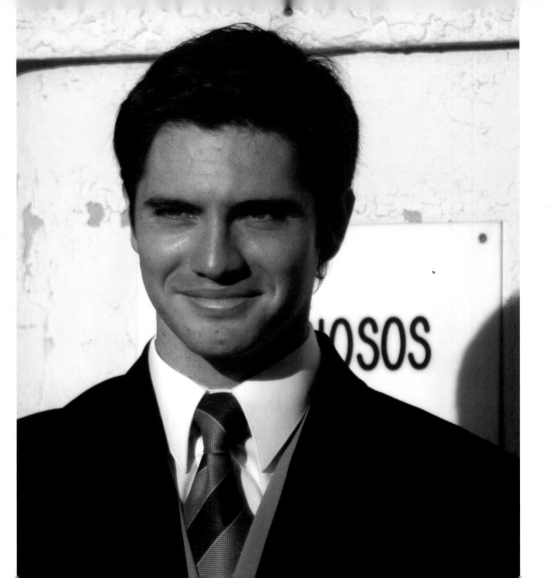

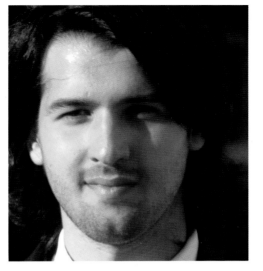
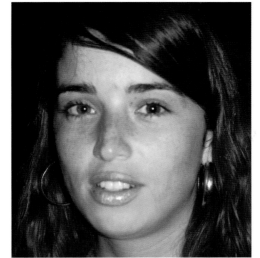
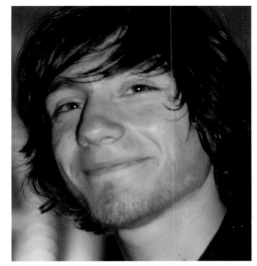
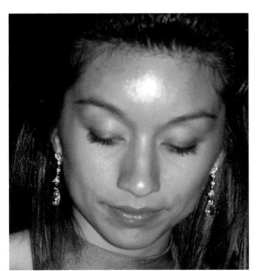
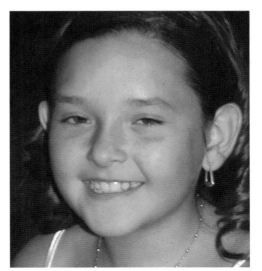
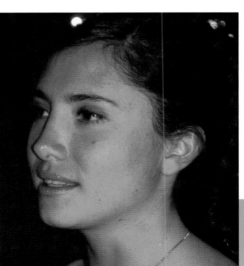

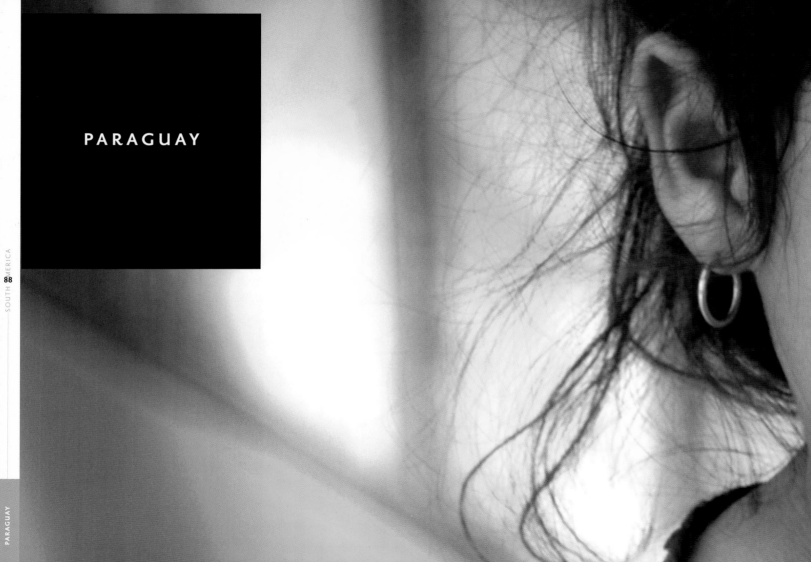

PARAGUAY

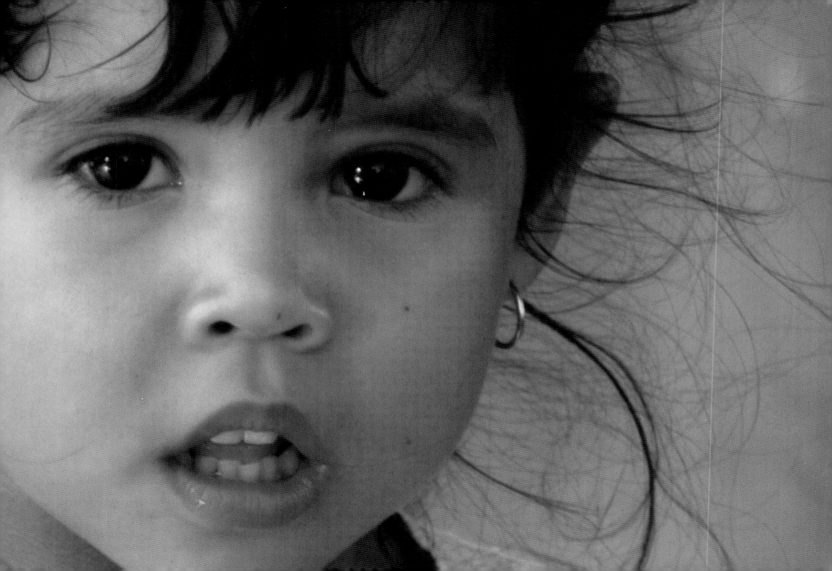

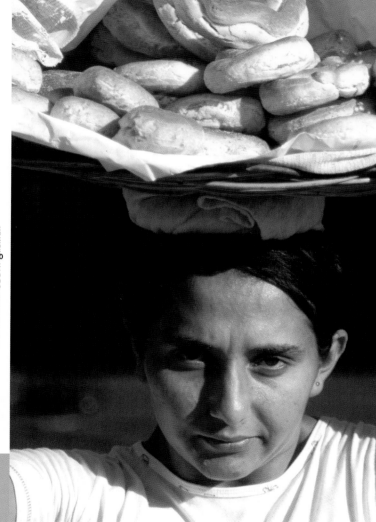
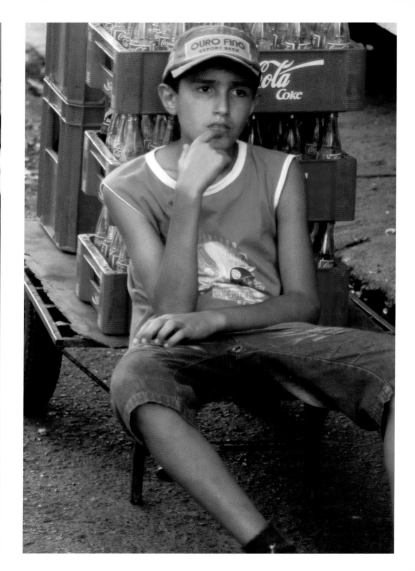

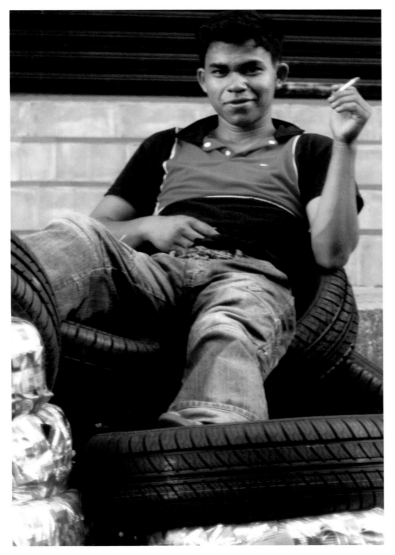
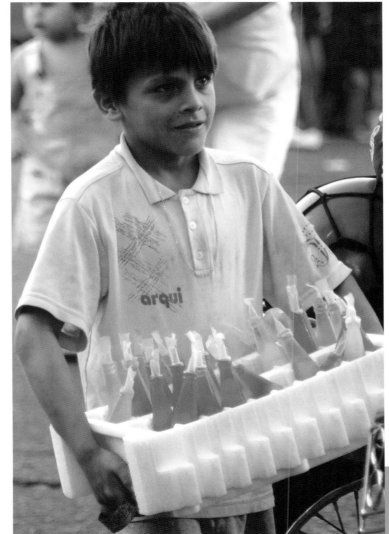

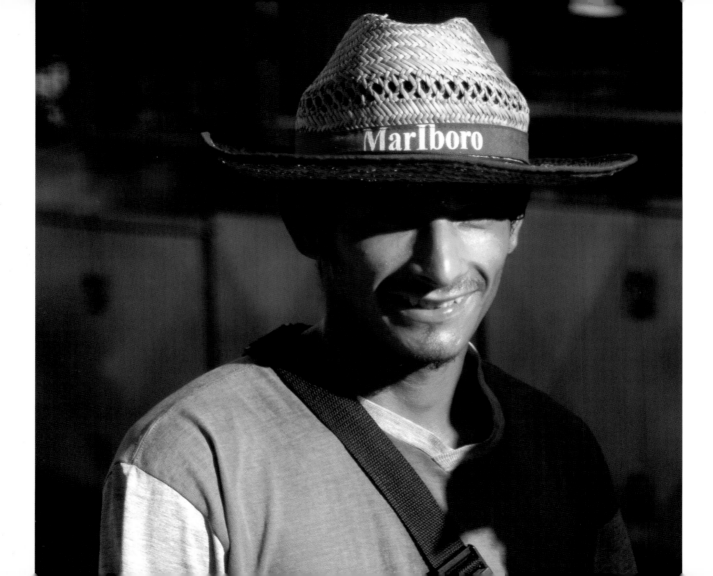

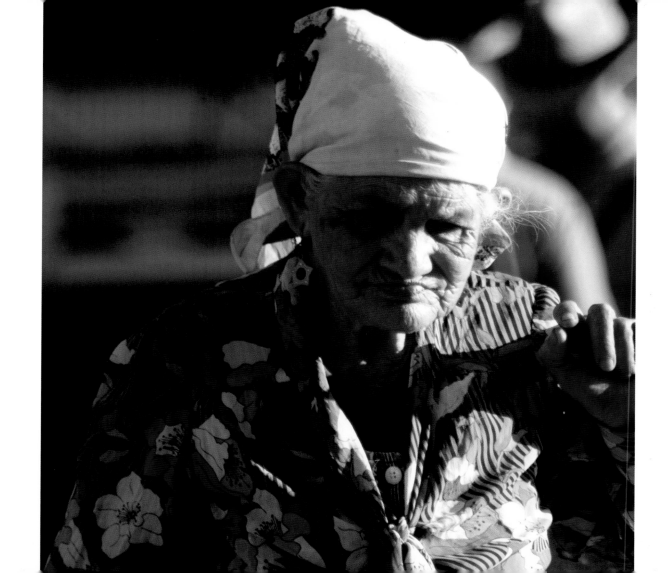

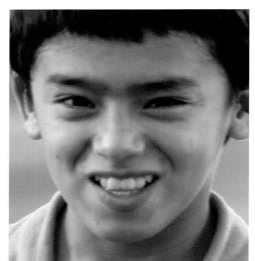

SOUTH AMERICA

PARAGUAY

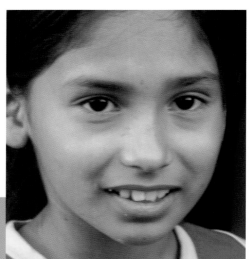

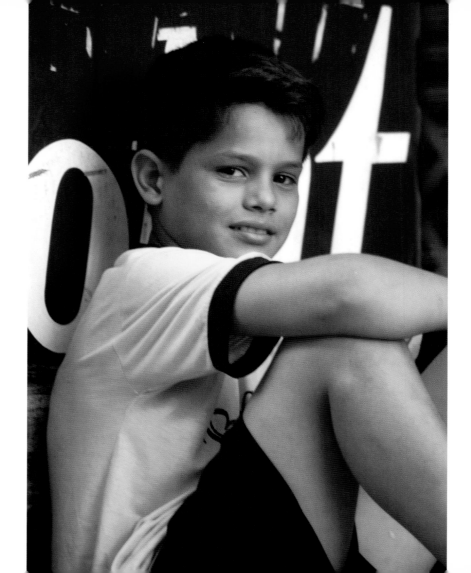

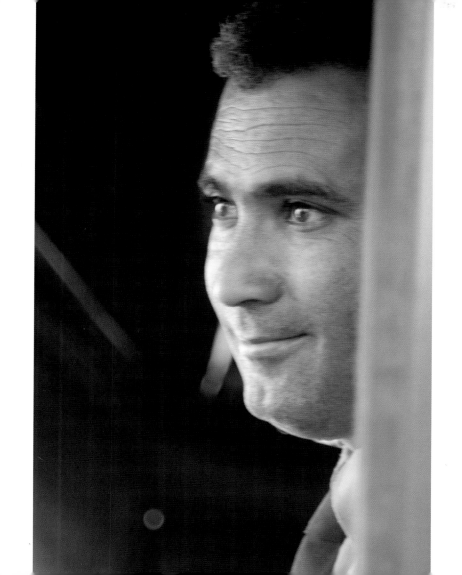

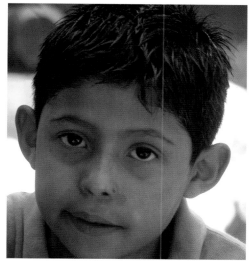

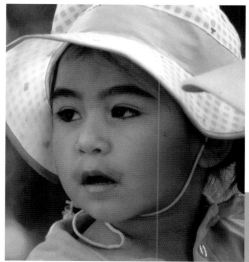

BRAZIL

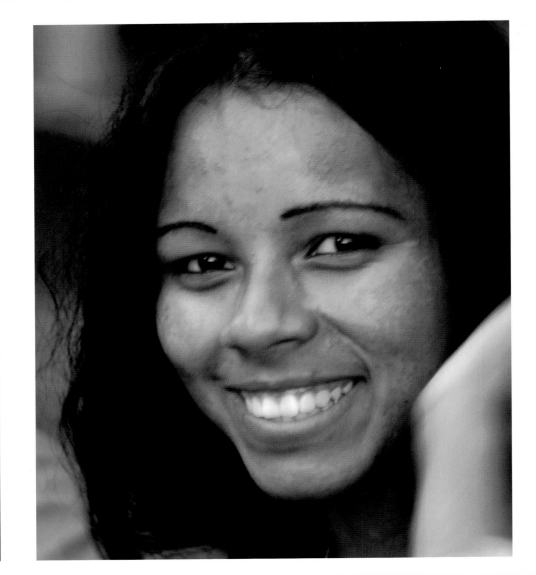

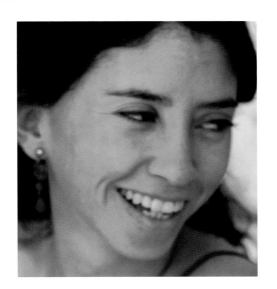

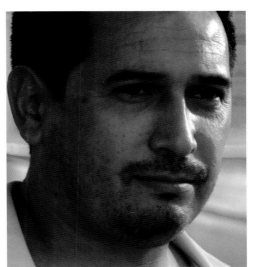

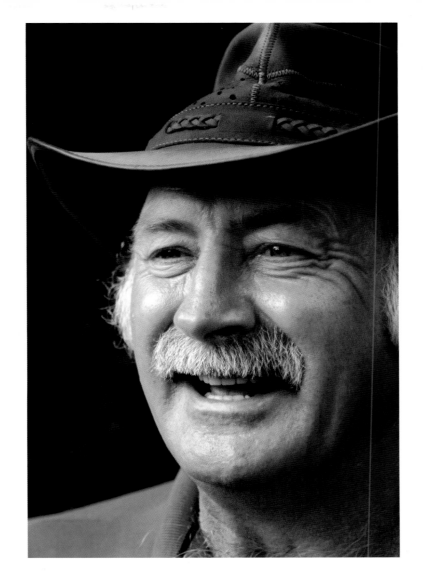

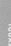

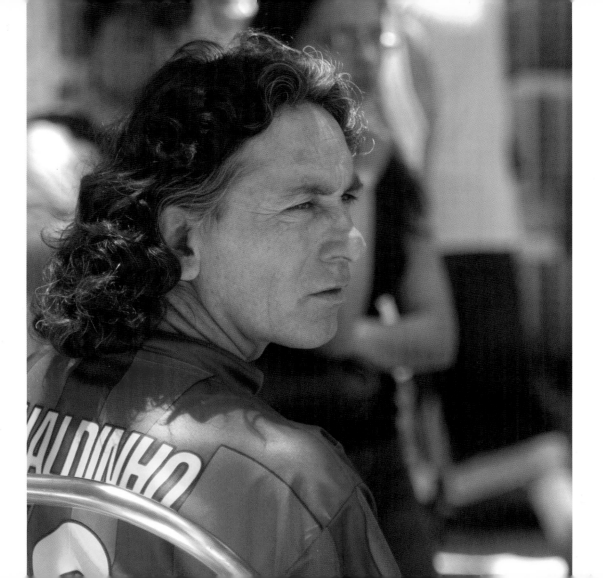

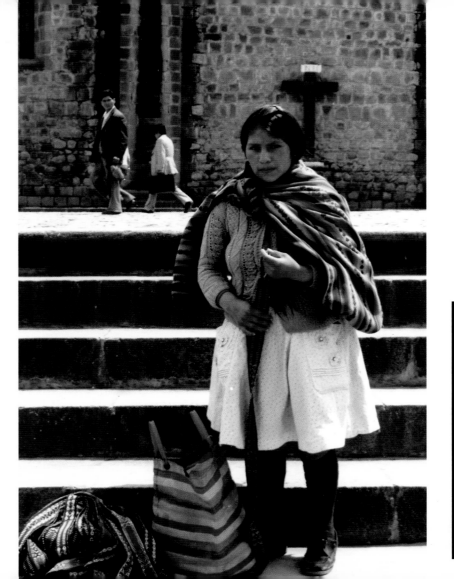

PERU

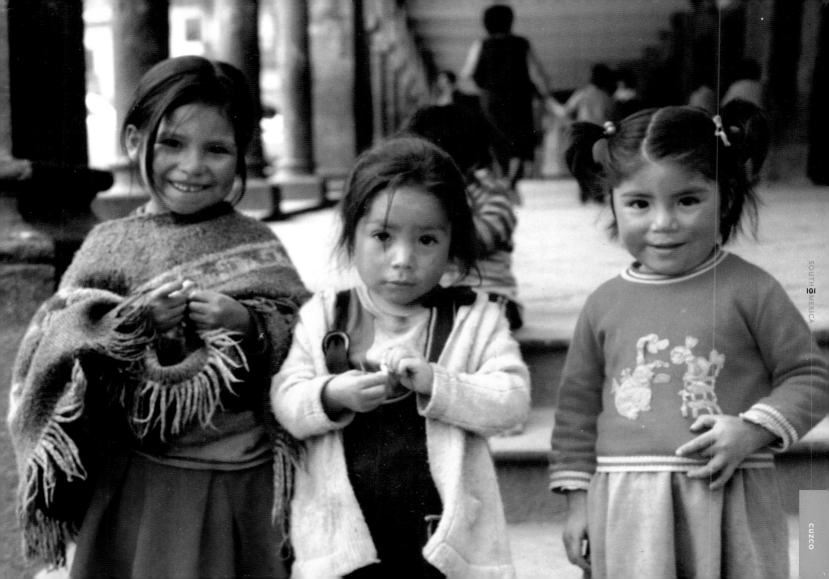

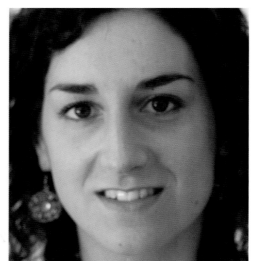

ARGENTINA

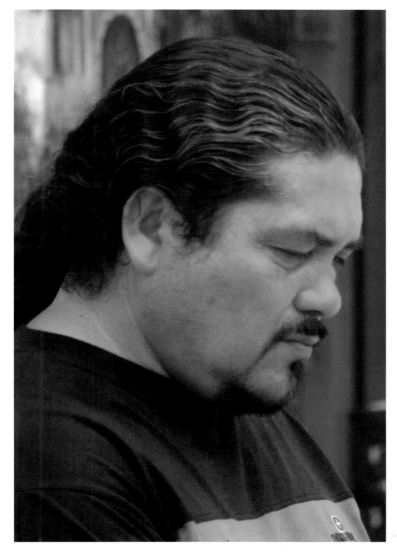
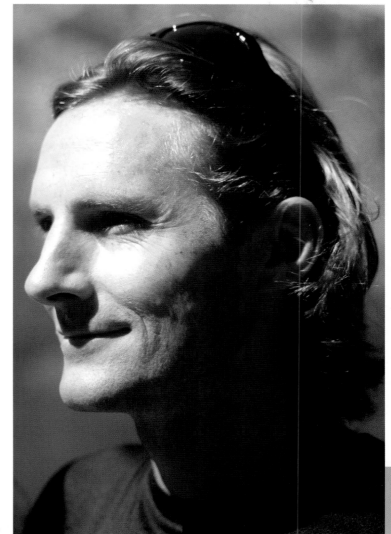

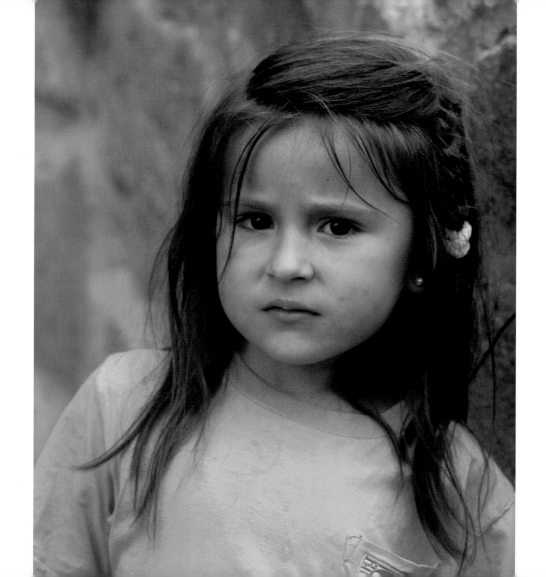

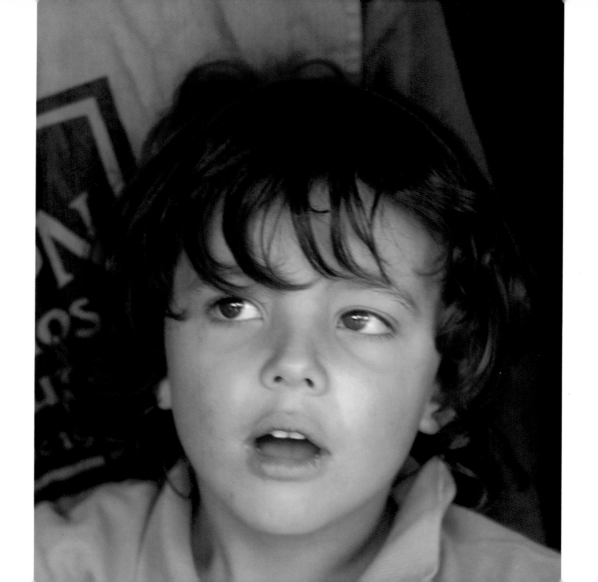

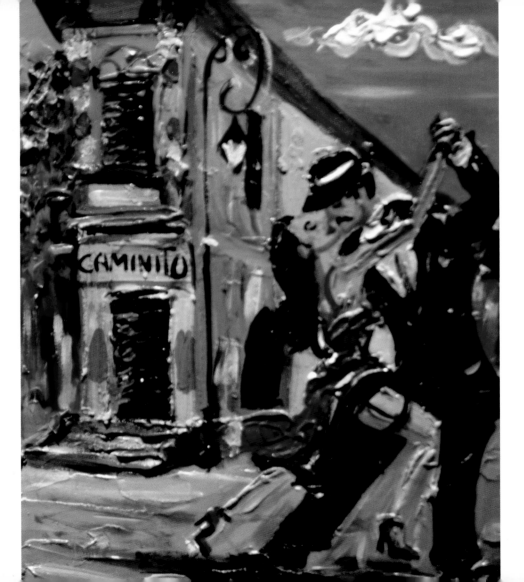

CUBA

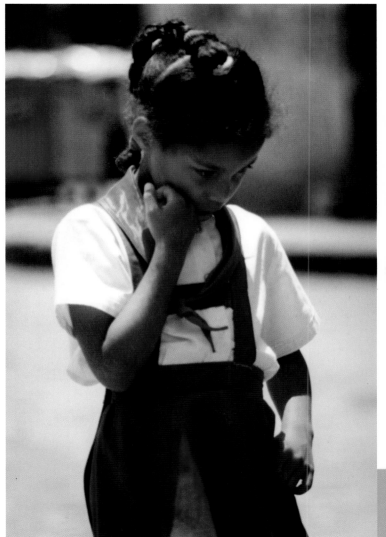

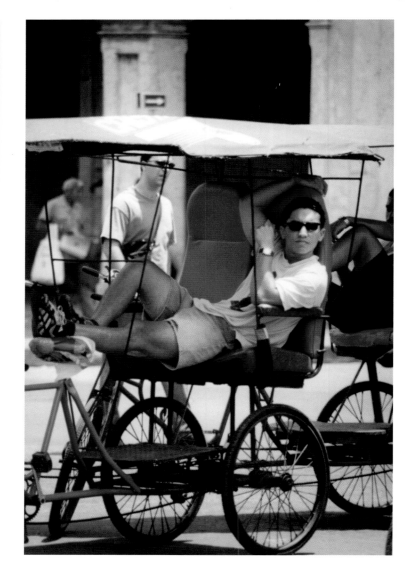

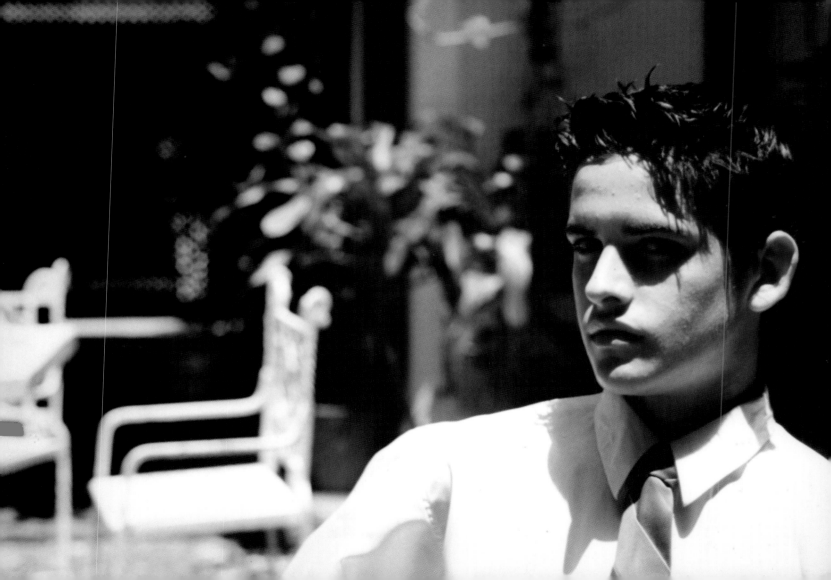

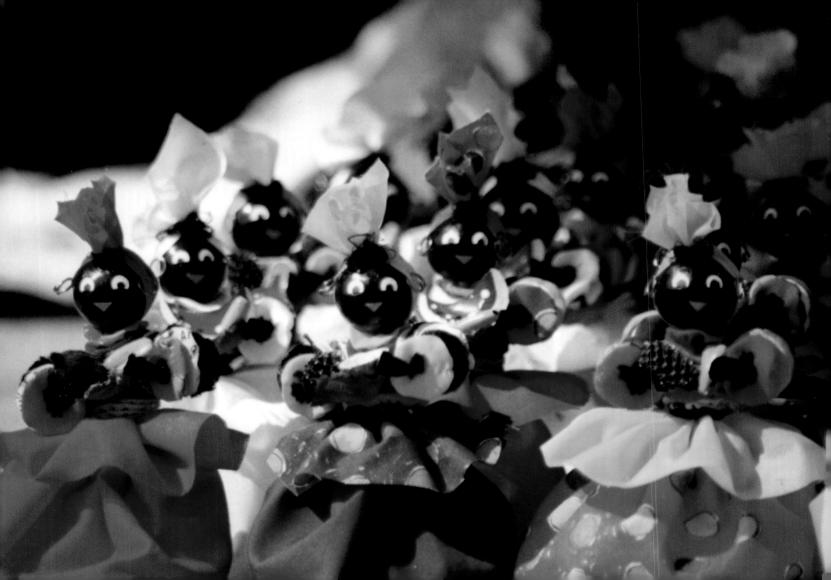

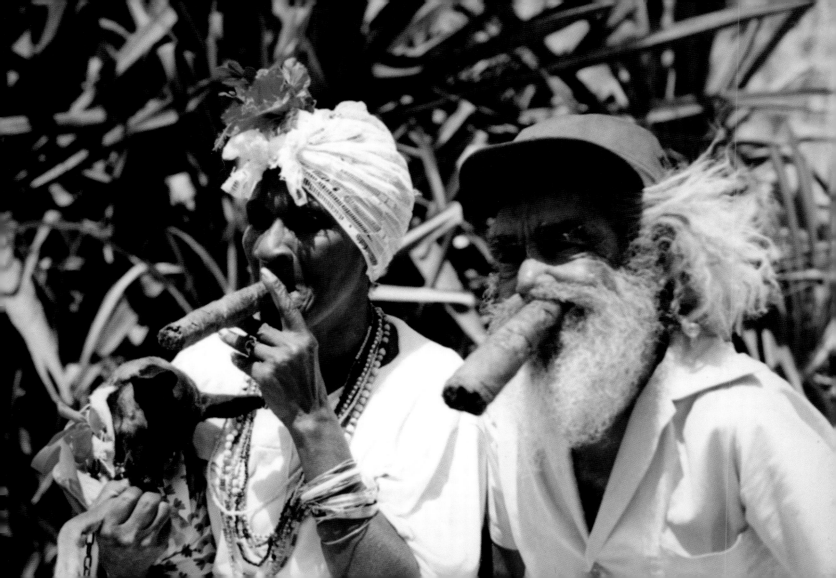

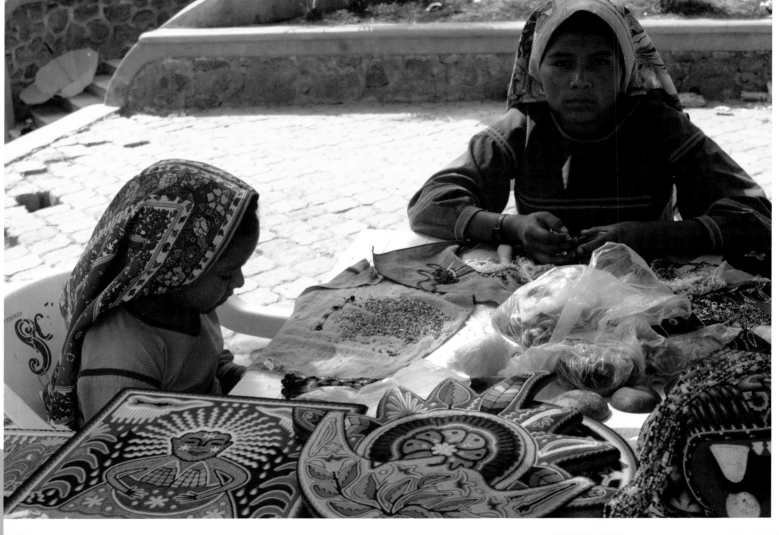

MEXICO

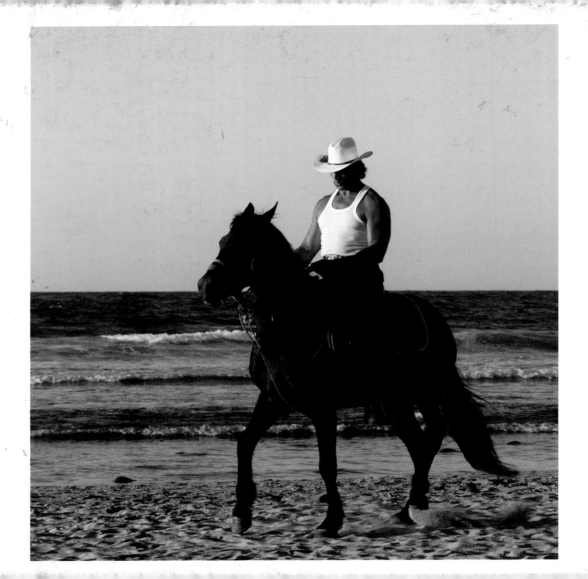

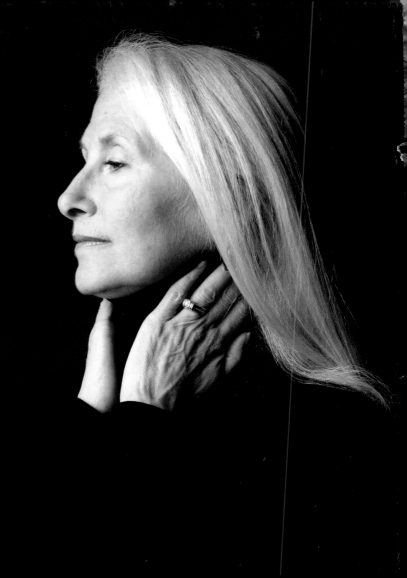

AMERICAN PORTRAITS

The photographs in GLOBAL FACES were all taken on the world's city streets, in small villages, and places where everyday people gather, such as at markets, public squares, and local festivals. It was in these surroundings that I attempted to capture the world's people, sometimes in unexpected ways.

But in my search for faces, I also learned that if individuals had the time to think about how they might want to be photographed, or what expression they believe best captures their personality, it created a completely different experience. As a result, I asked some friends, colleagues, and some complete strangers to sit for a portrait, so that I could explore faces in a completely different way.

The following faces are a result of that experience...faces representing the multiculturalism of my country, as they are all Americans, from many different backgrounds.

Some of these great faces came to life with smiles, others came to life with more subdued expressions. But in each case, I believe that I was able to capture each individual's personality and comfort level in how they wanted the world to see them. These American Portraits prove that time and time again, it is other people that are the most interesting subjects for us. Because in at least one of them, we recognize a small part of ourselves.

MICHAEL CLINTON

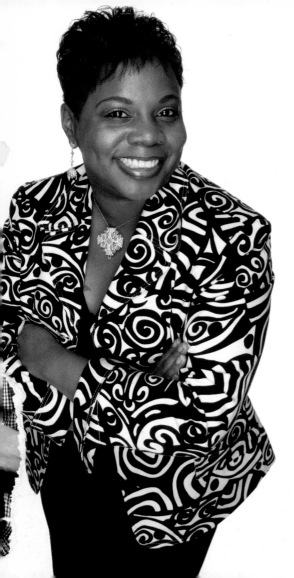
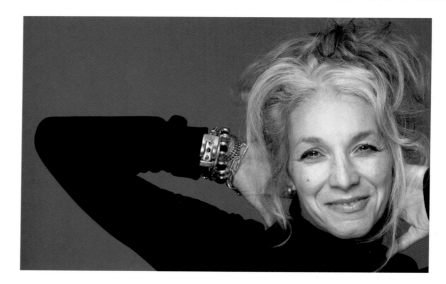
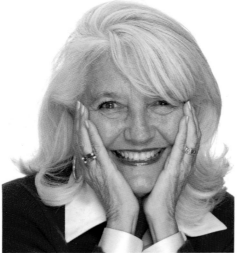
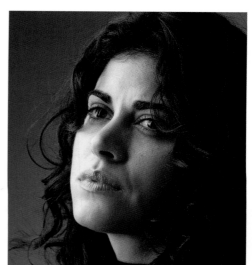

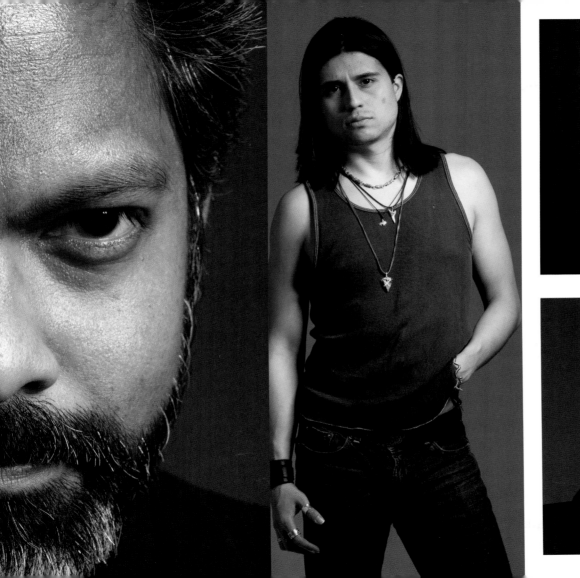
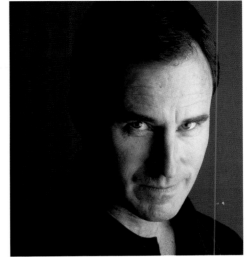

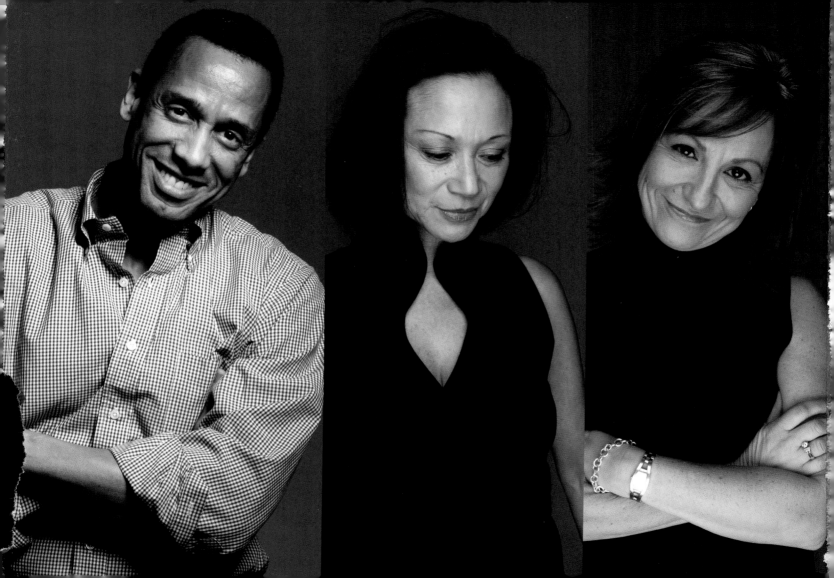

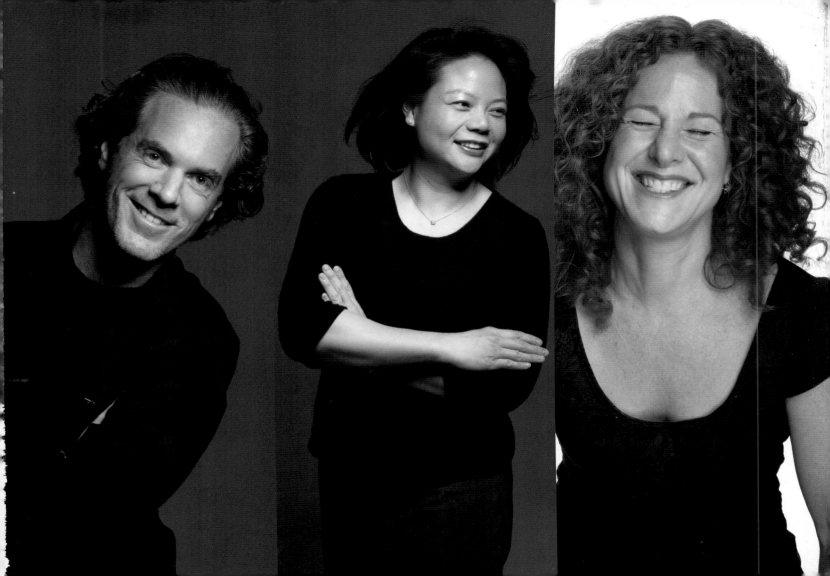

UNITED STATES

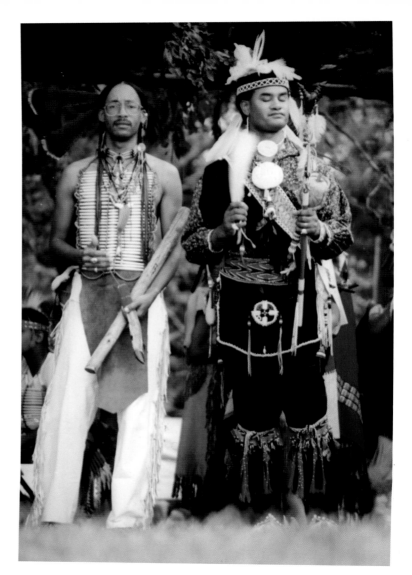

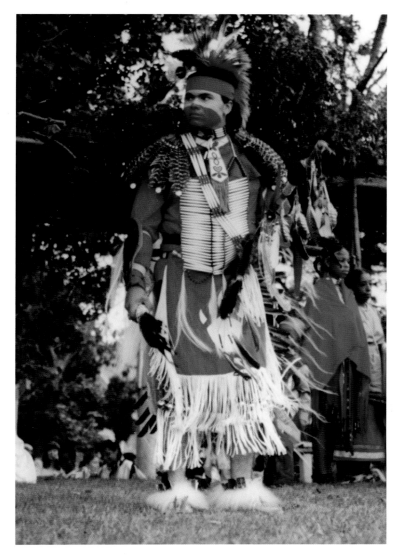
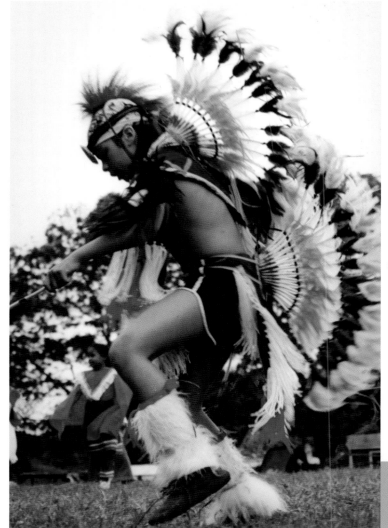

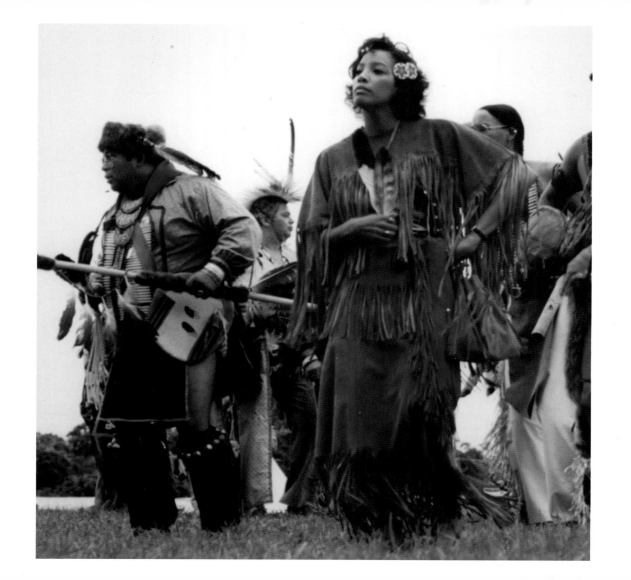

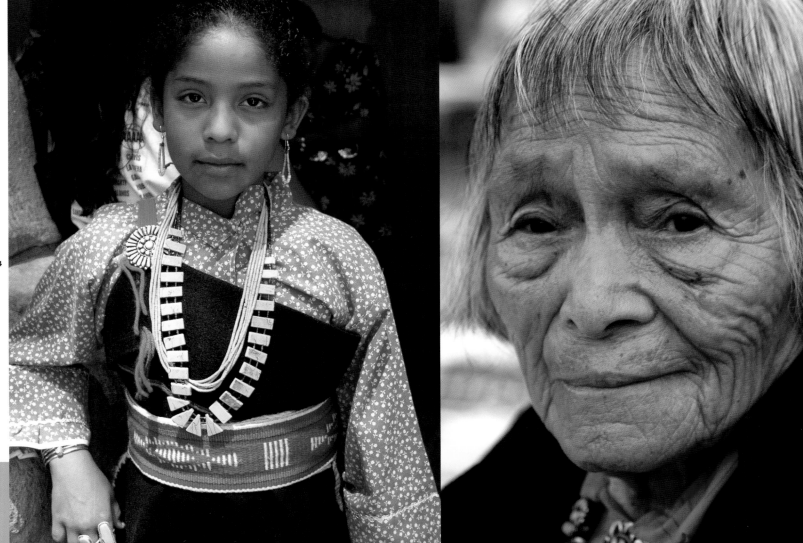

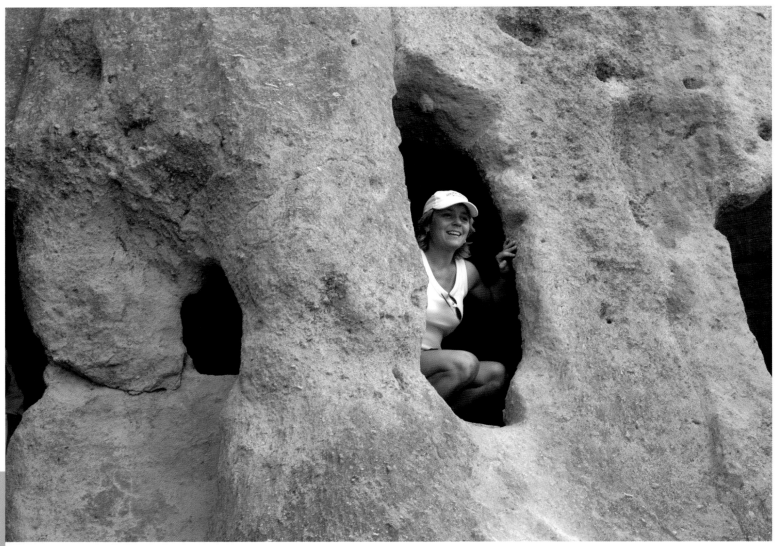

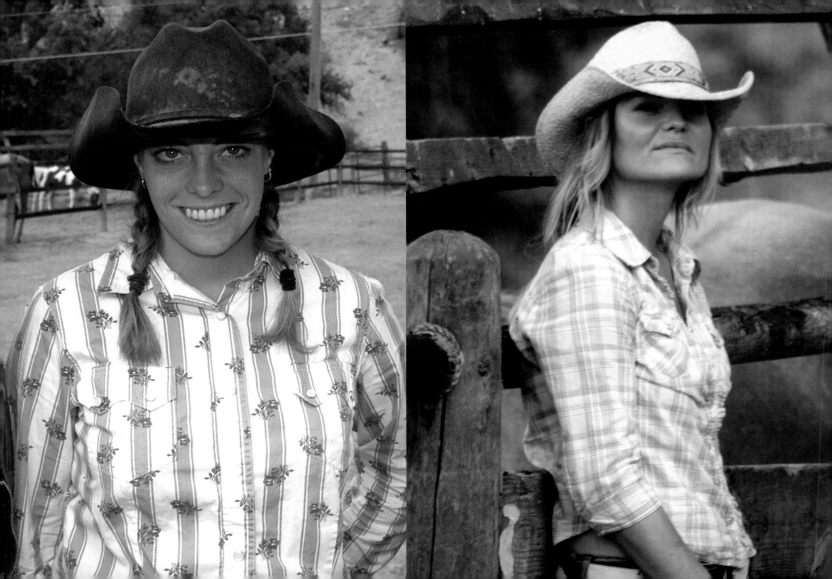

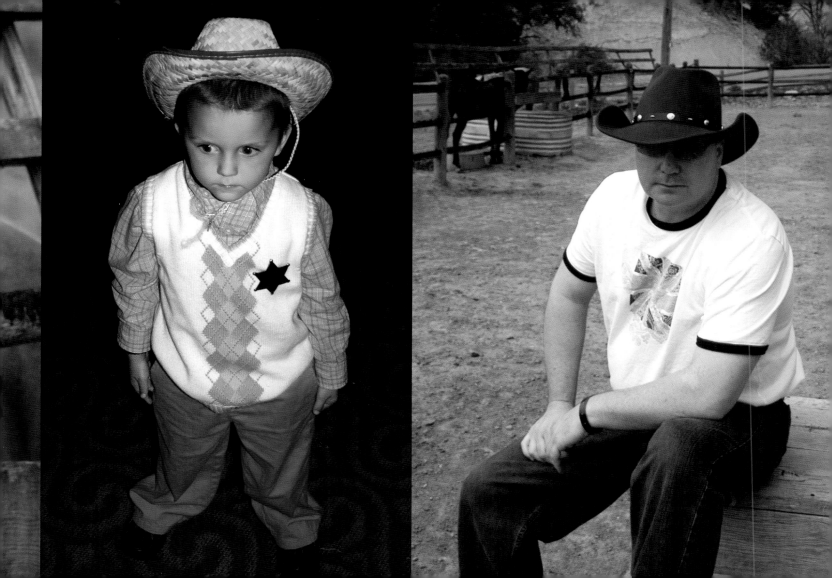

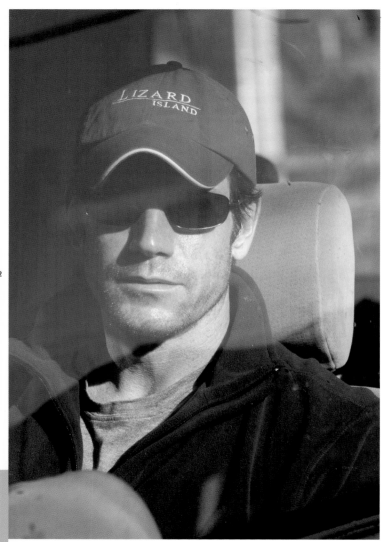

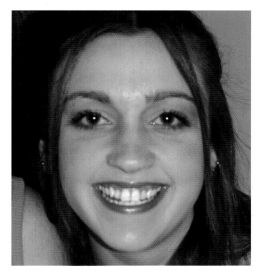 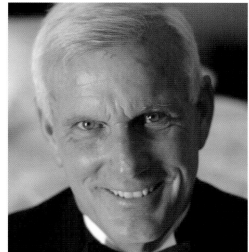 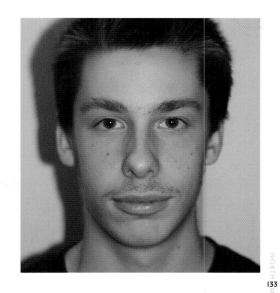

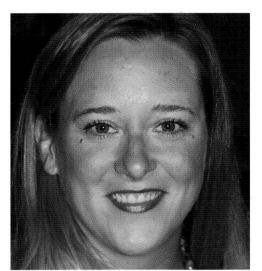 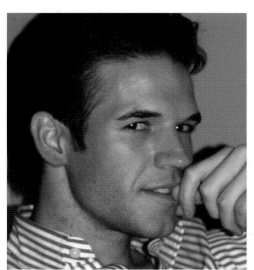 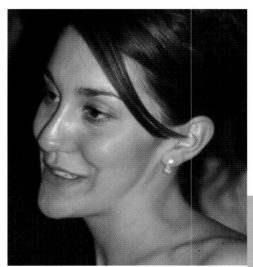

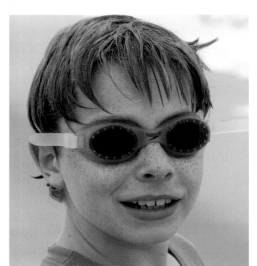

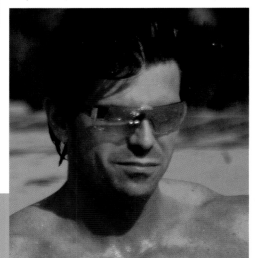

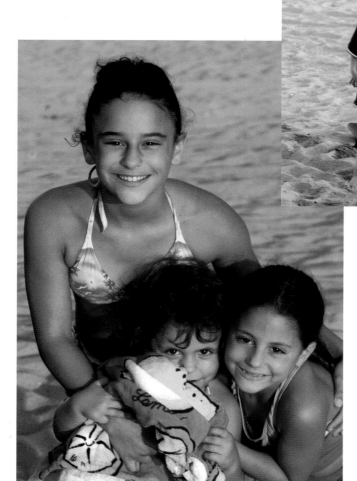

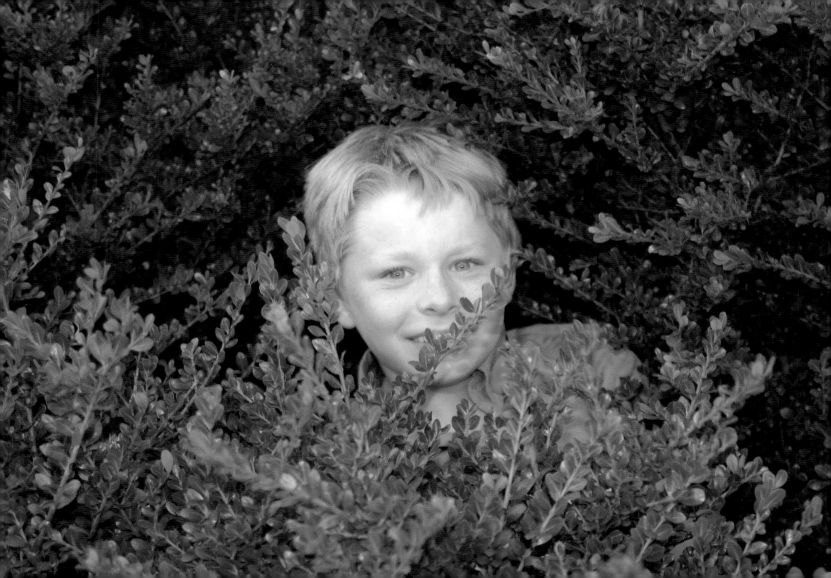

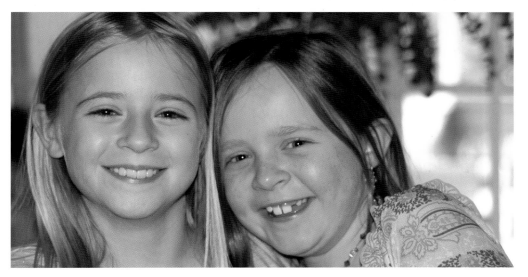
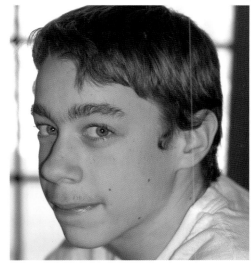
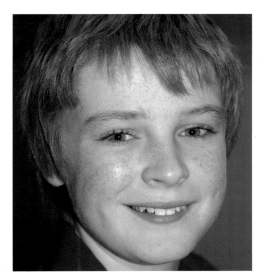
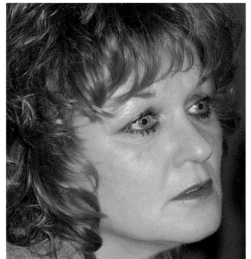
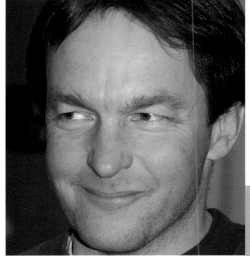

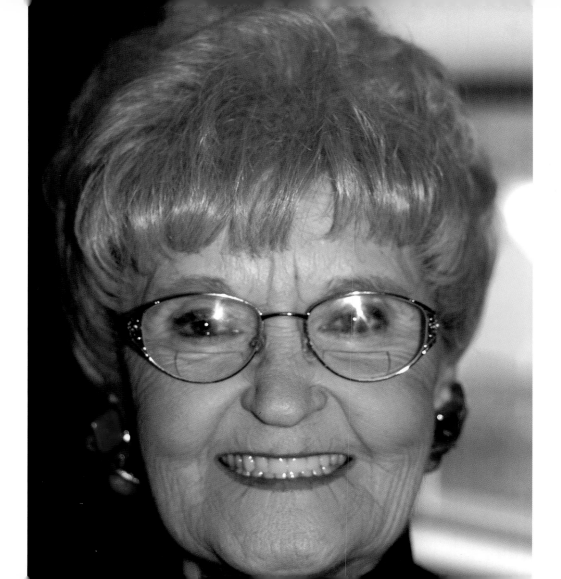

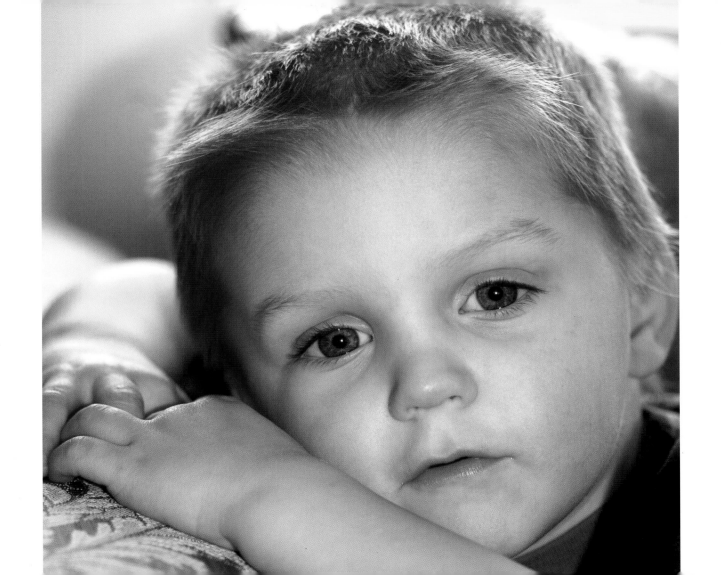

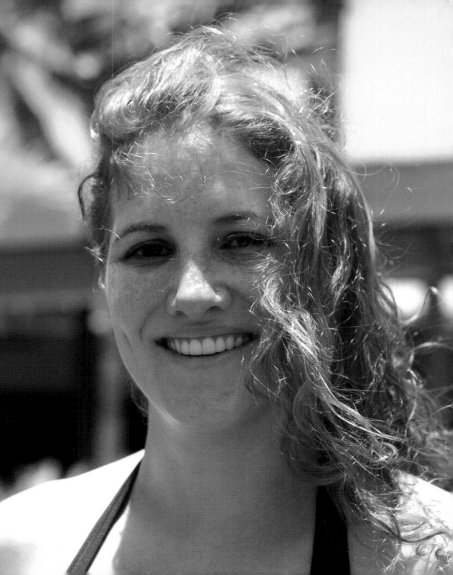

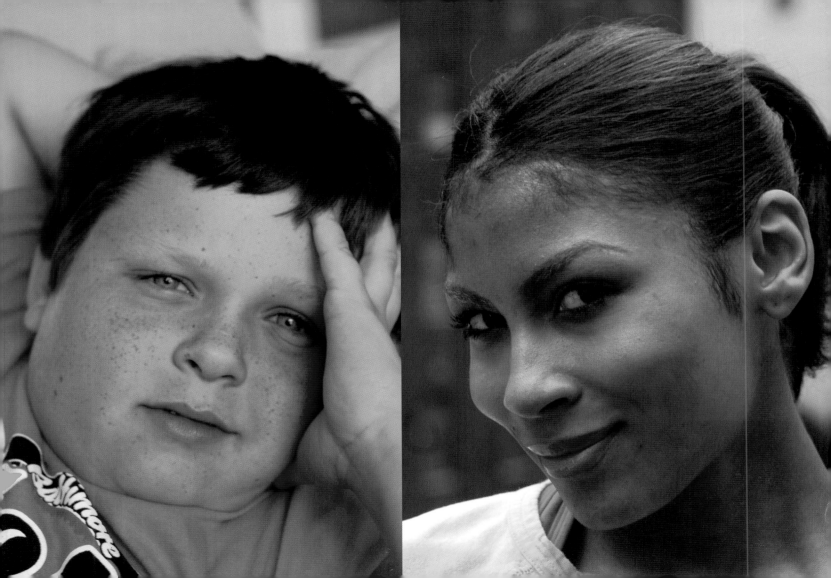

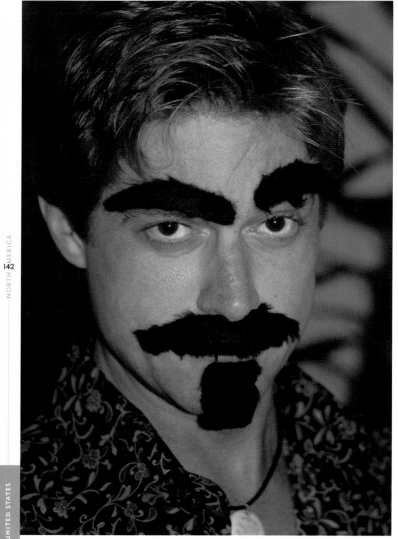
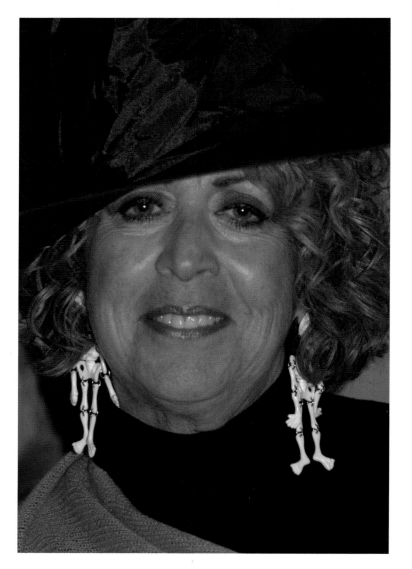

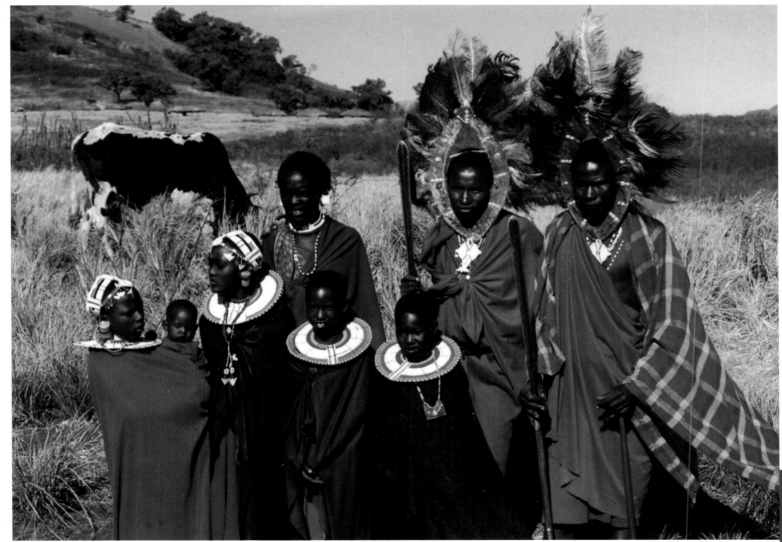

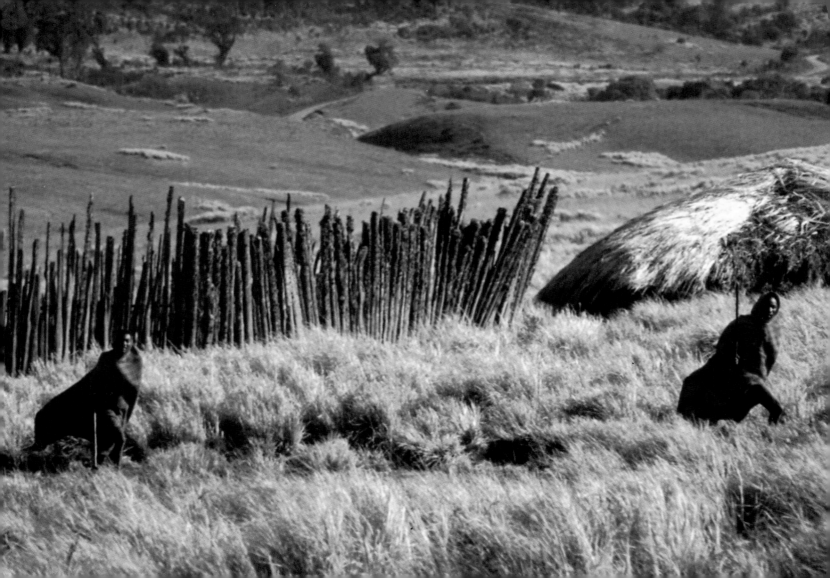

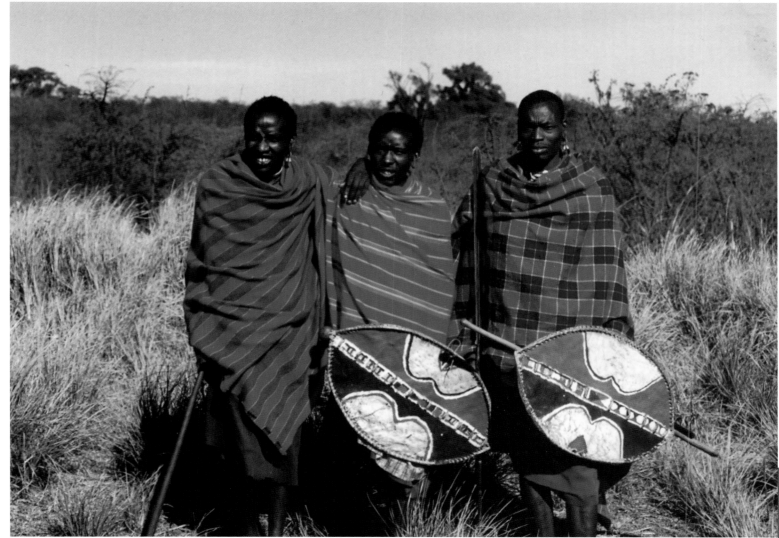

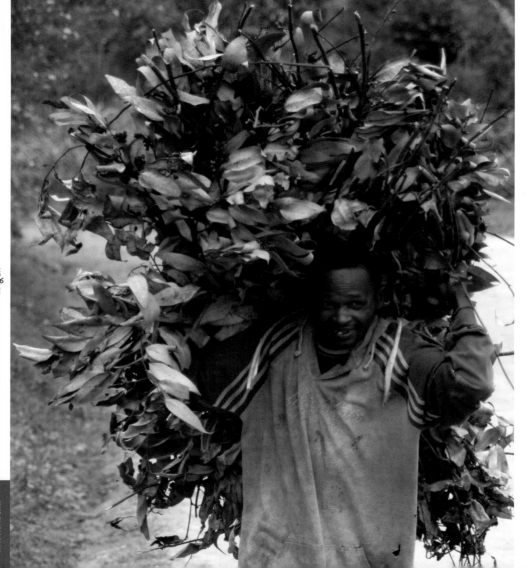

MADAGASCAR

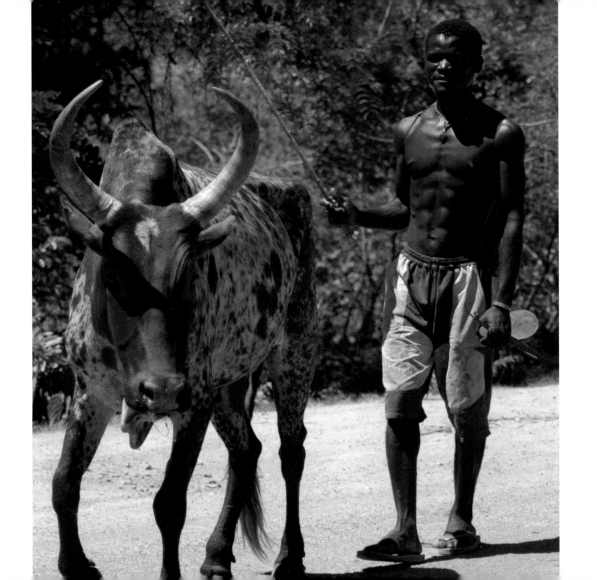

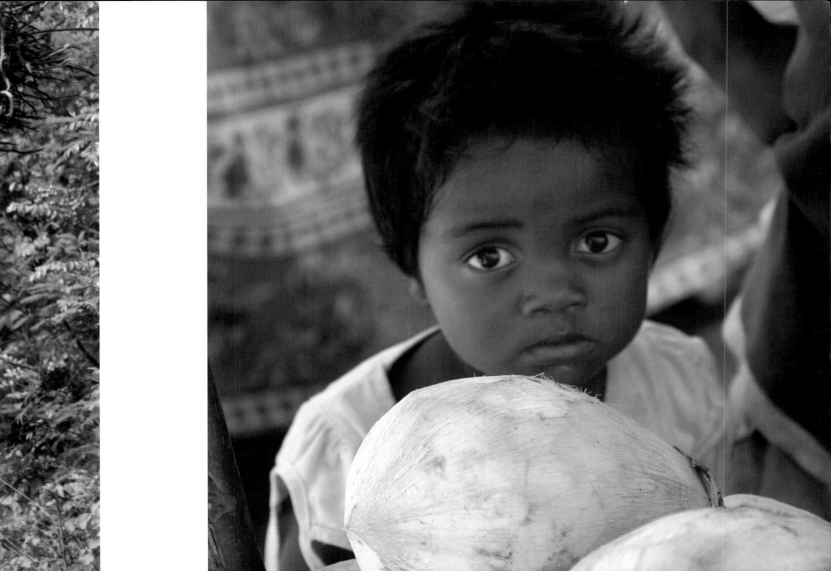

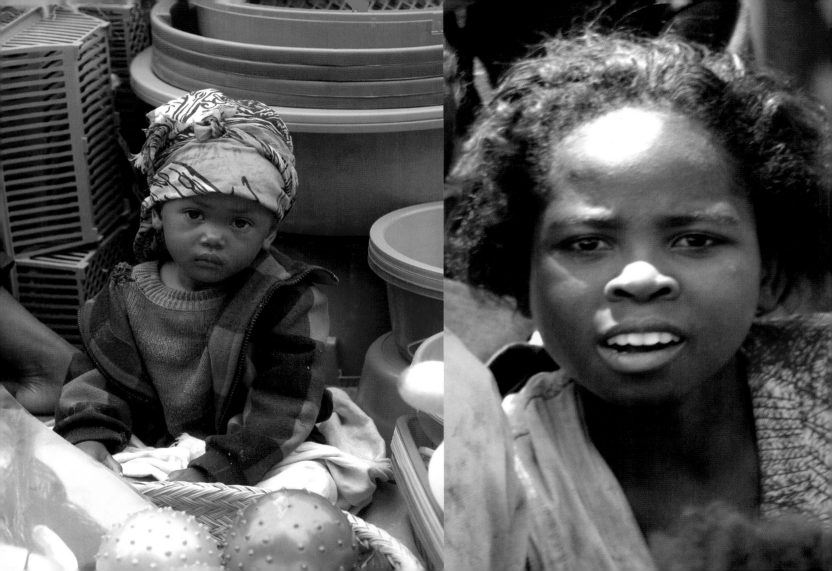

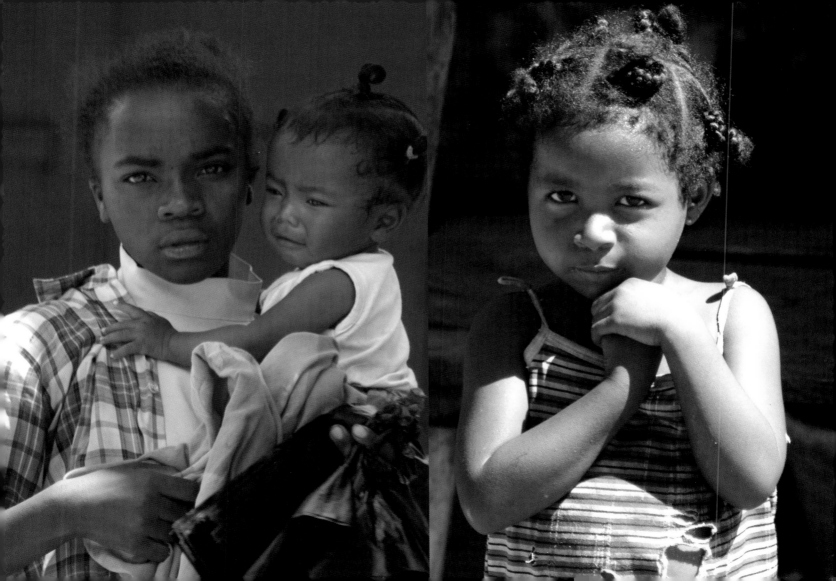

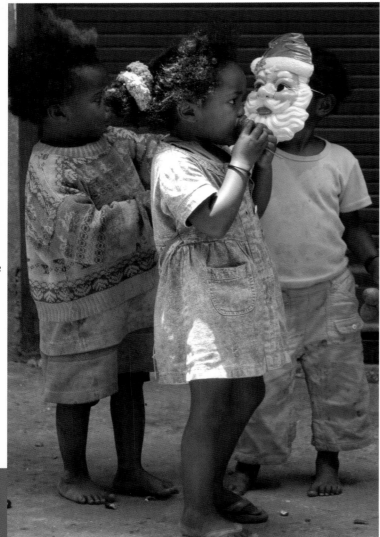

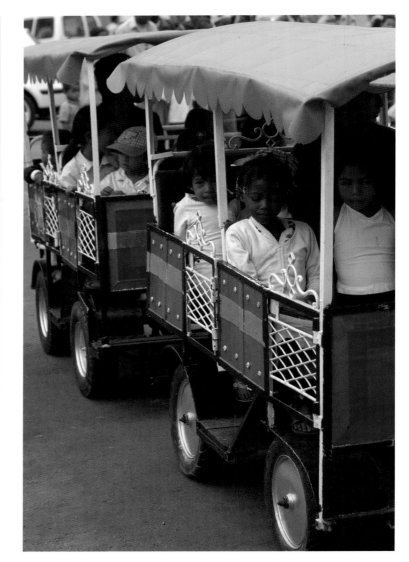

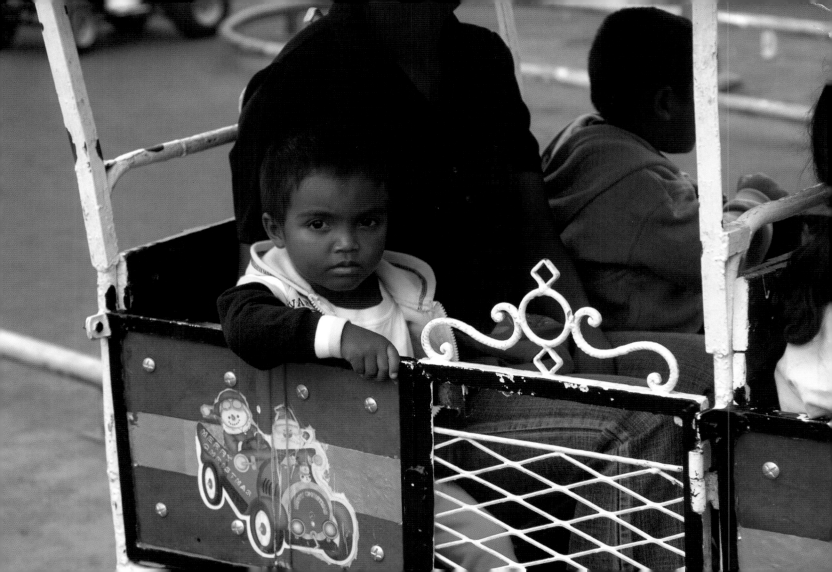

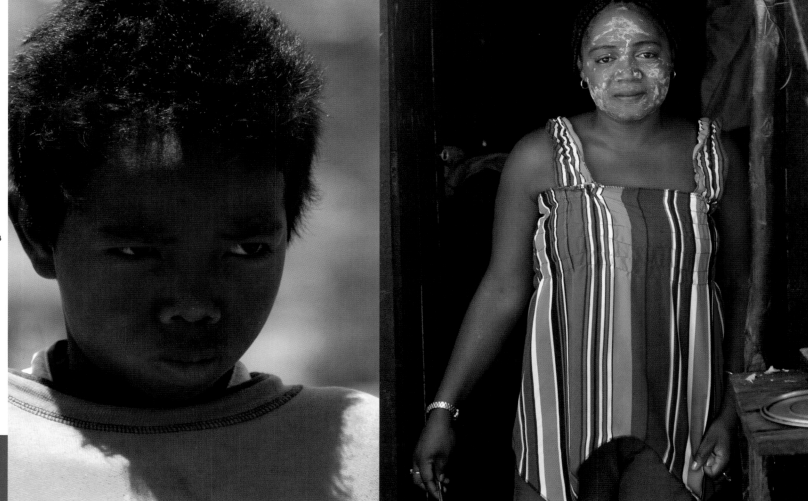

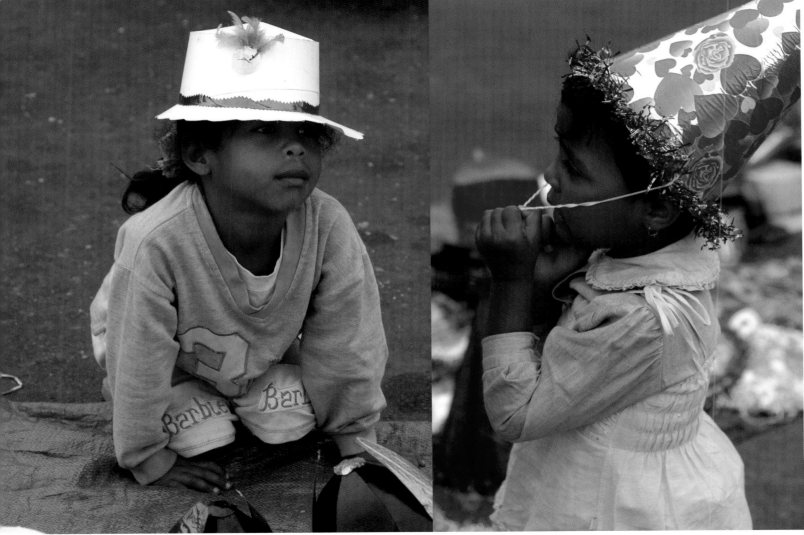

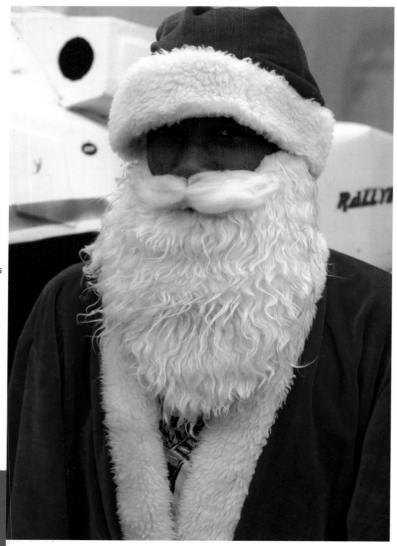

166

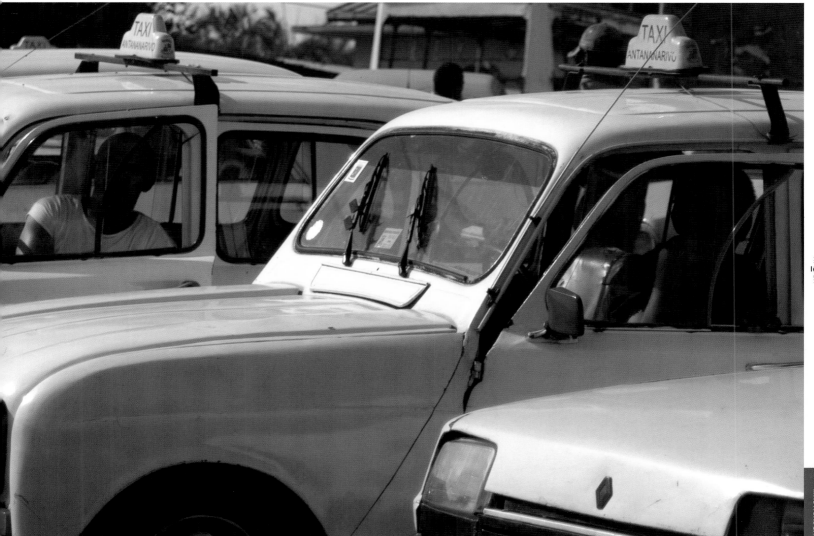

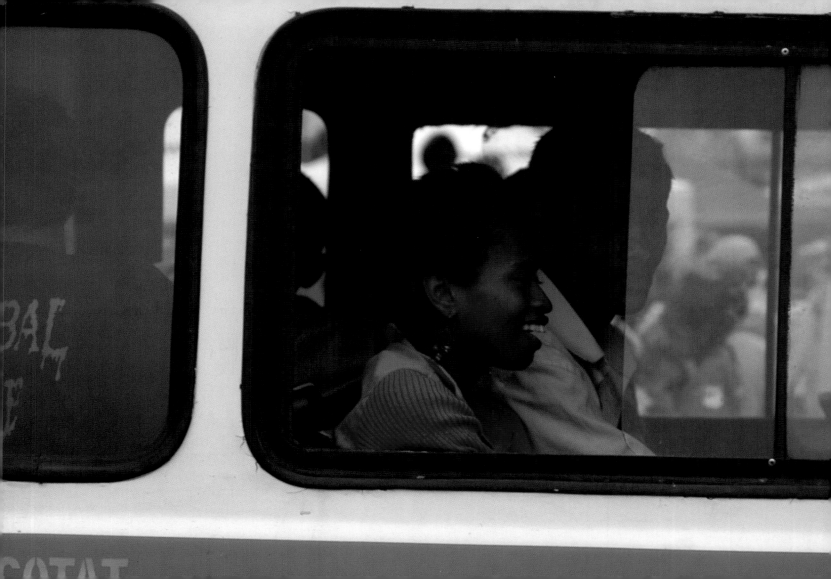

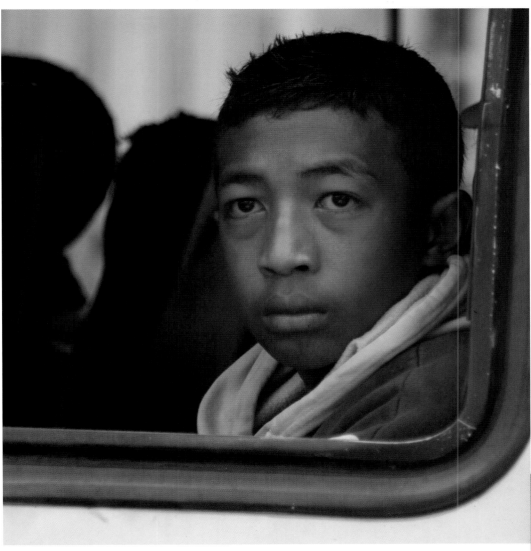

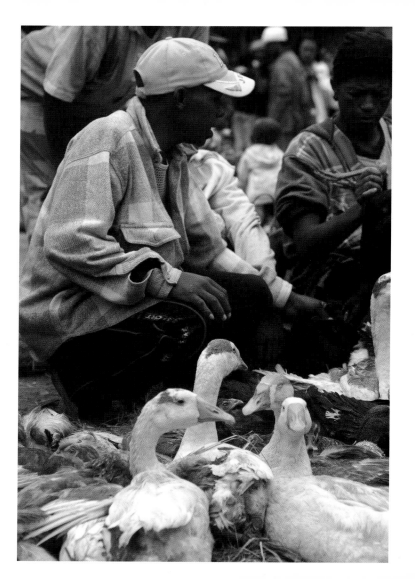

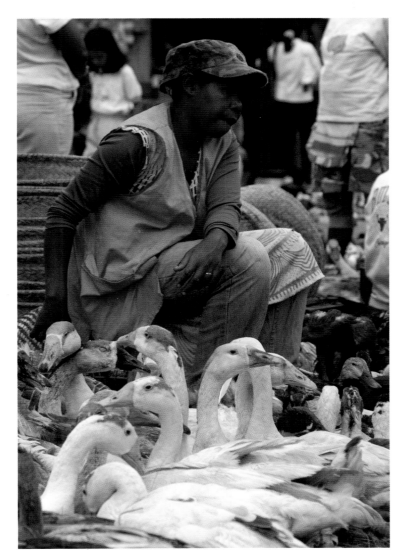
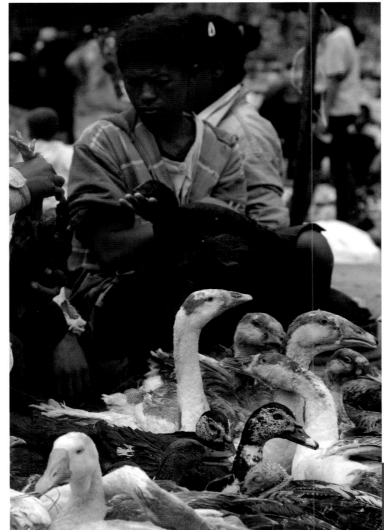

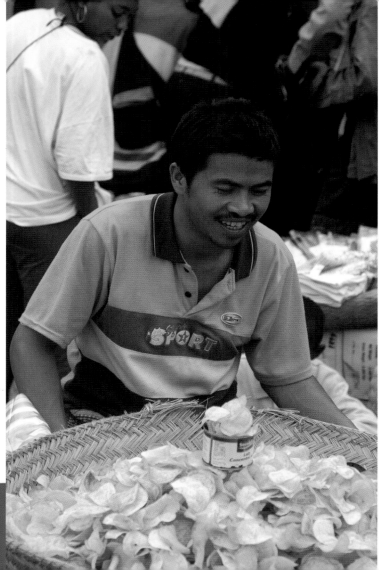

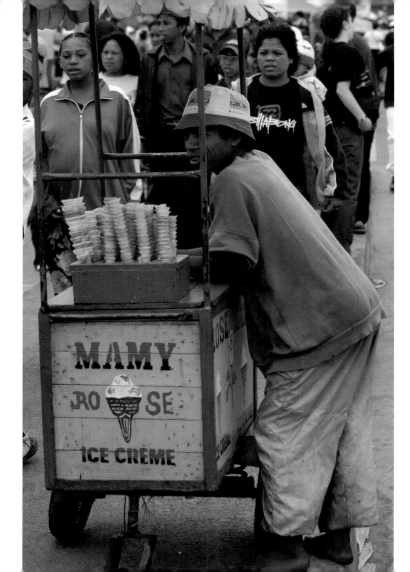

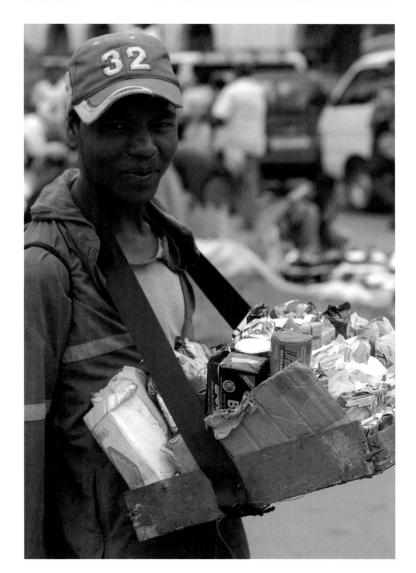
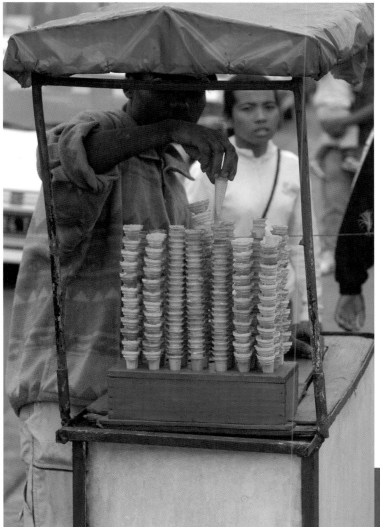

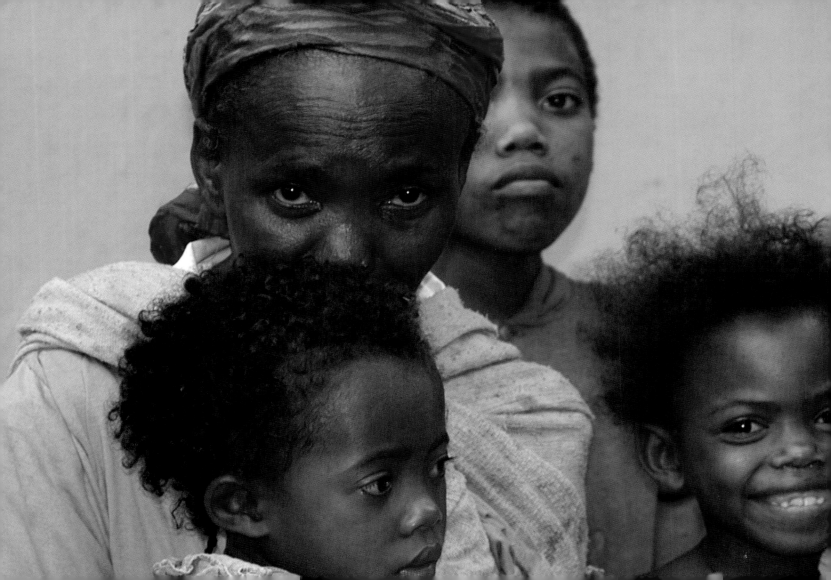

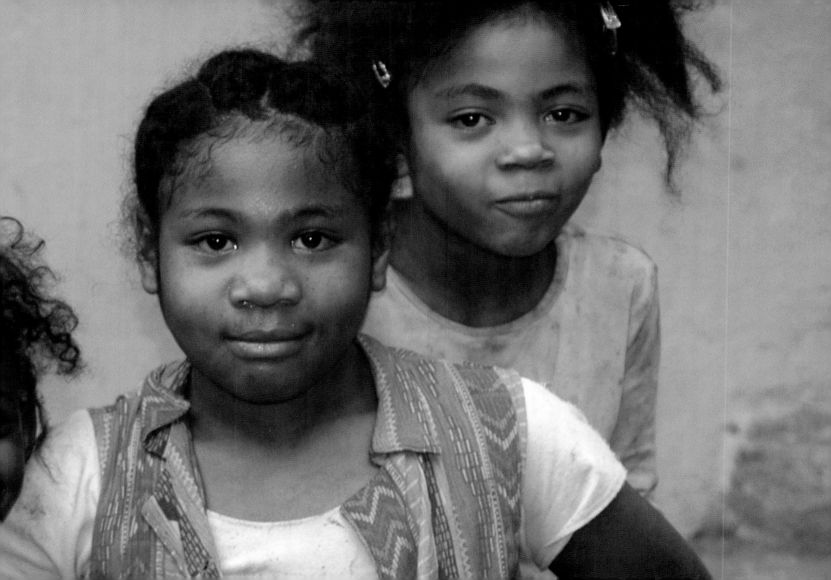

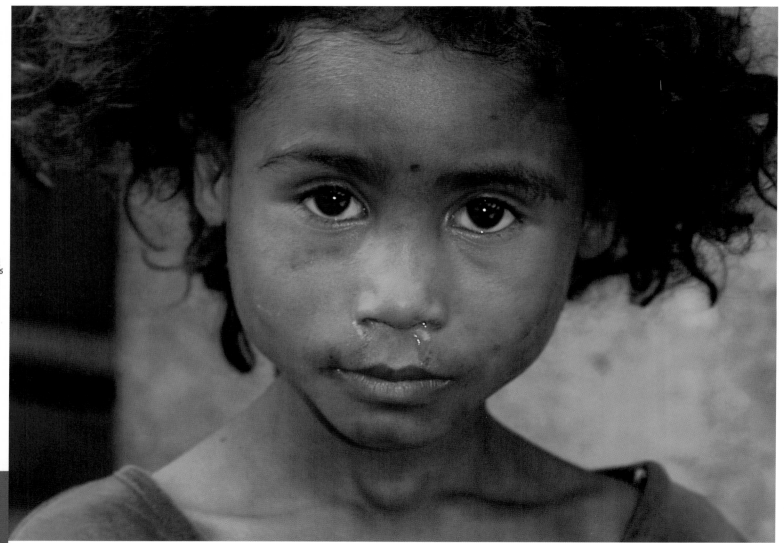

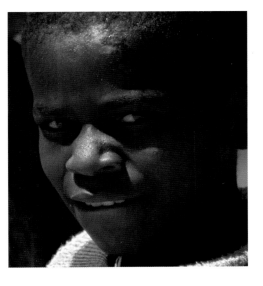
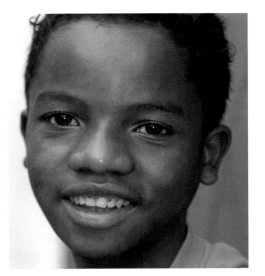
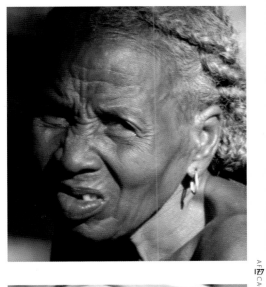
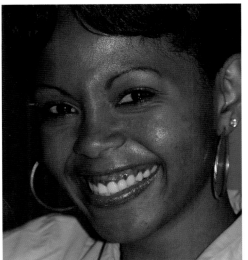
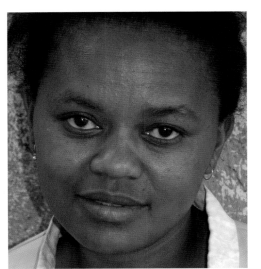
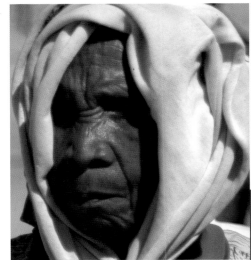

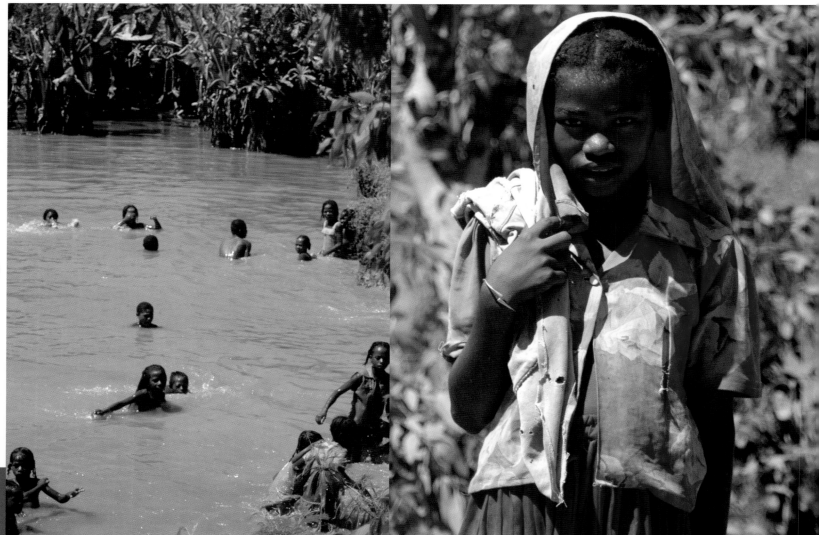

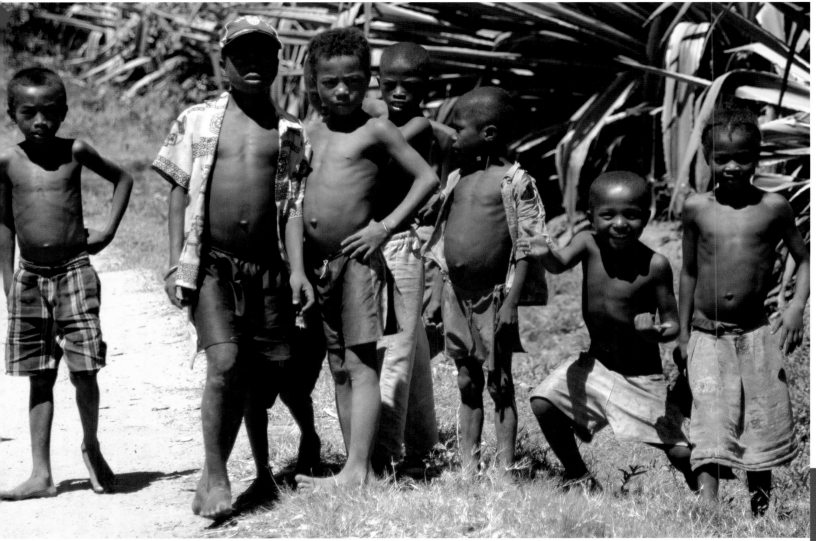

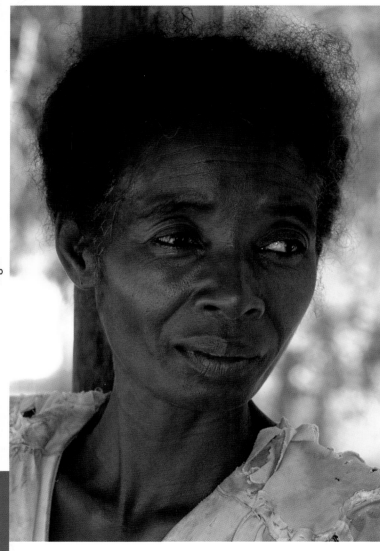

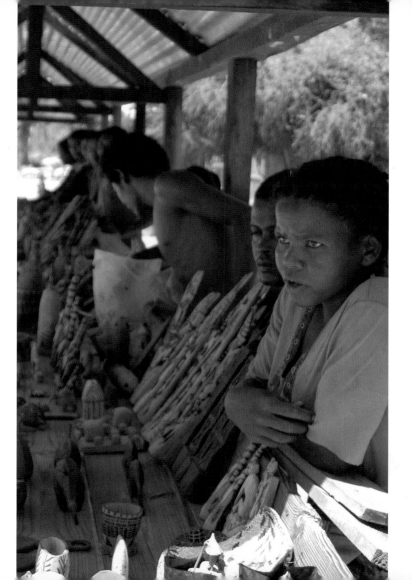

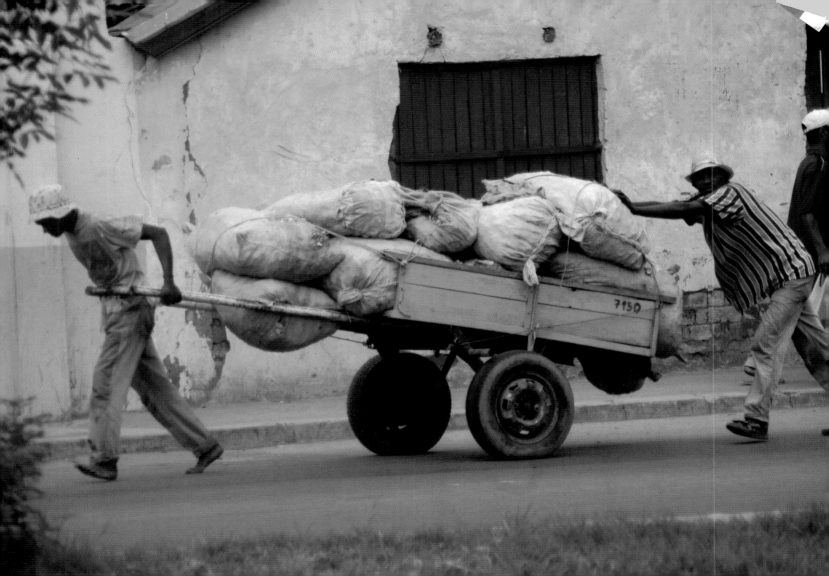

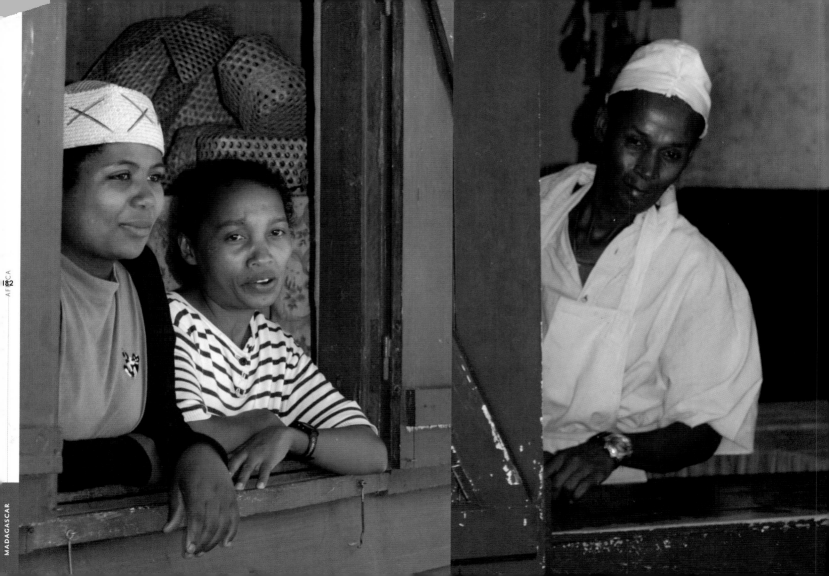

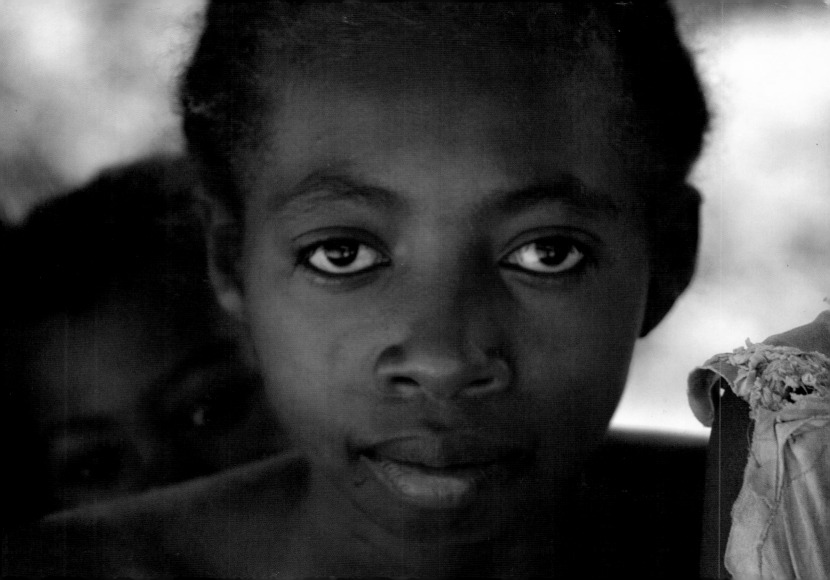

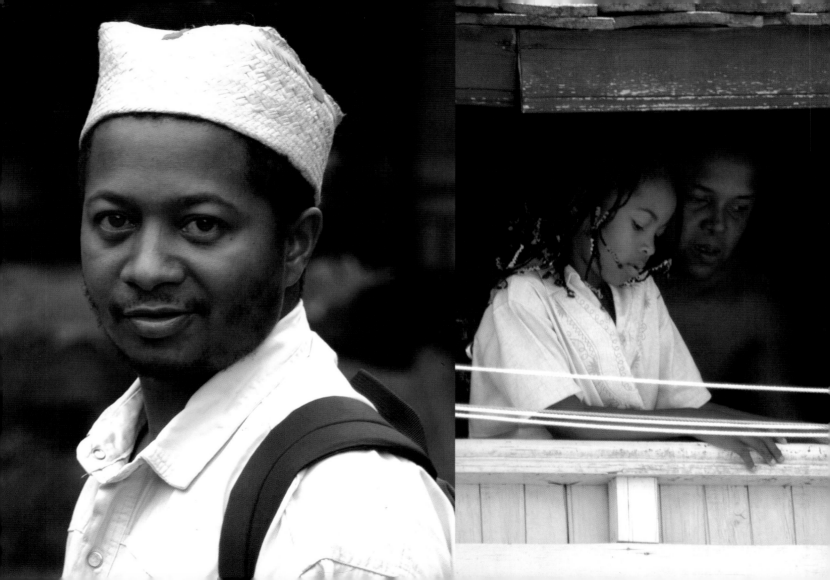

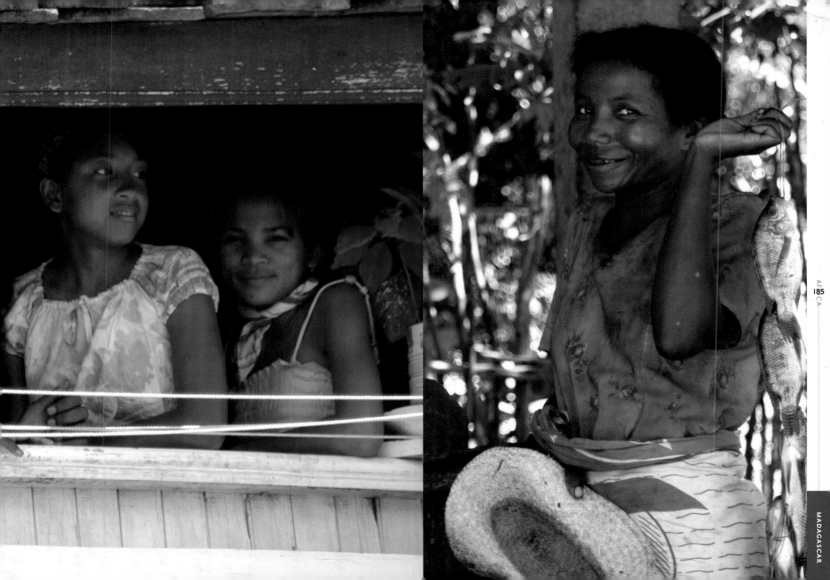

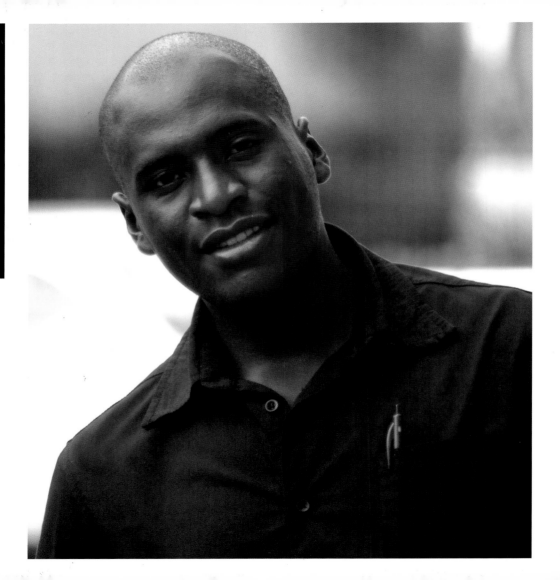

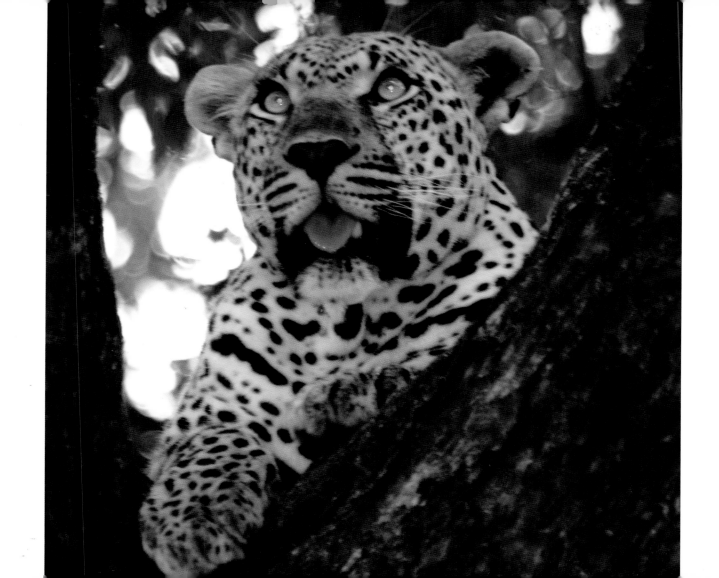

178

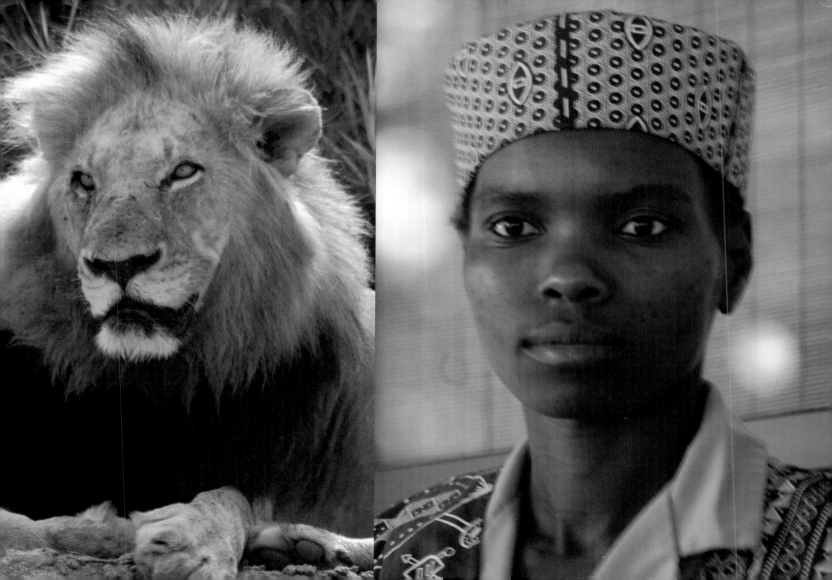

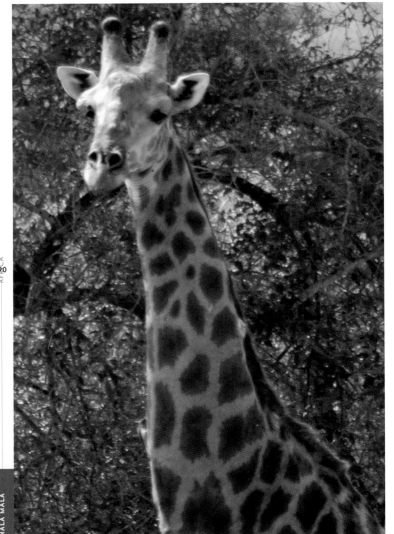
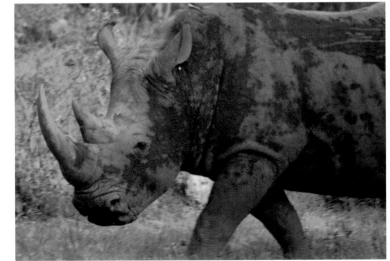
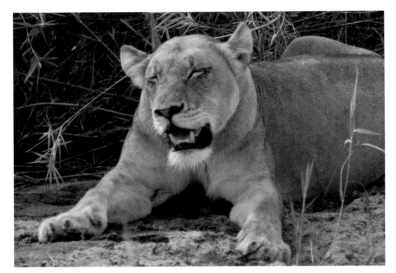

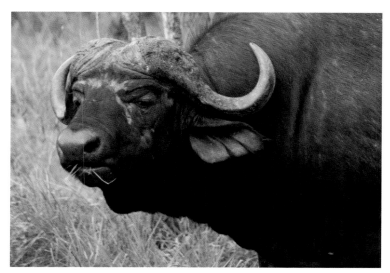

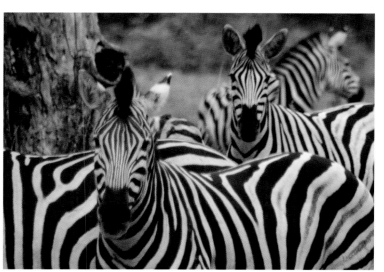

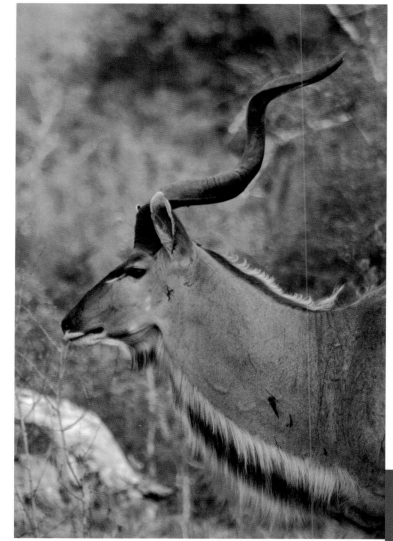

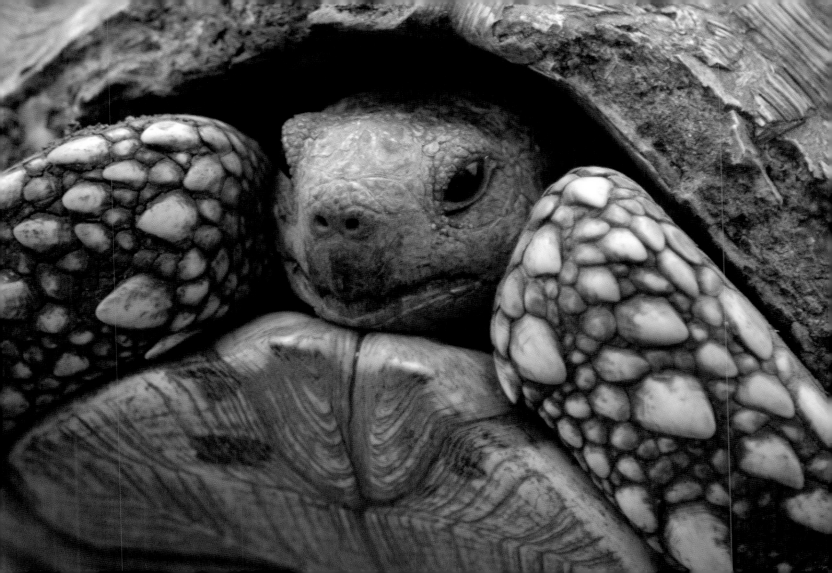

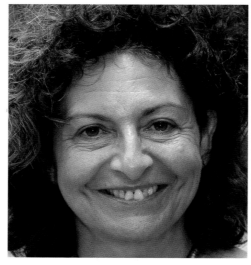
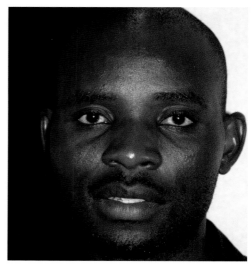
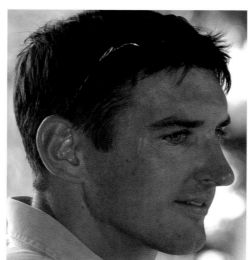
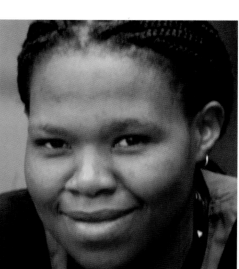

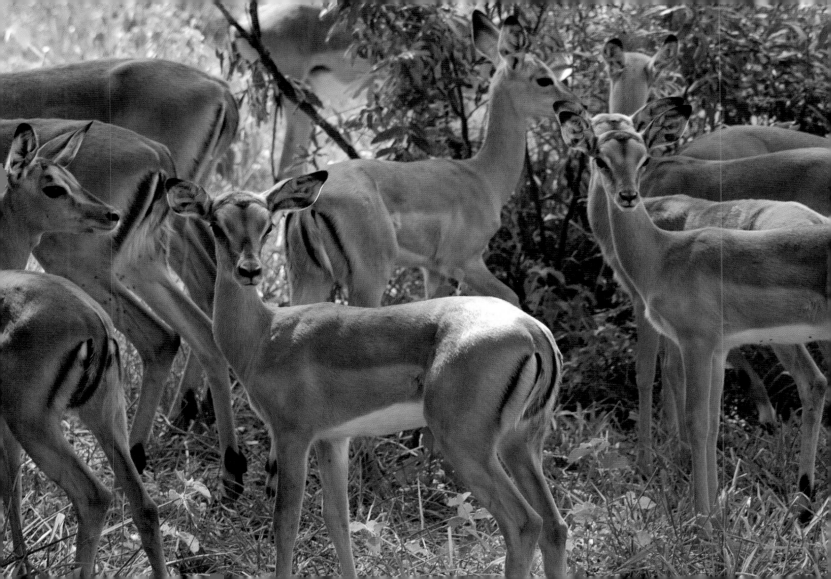

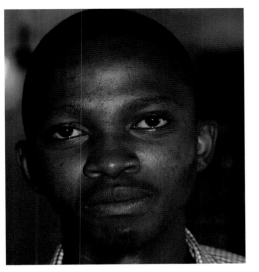
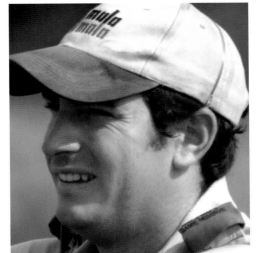
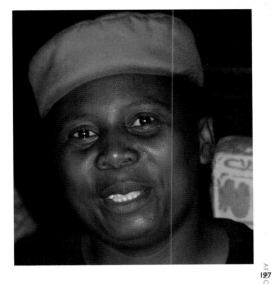
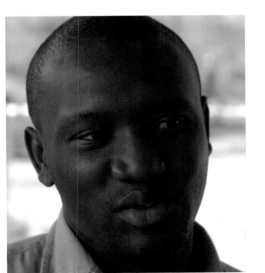
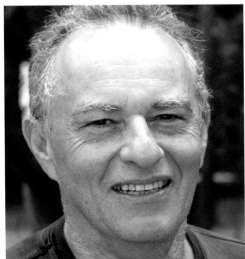
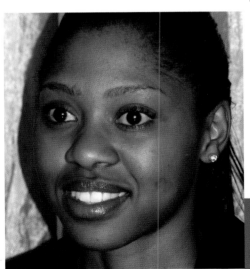

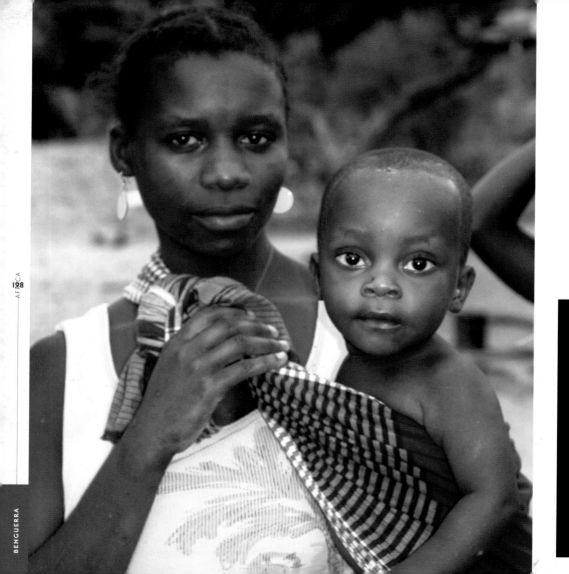

MOZAMBIQUE

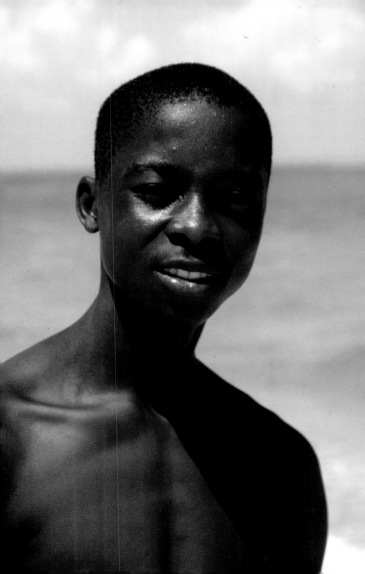
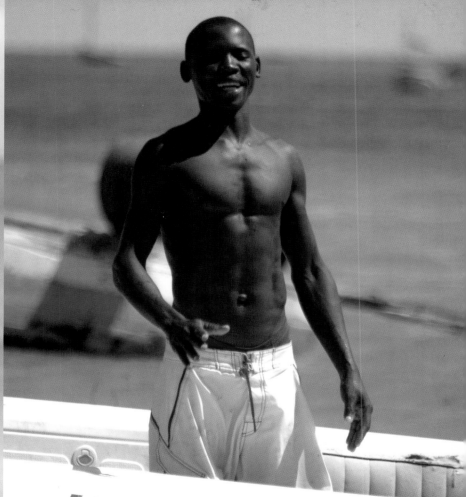

pélago do B

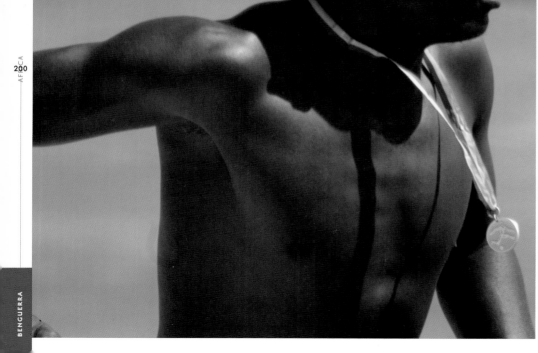

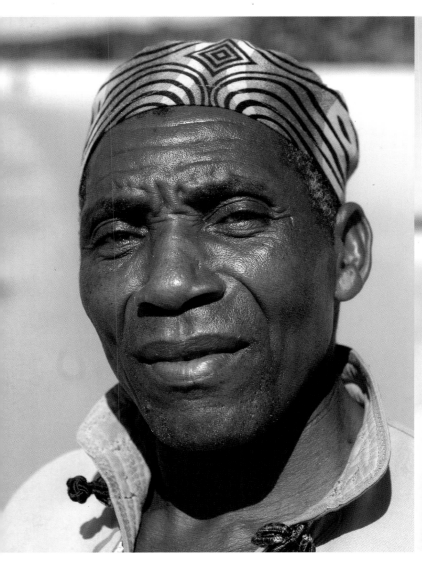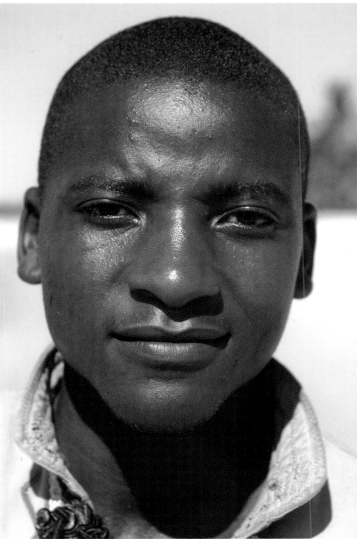

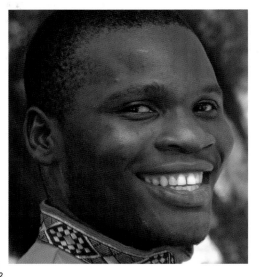
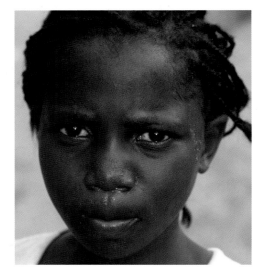
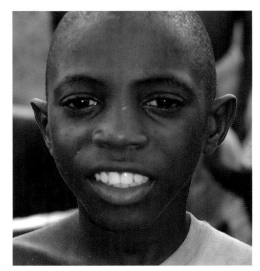
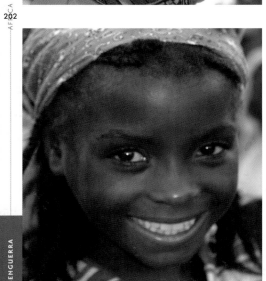
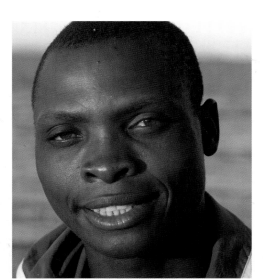
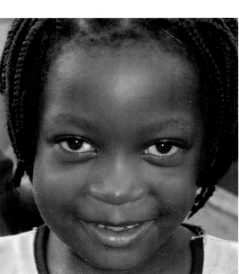

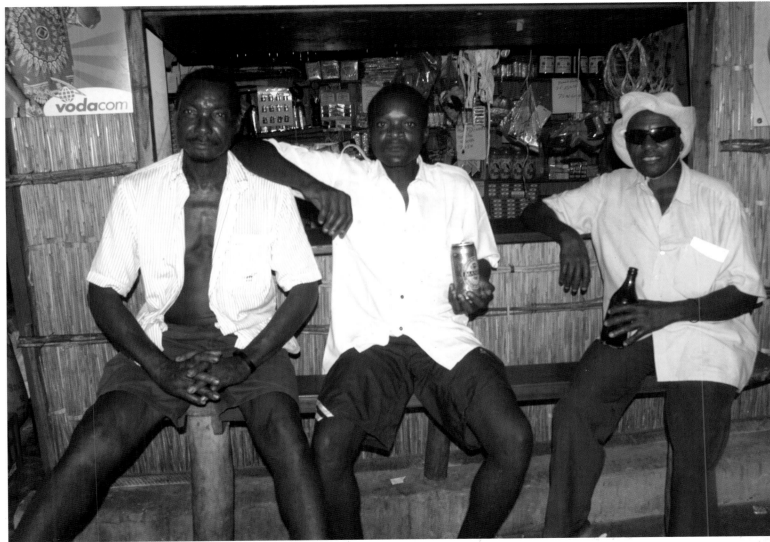

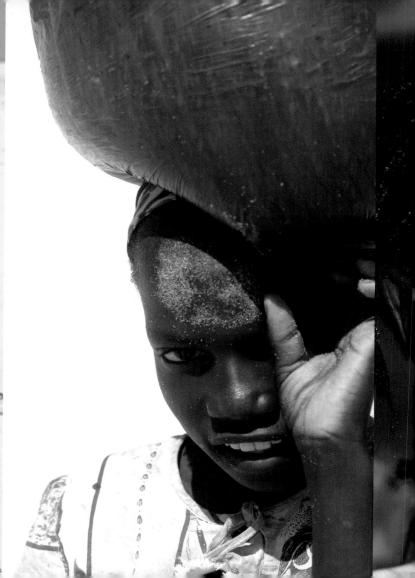

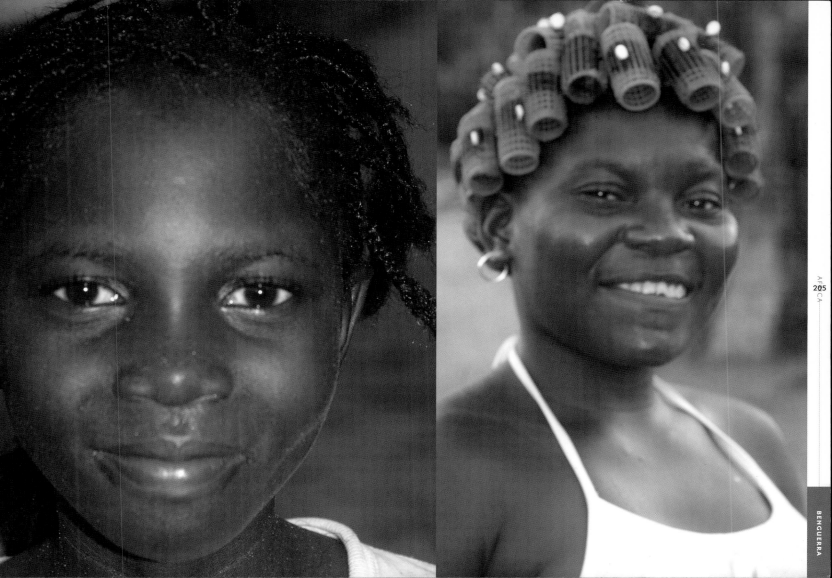

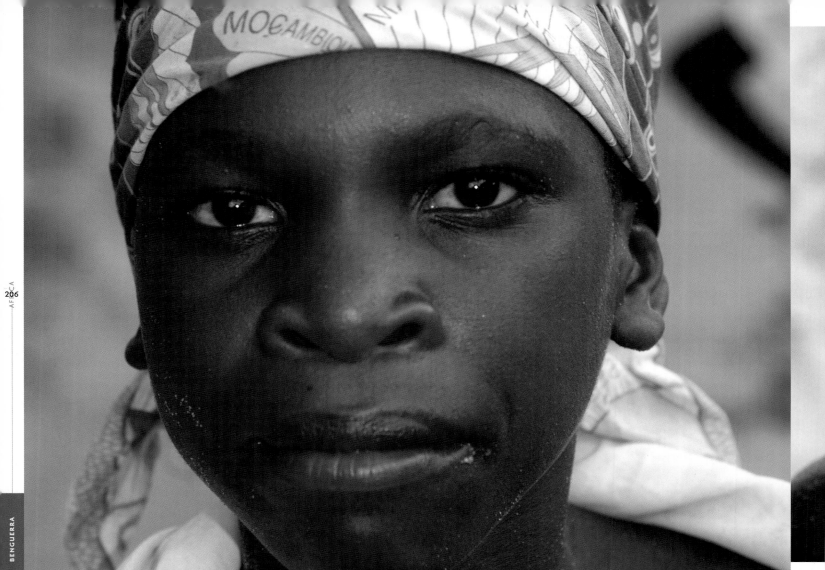
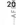

206

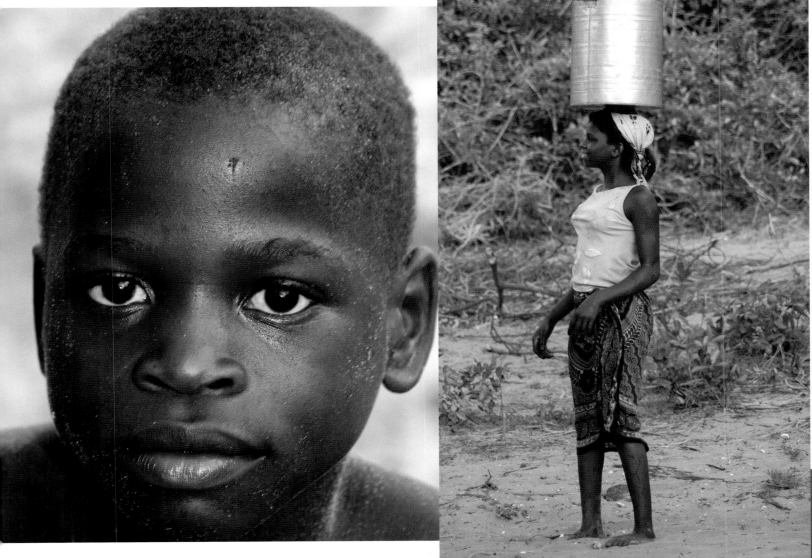

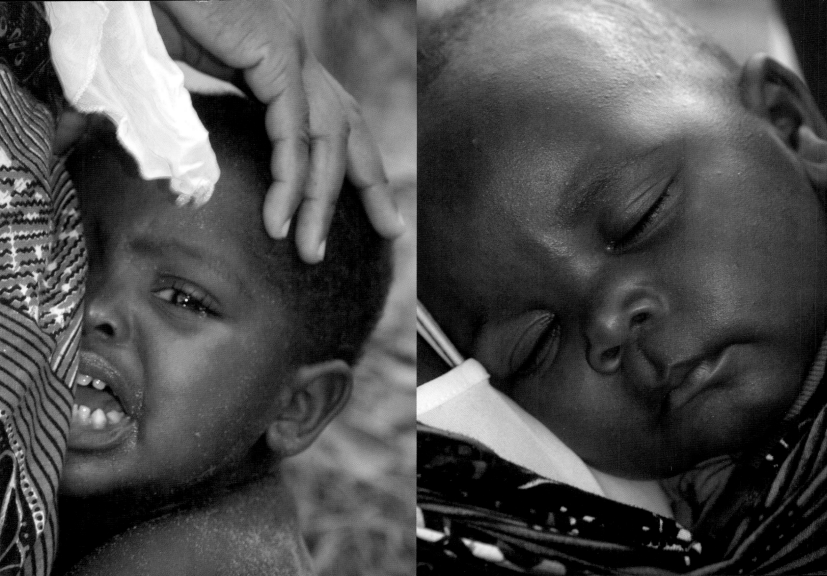

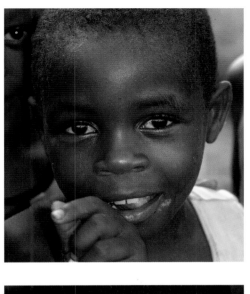
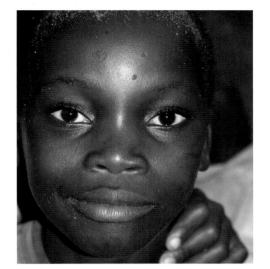
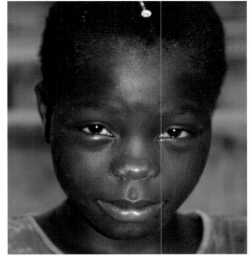
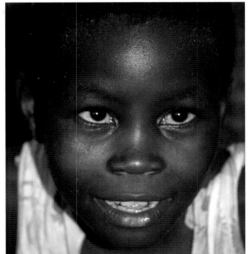
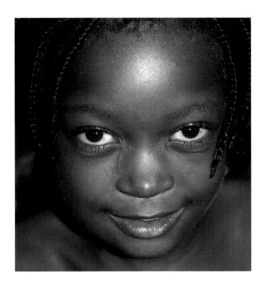
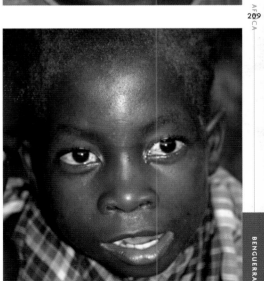

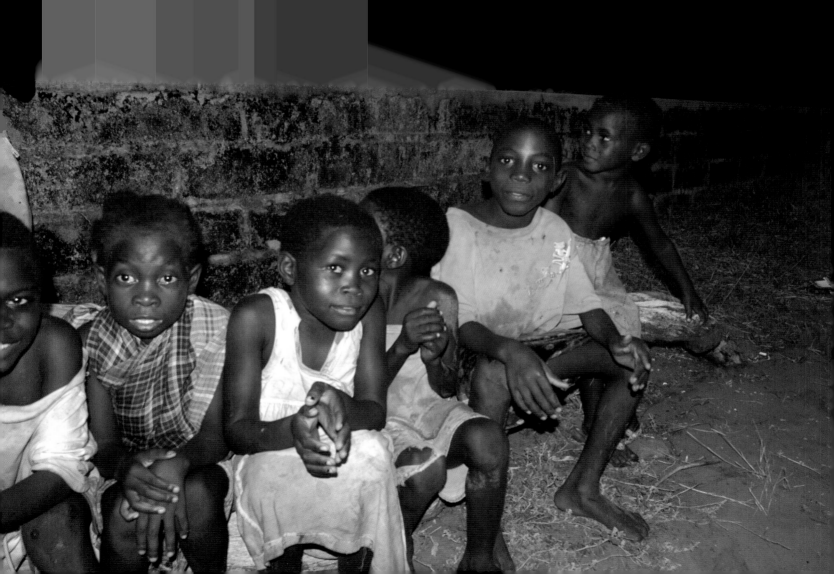

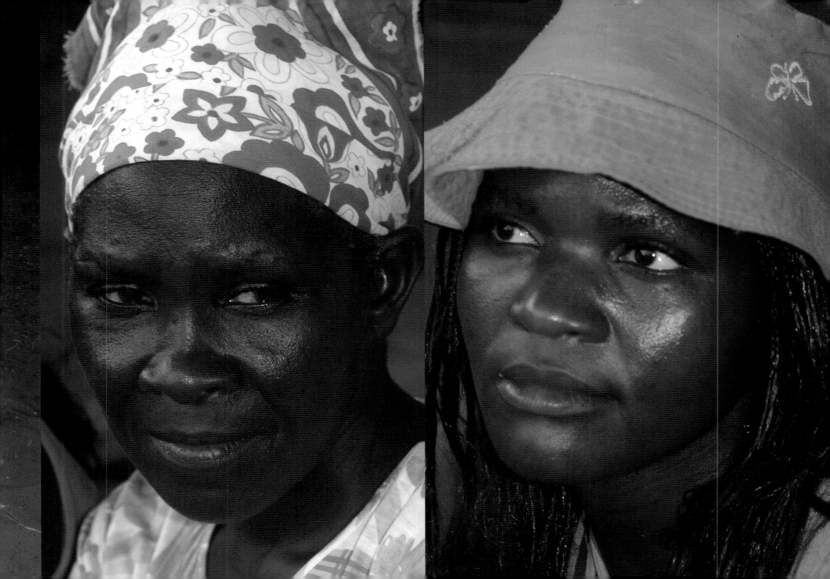

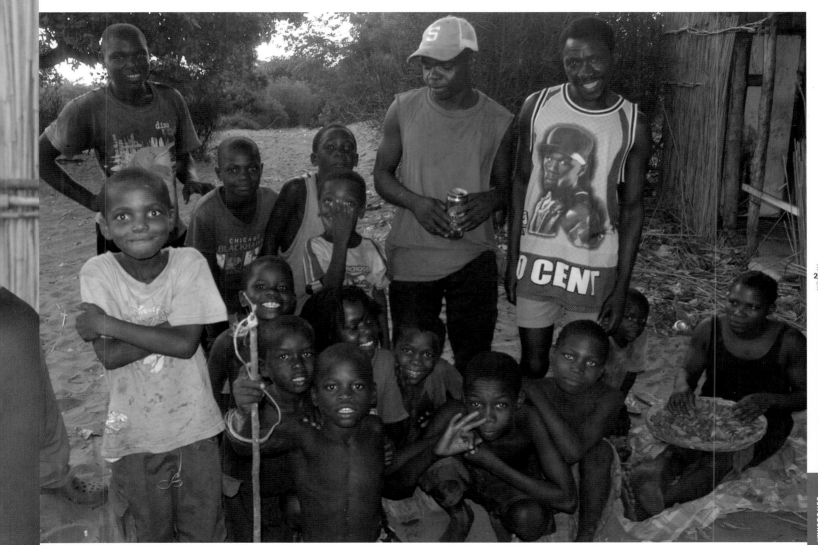

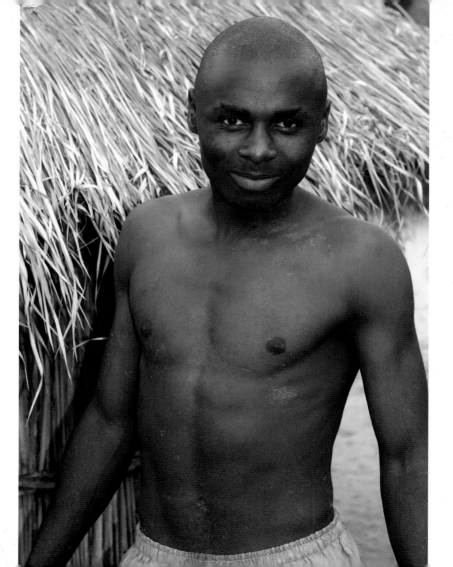

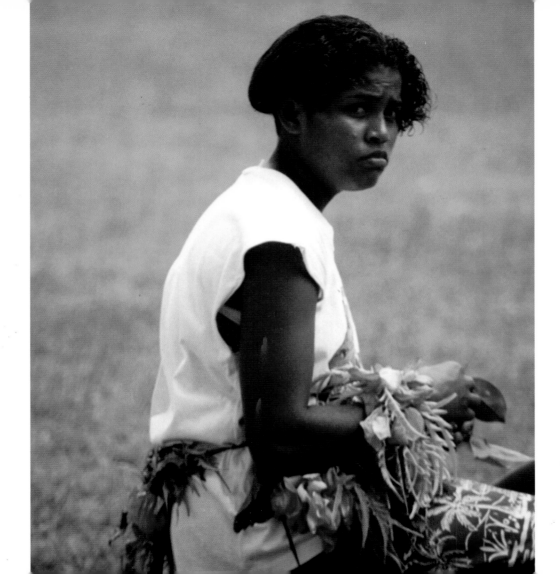

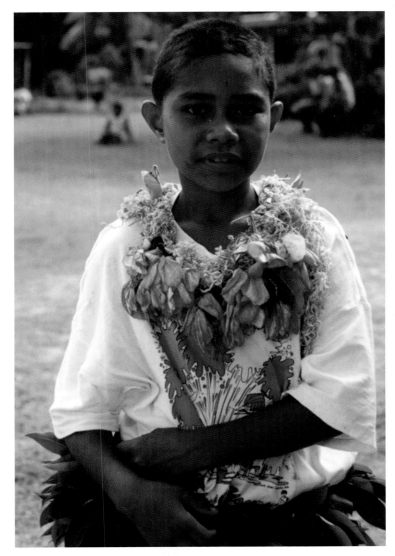
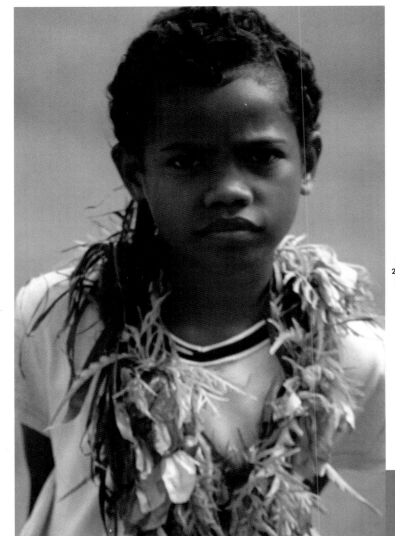

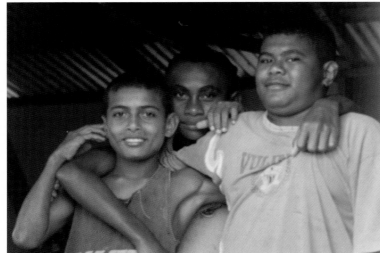

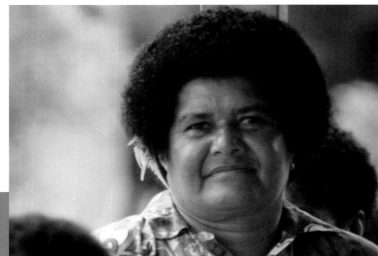

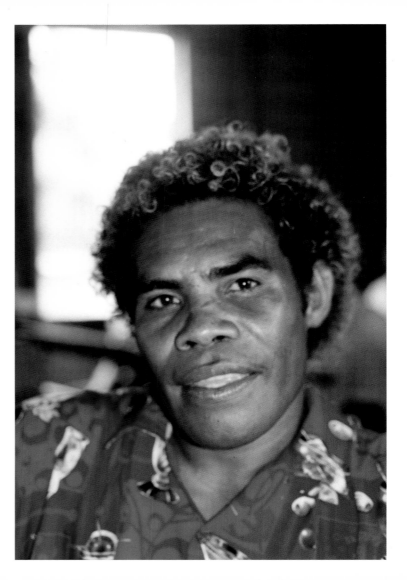

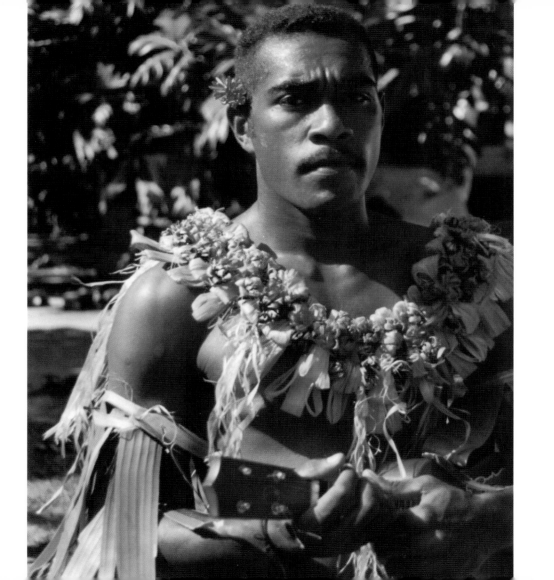

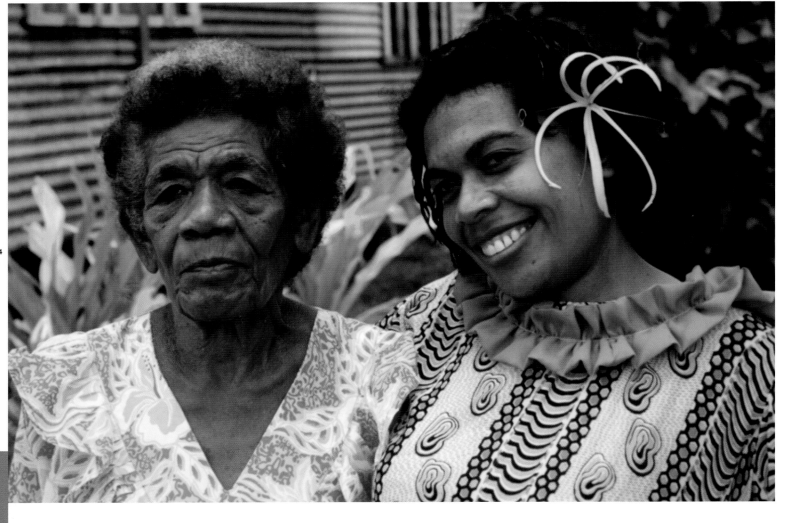

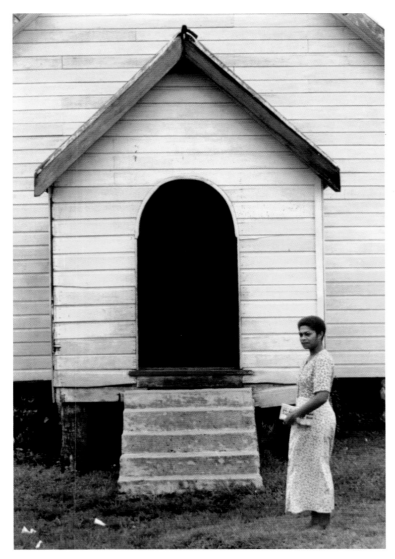
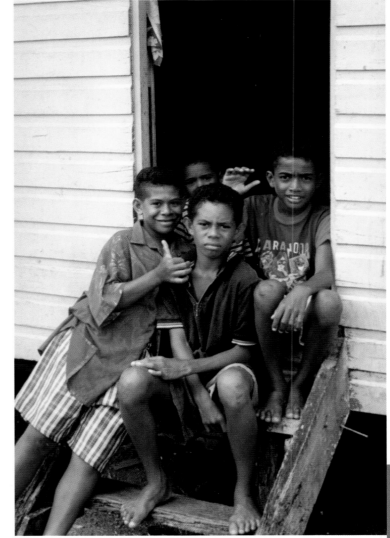

AUSTRALIA

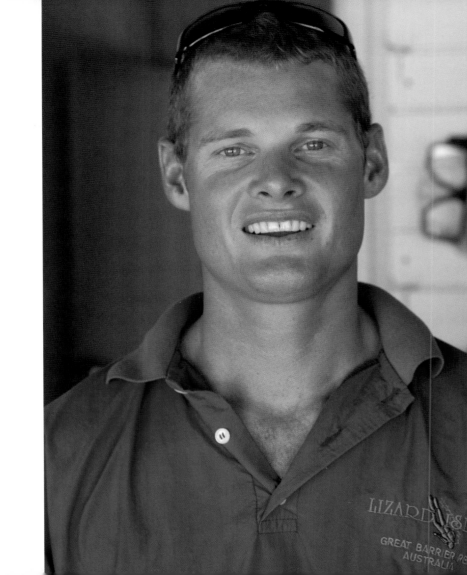

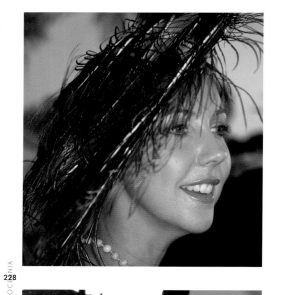

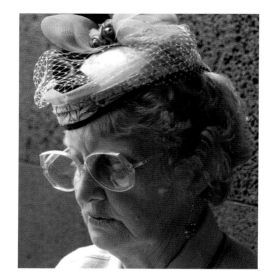
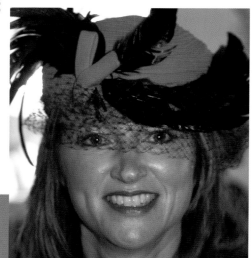
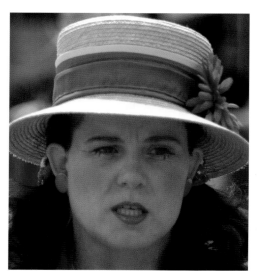
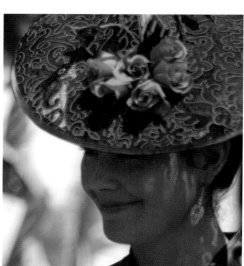

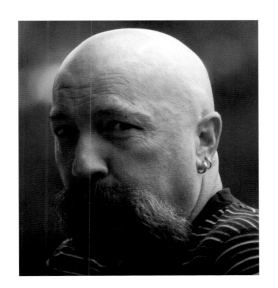

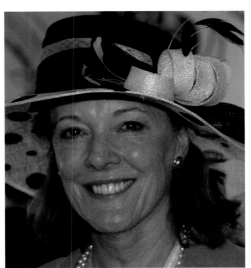

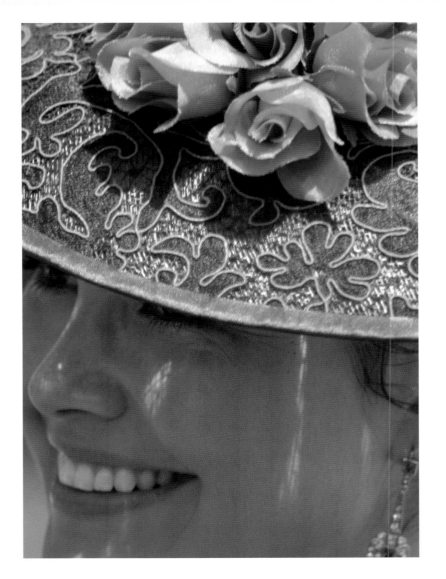

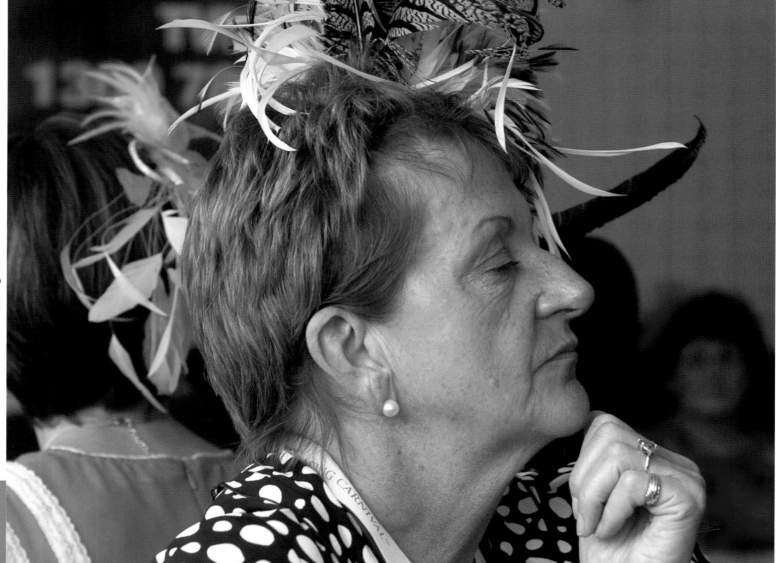

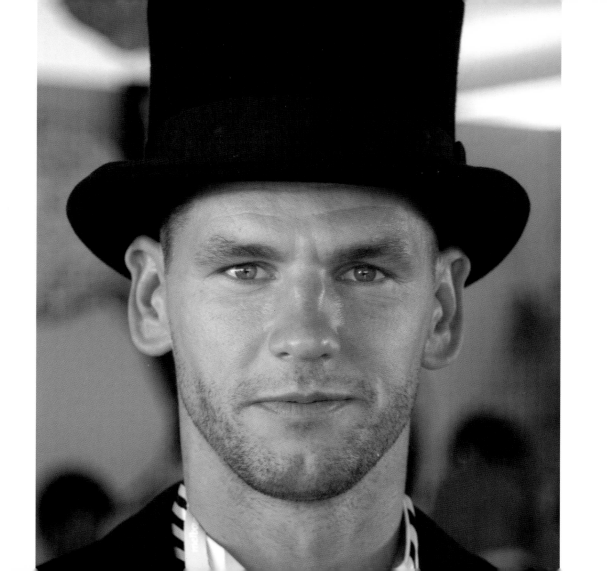

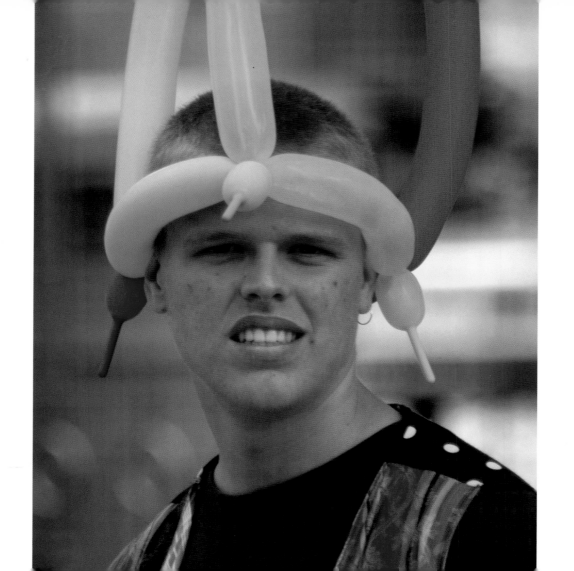

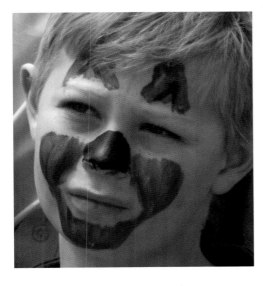
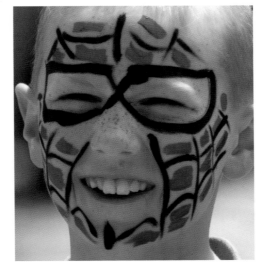
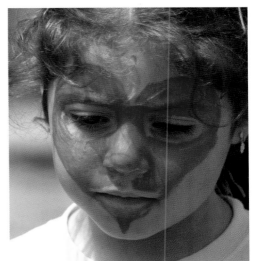
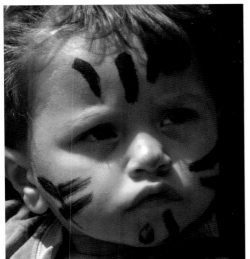
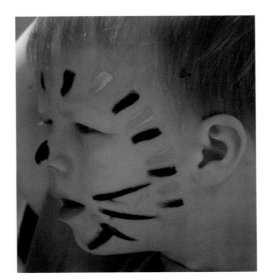
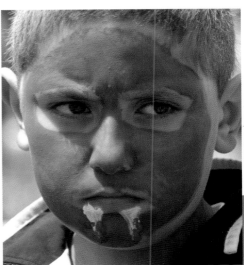

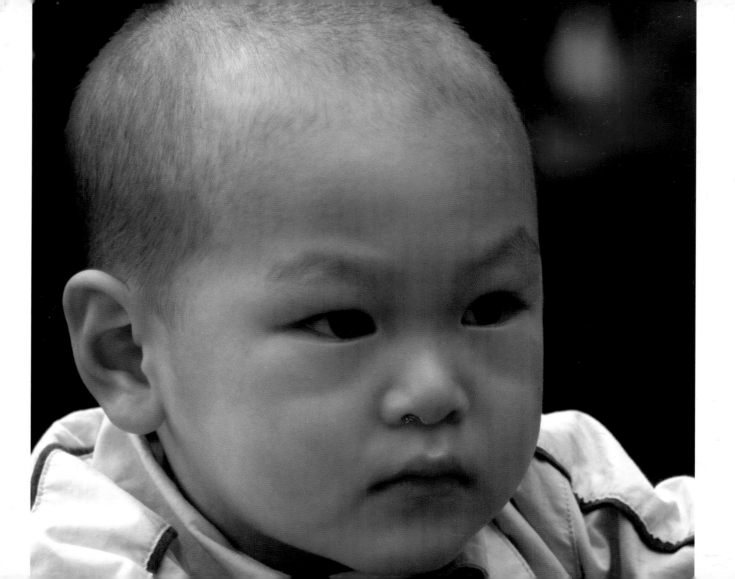

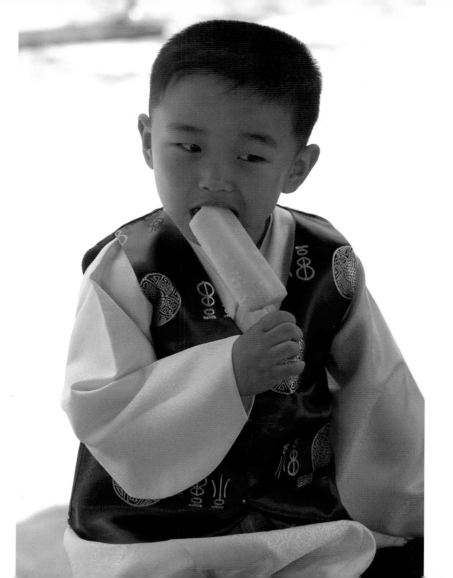

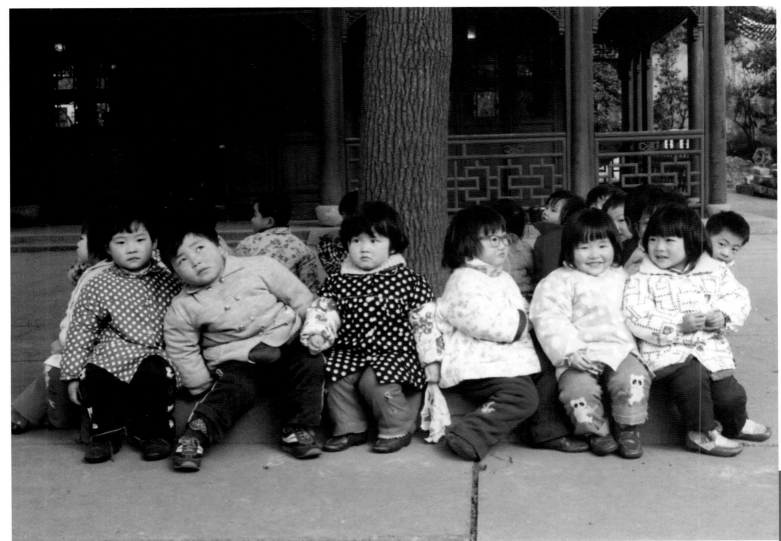

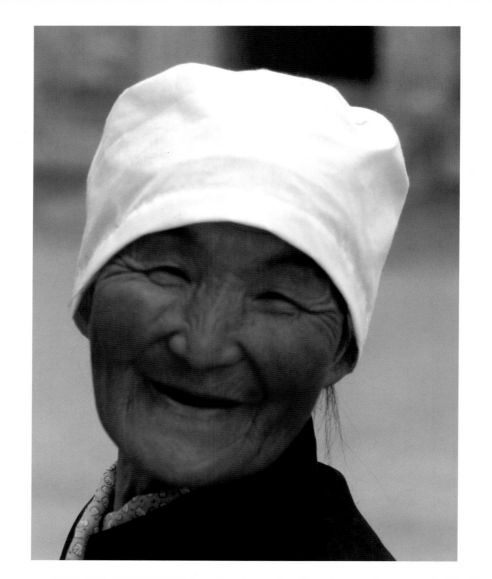

242

BEIJING

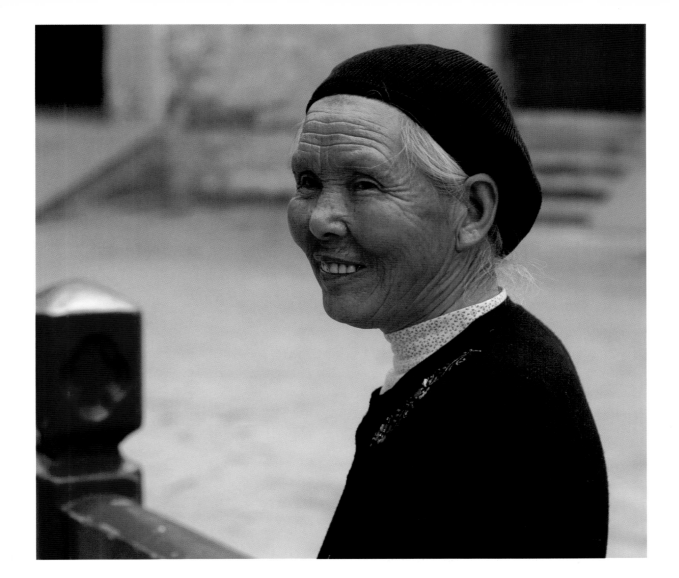

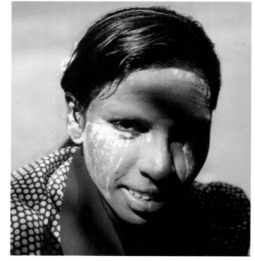

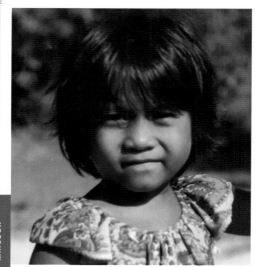

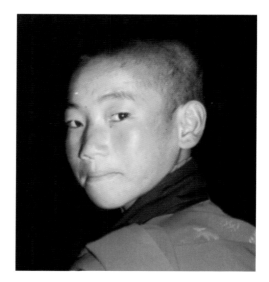

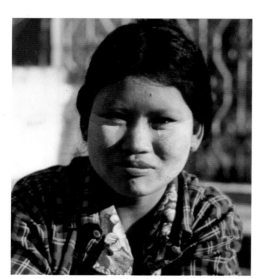

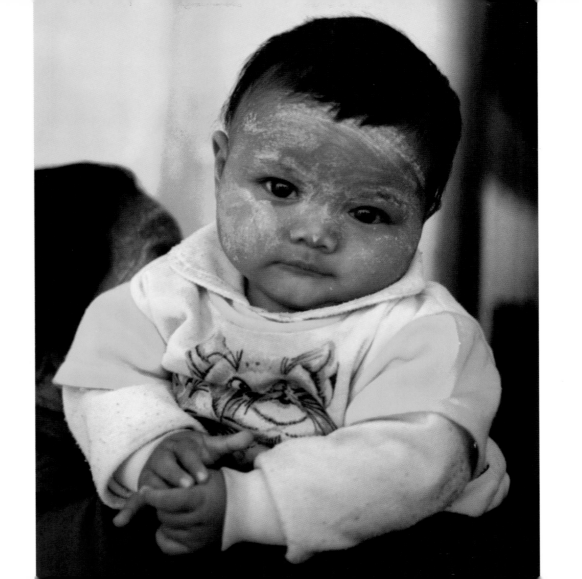

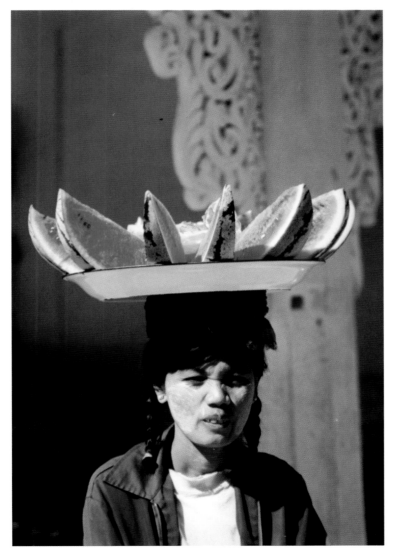
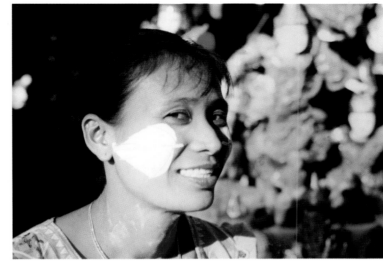
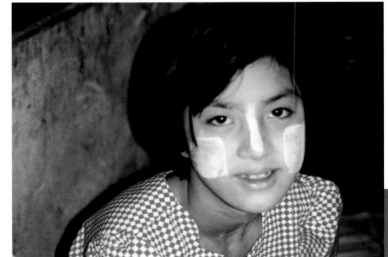

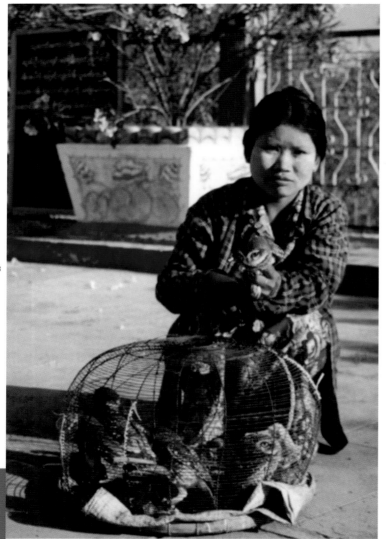
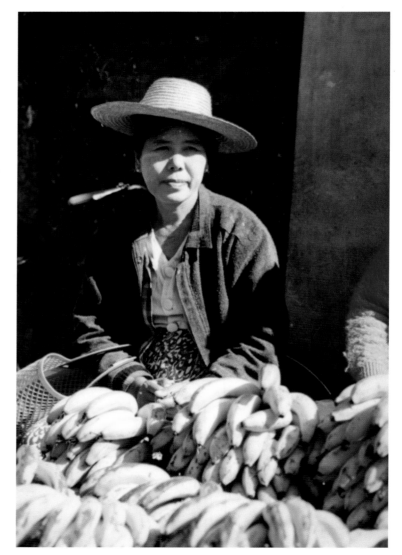

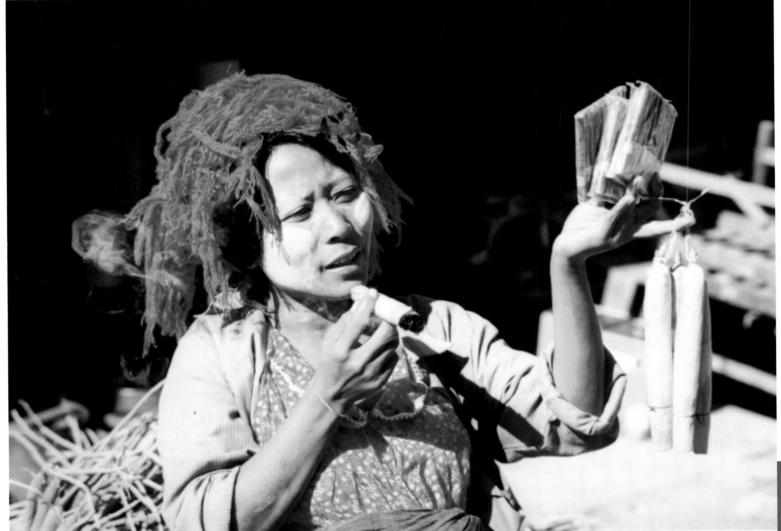

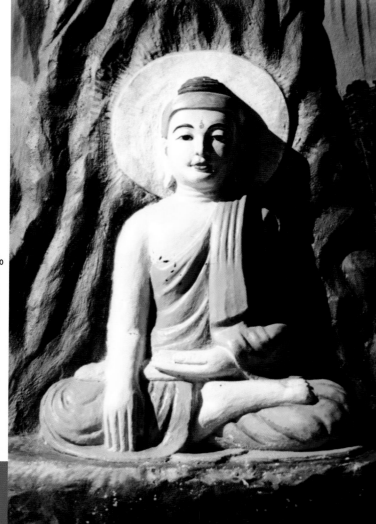

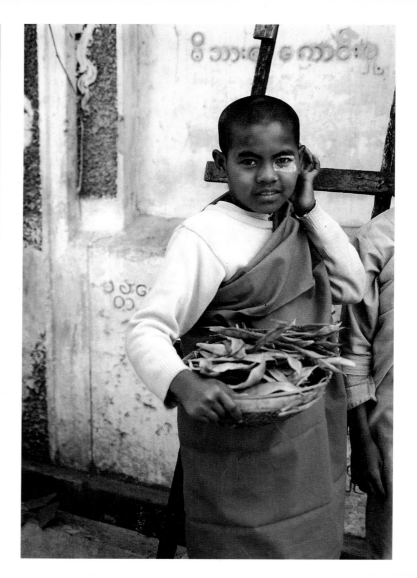

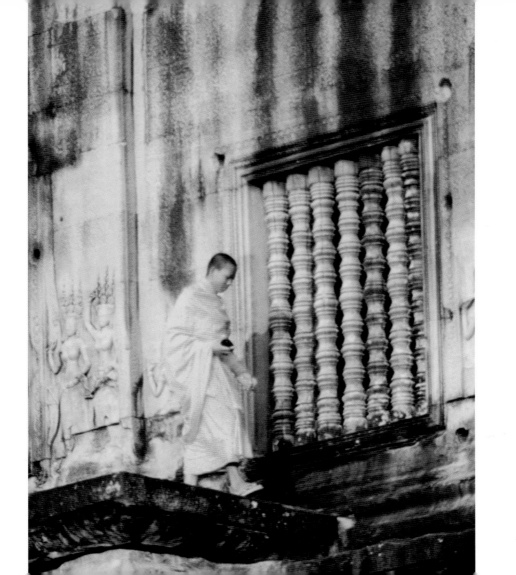

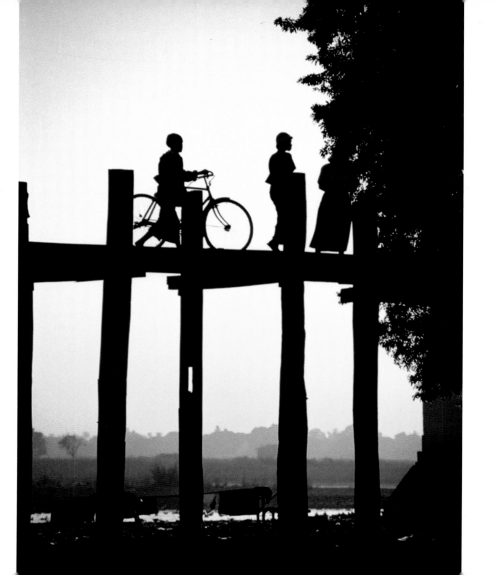

252

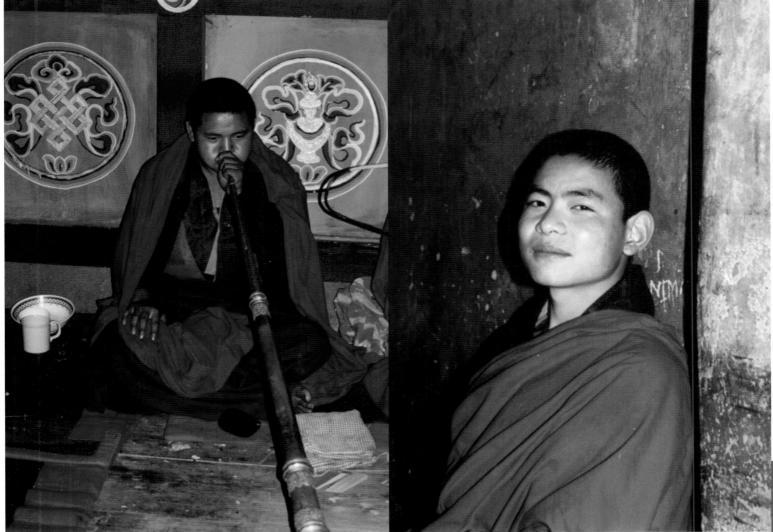

CAMBODIA

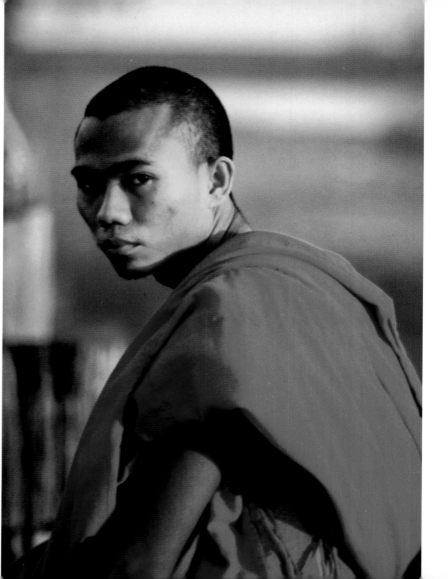

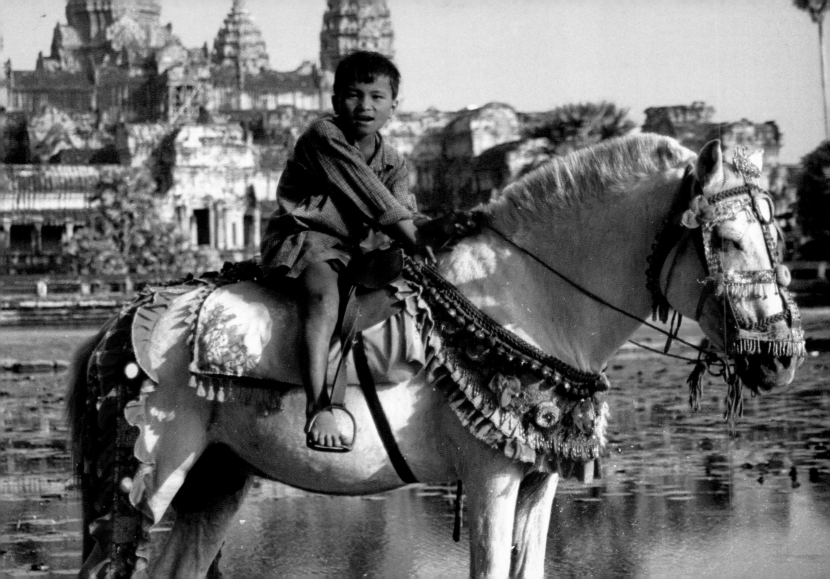

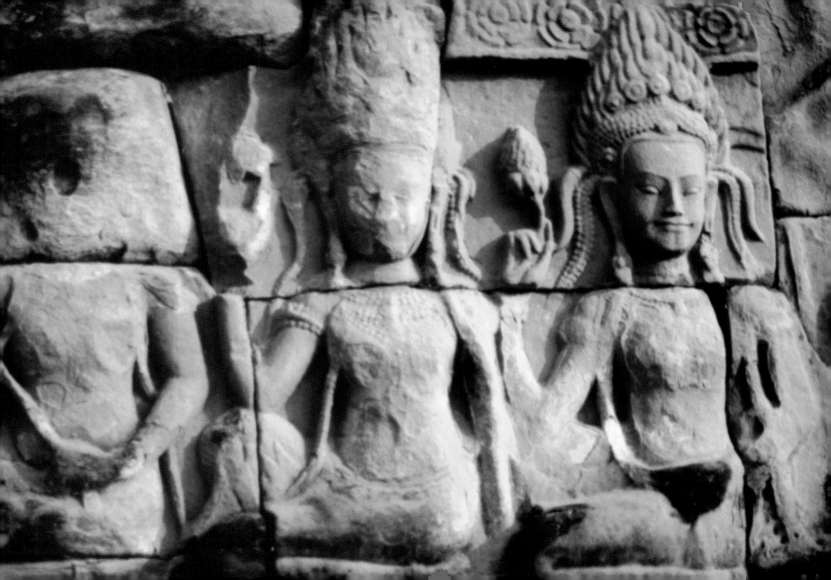

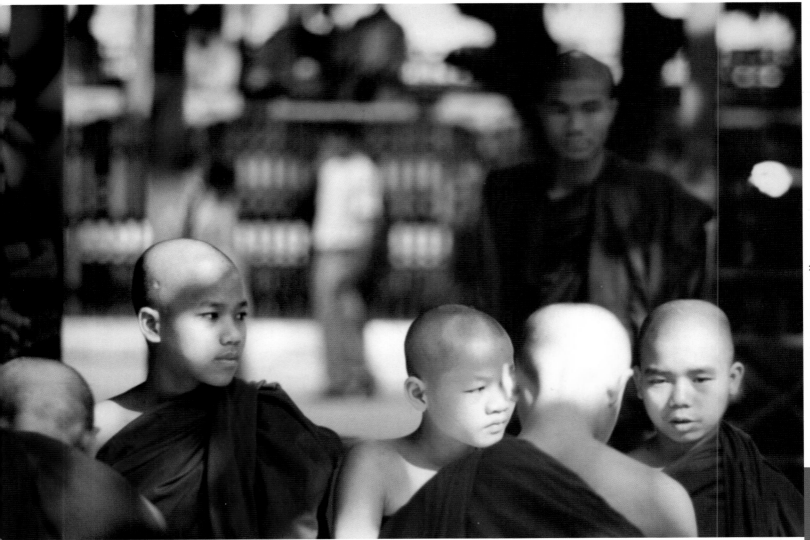

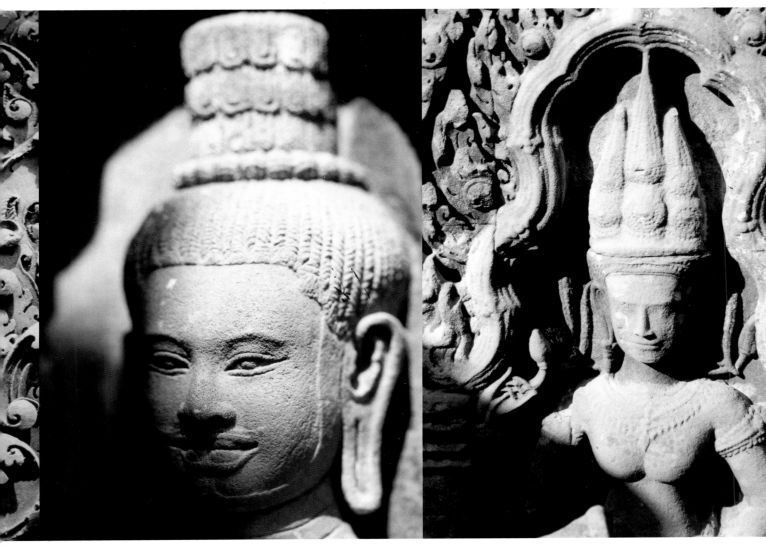

260

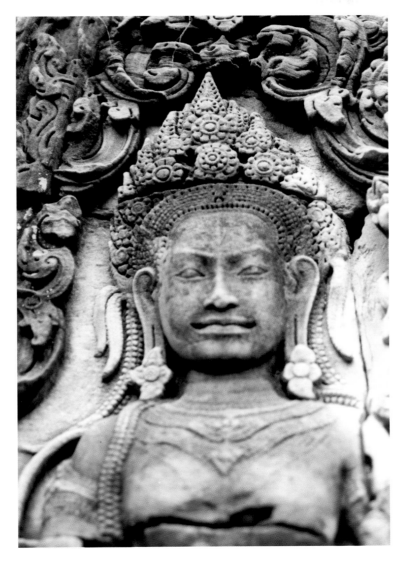
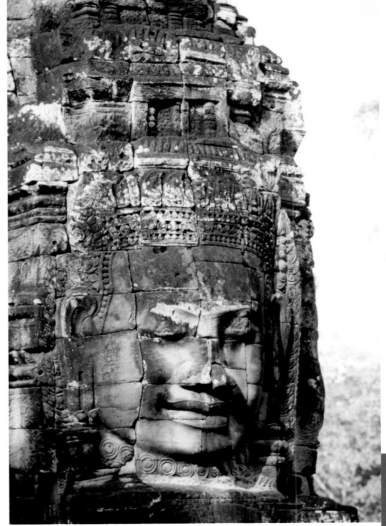

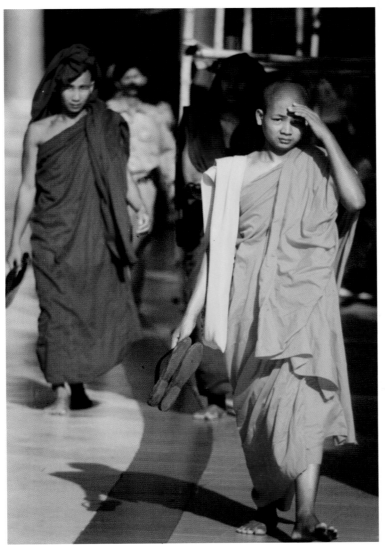

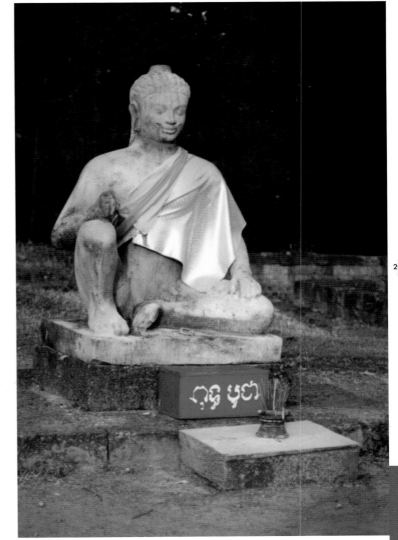

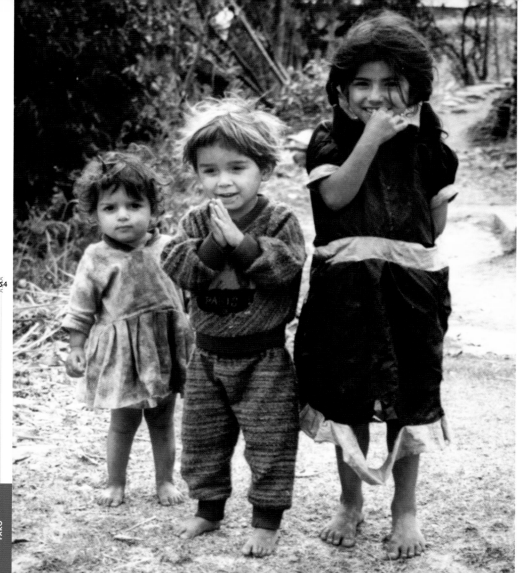

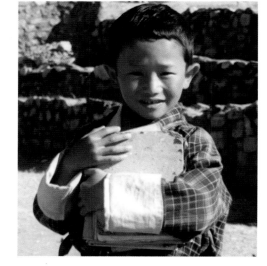

BHUTAN

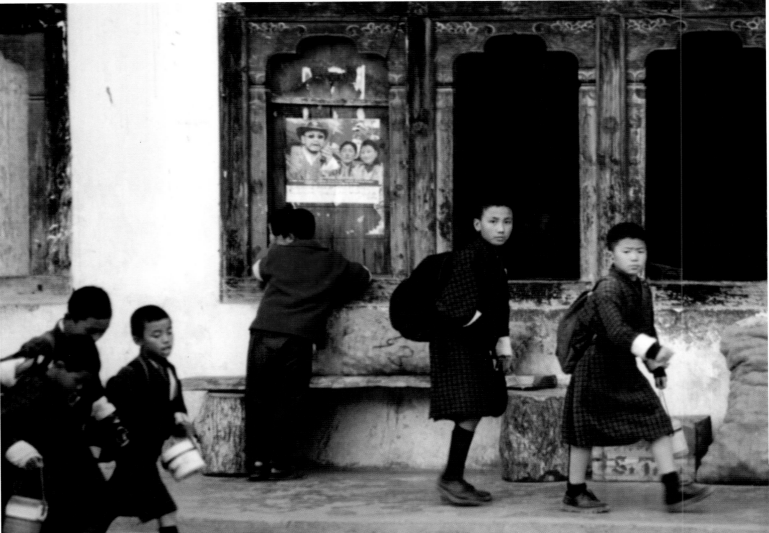

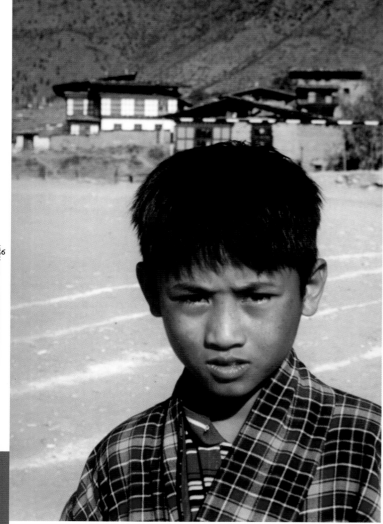

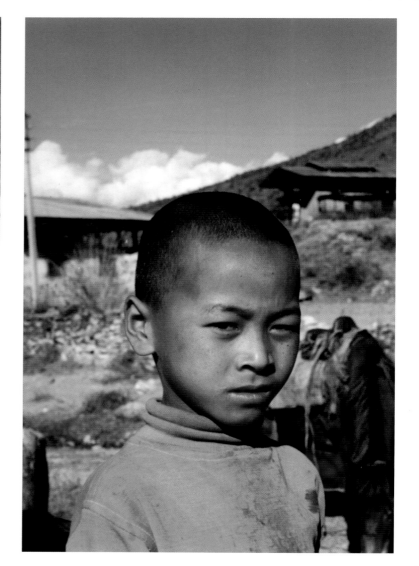

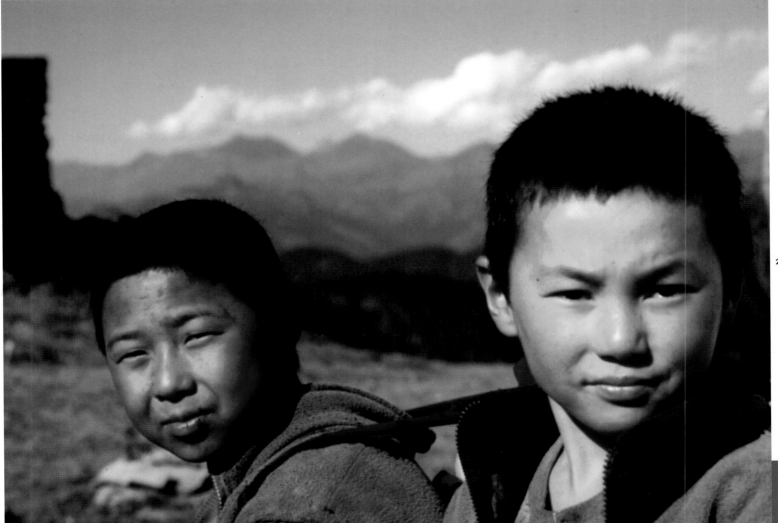

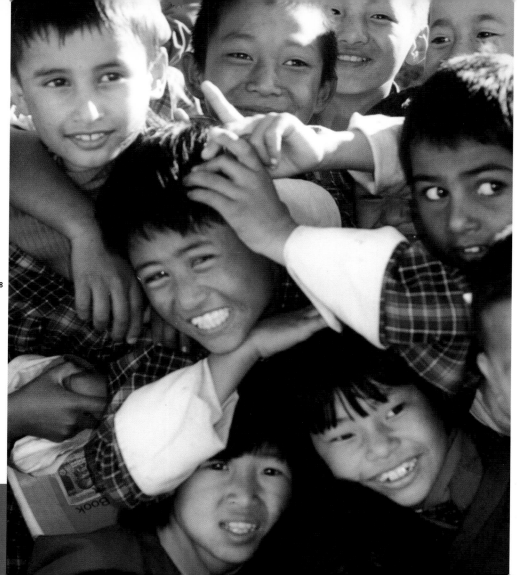
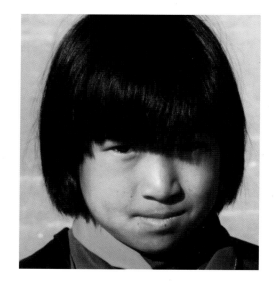
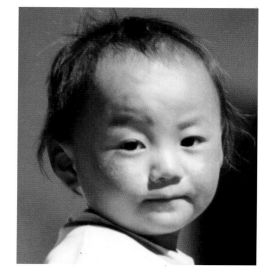

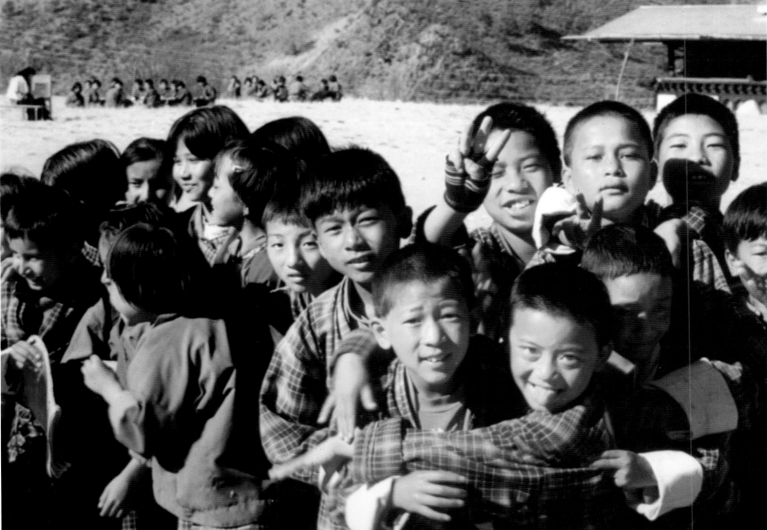

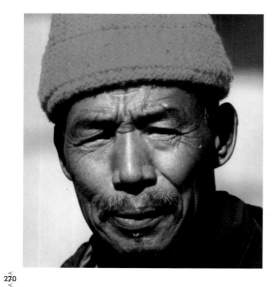

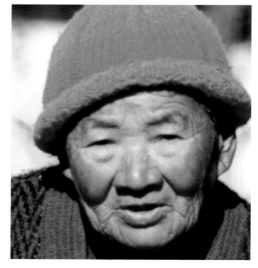
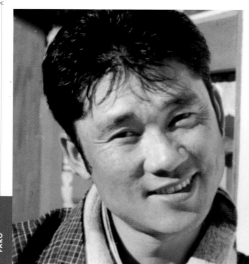
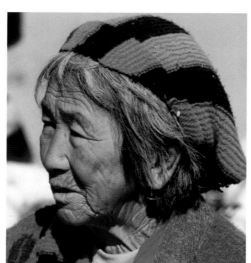
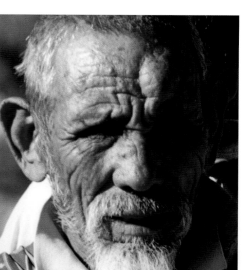

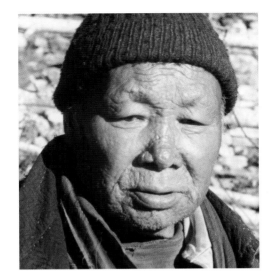

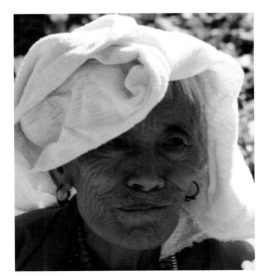

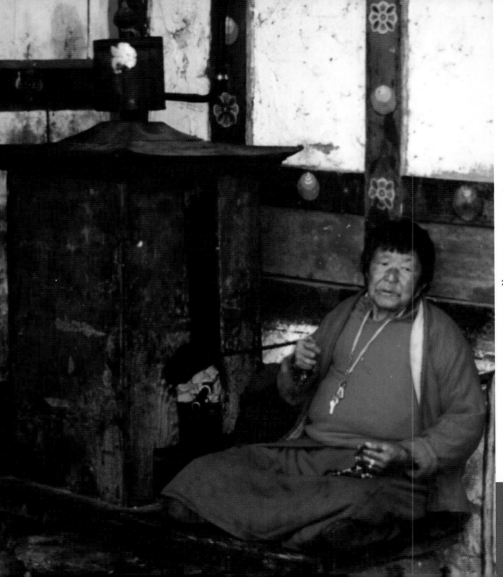

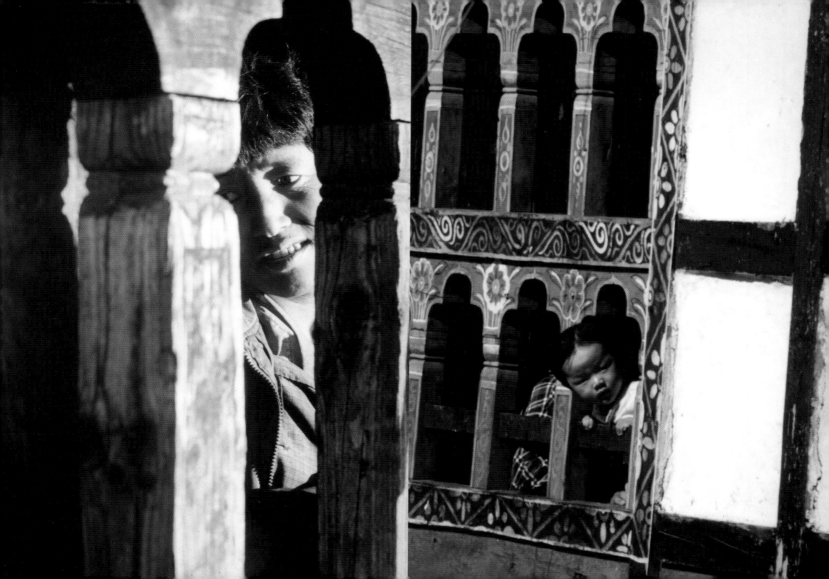

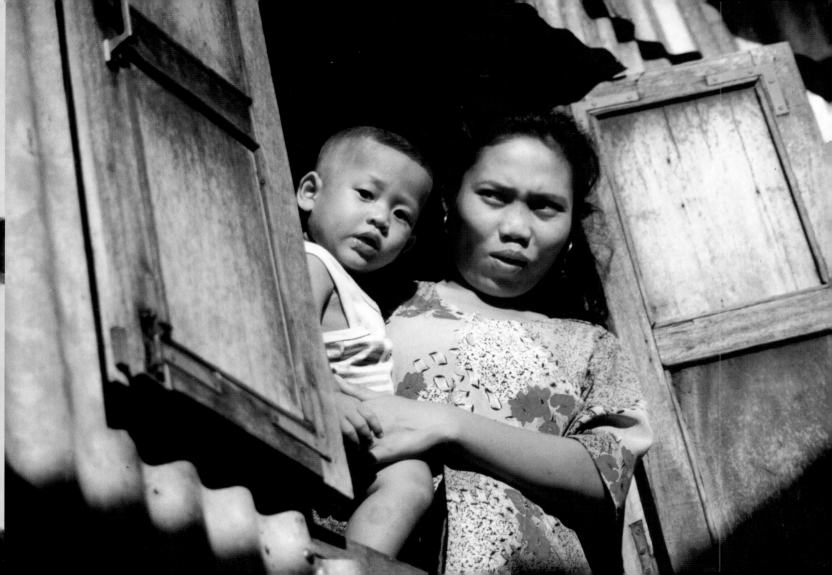

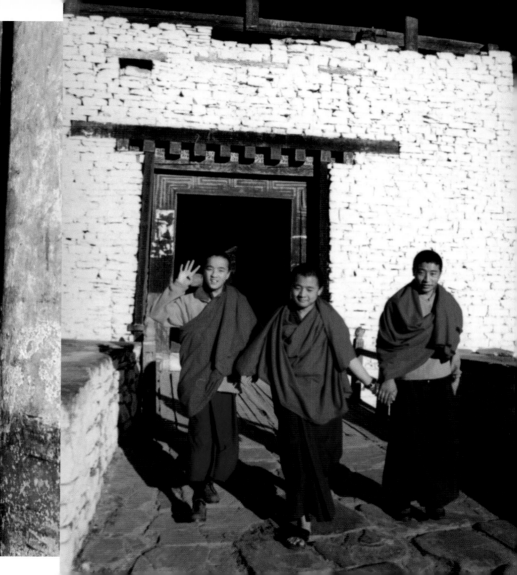

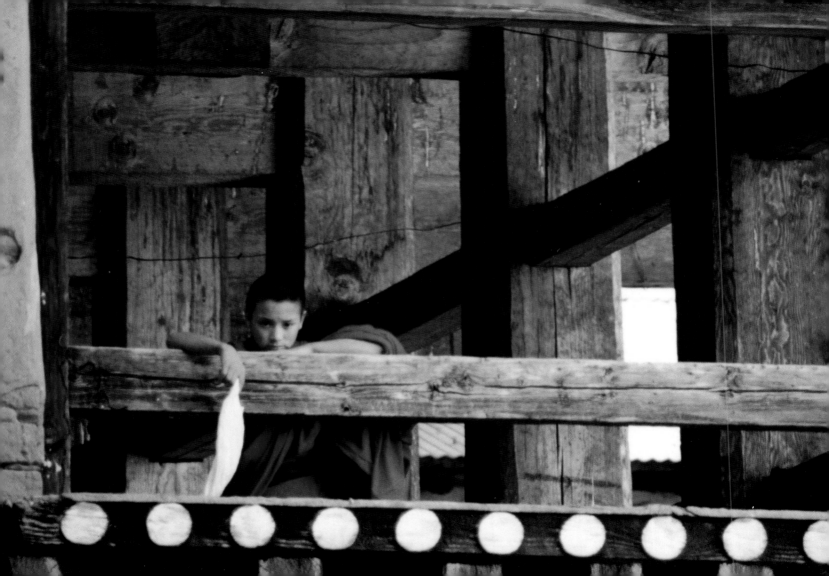

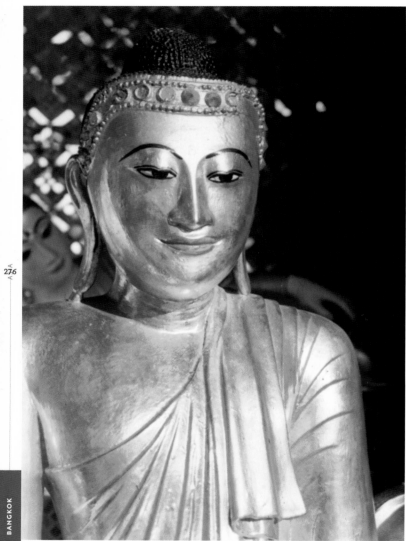

THAILAND

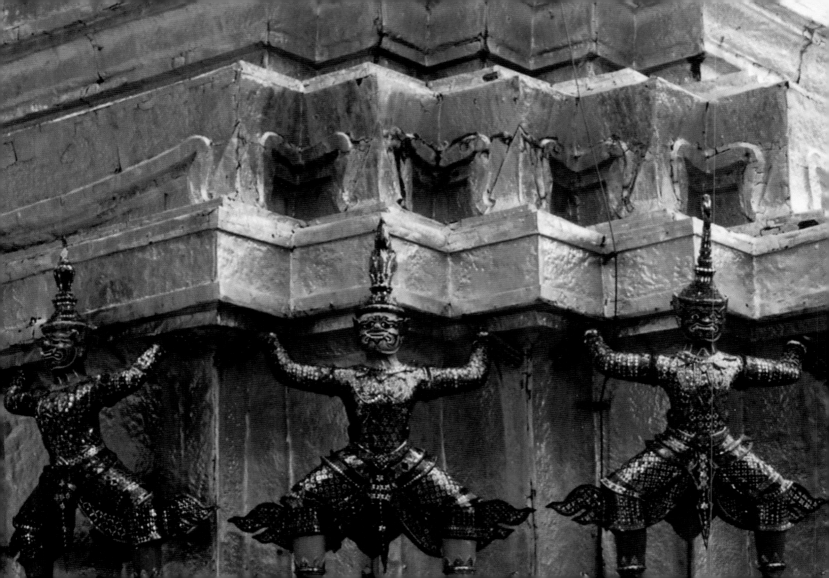

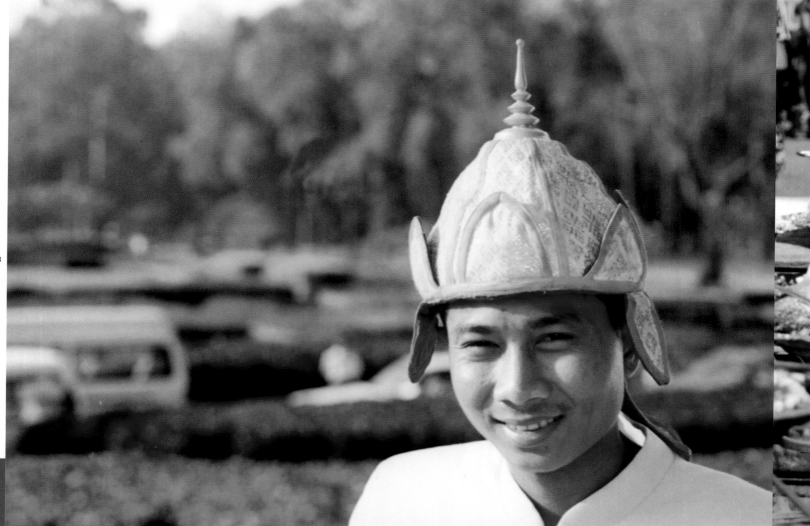

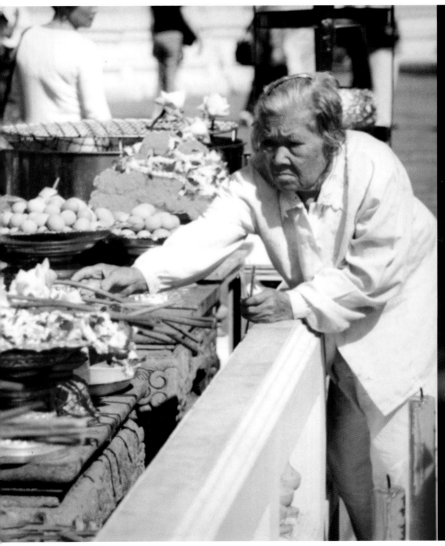
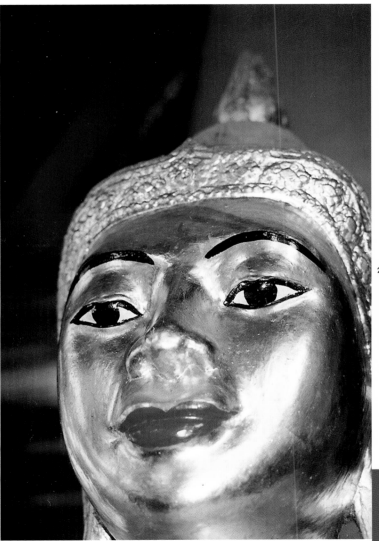

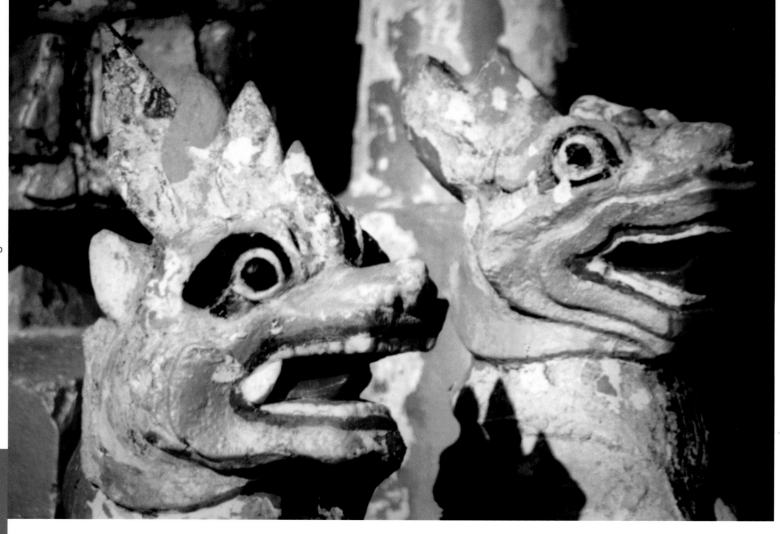

VIETNAM

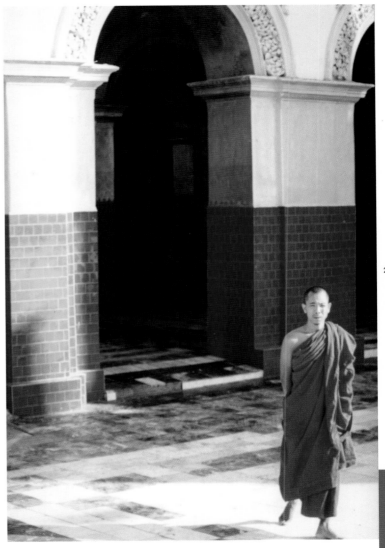

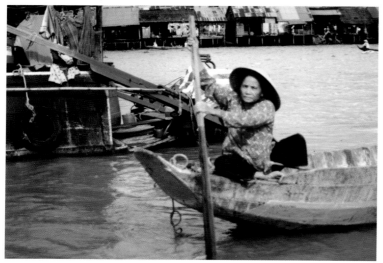
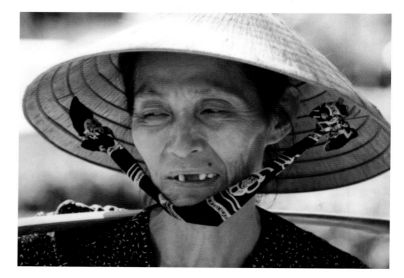
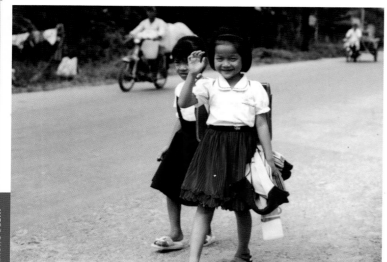
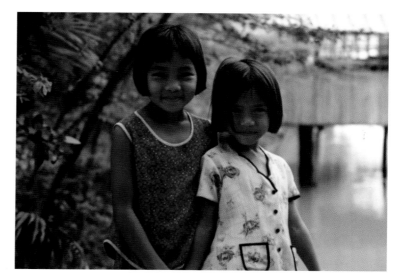

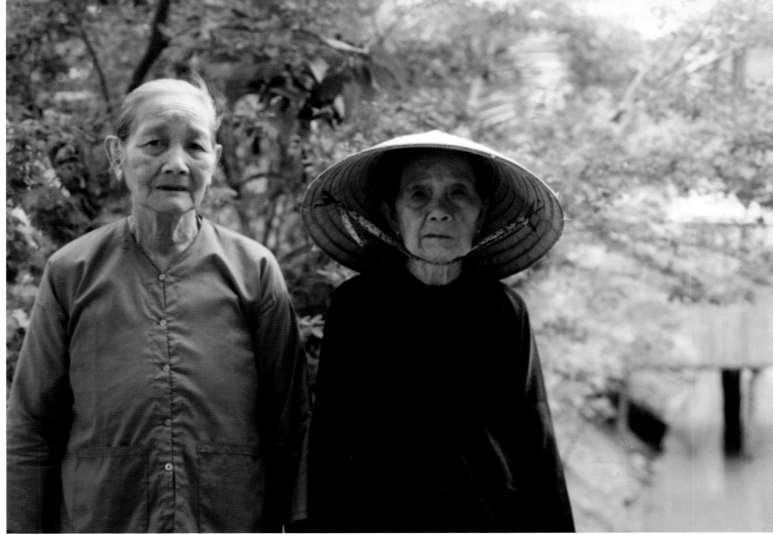

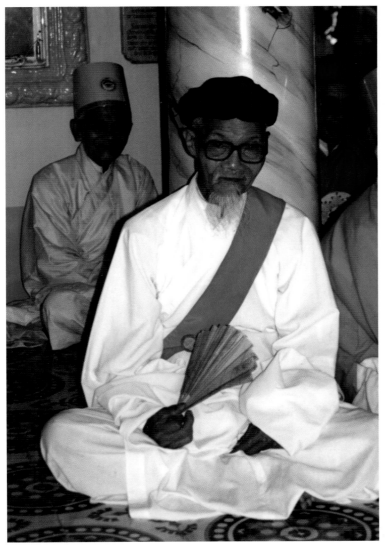

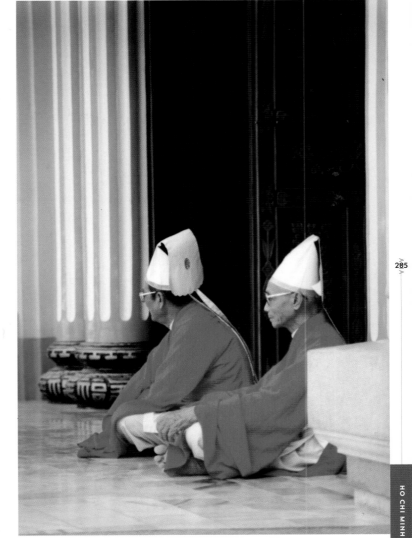

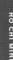

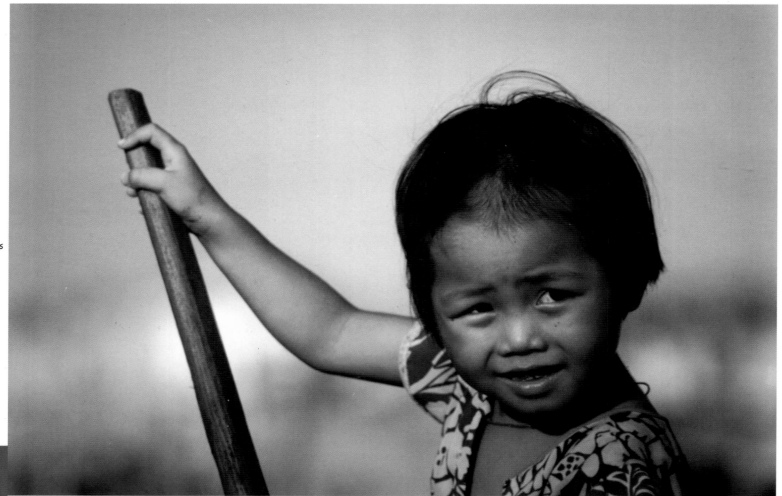

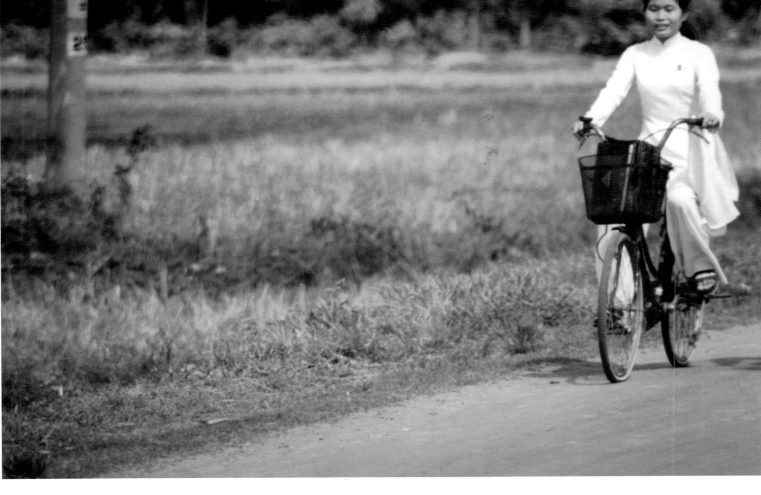

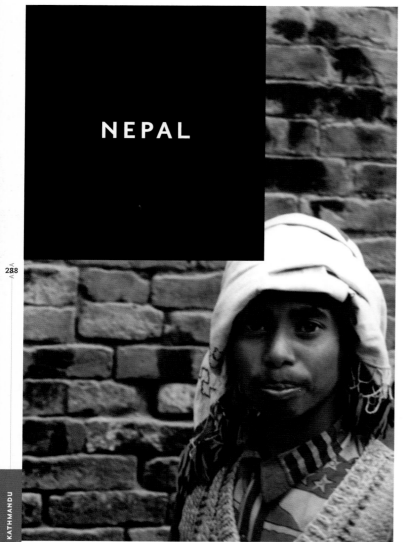

NEPAL

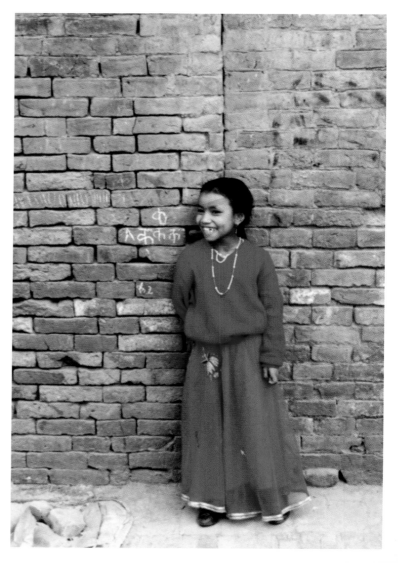

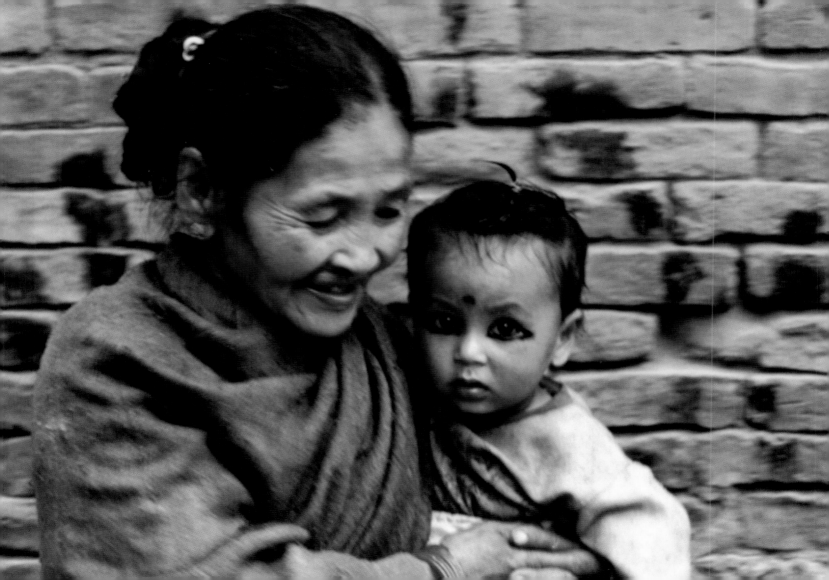

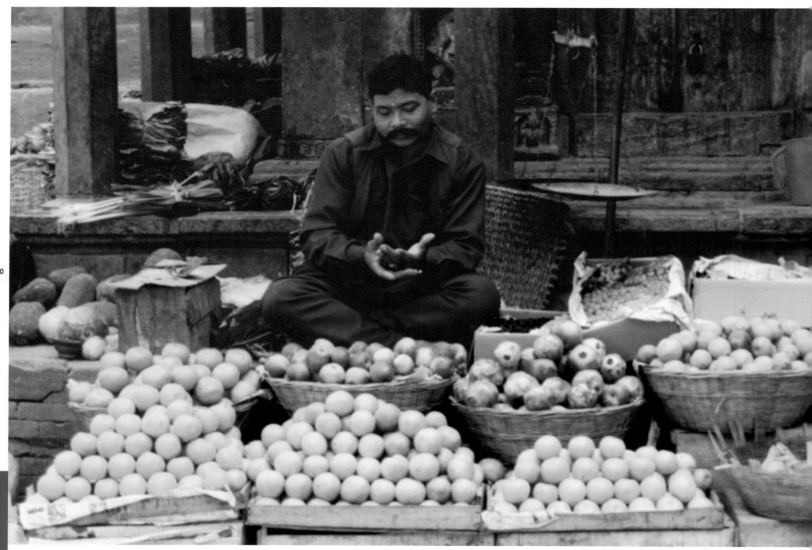

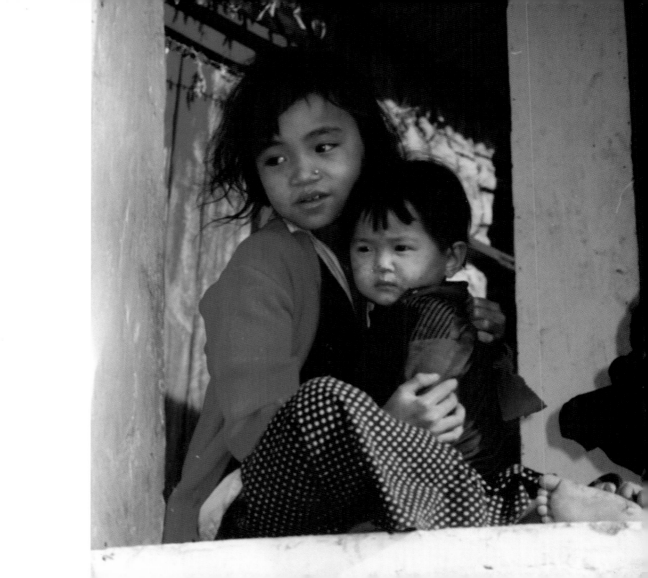

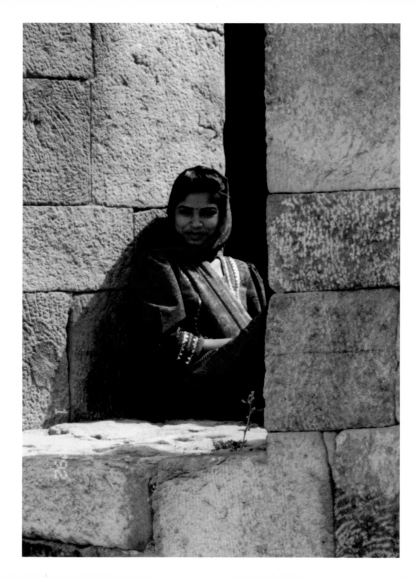

29.2

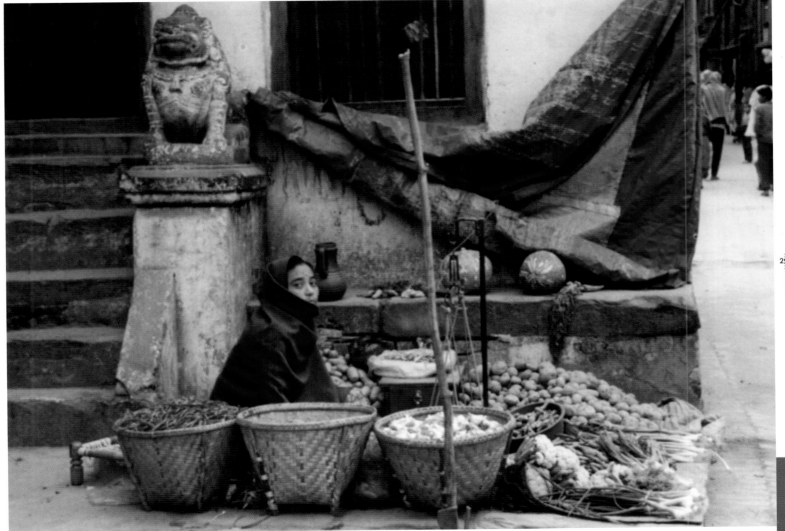

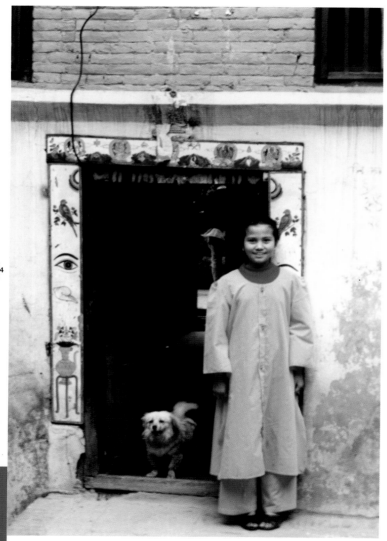
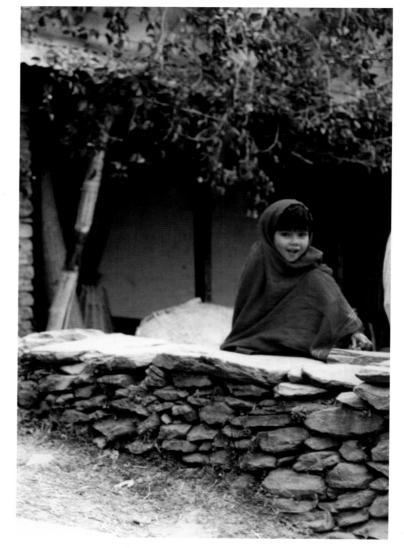

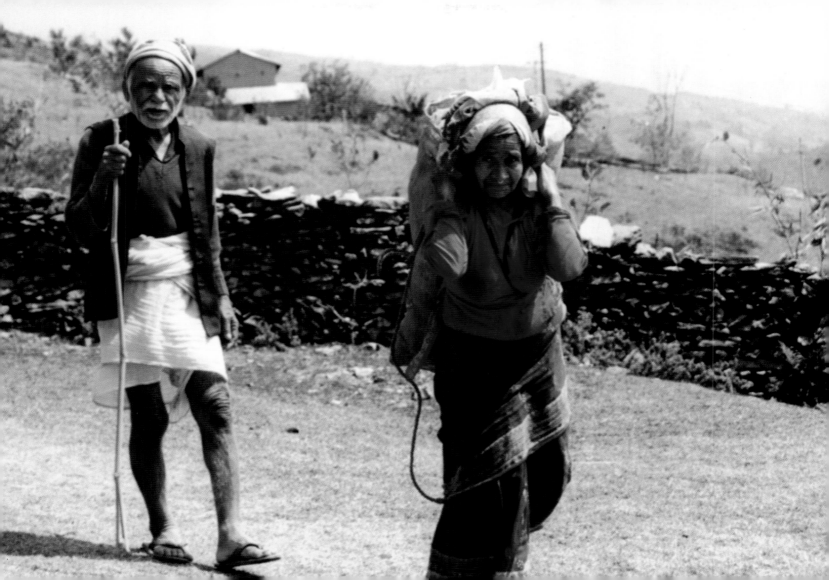

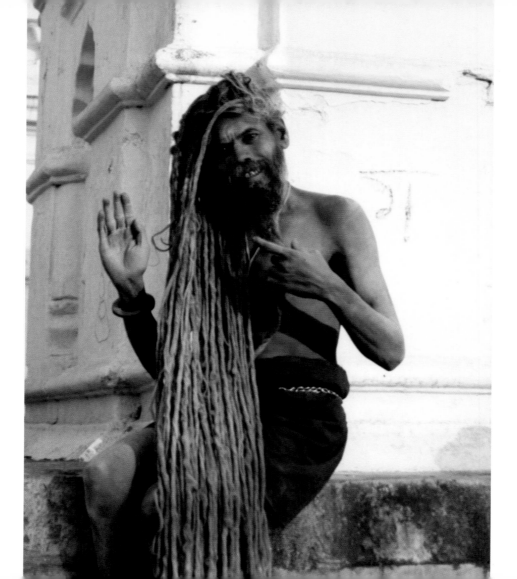

296

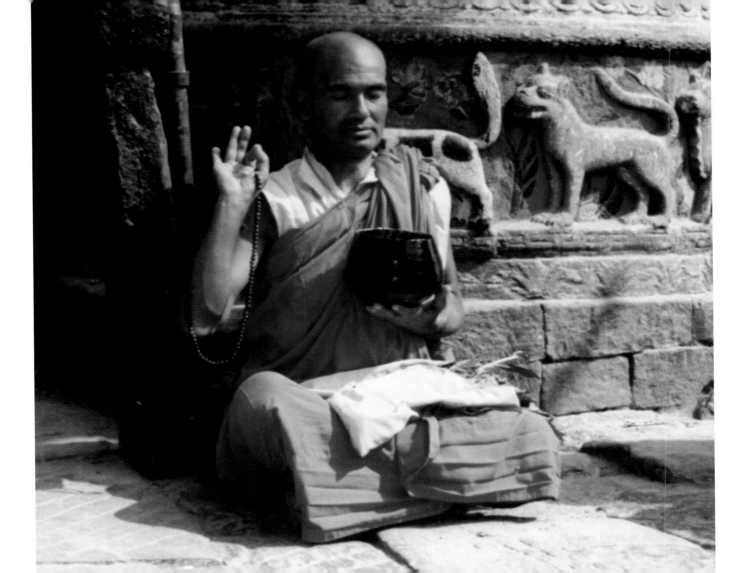

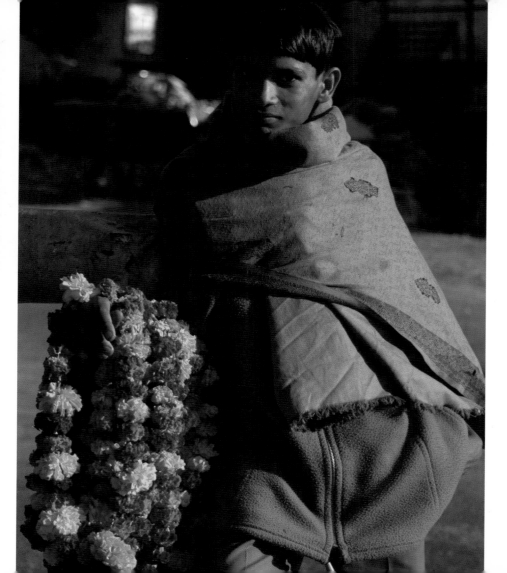

INDIA

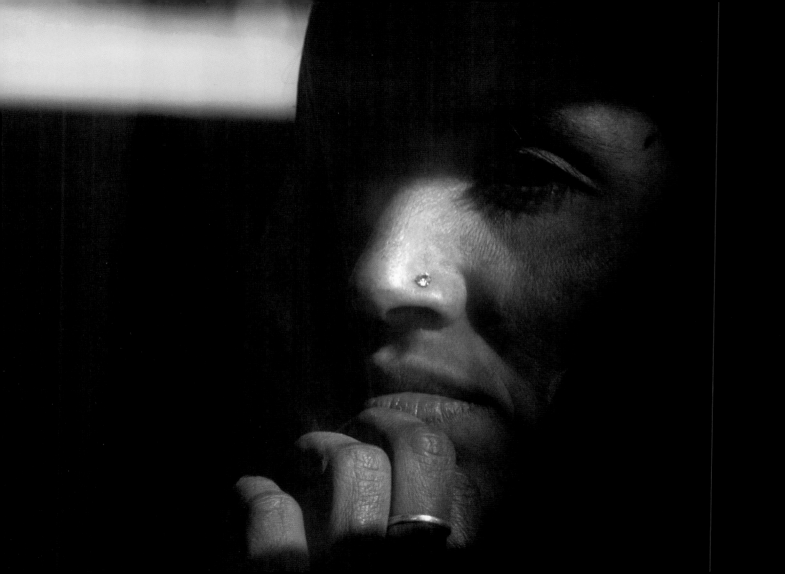

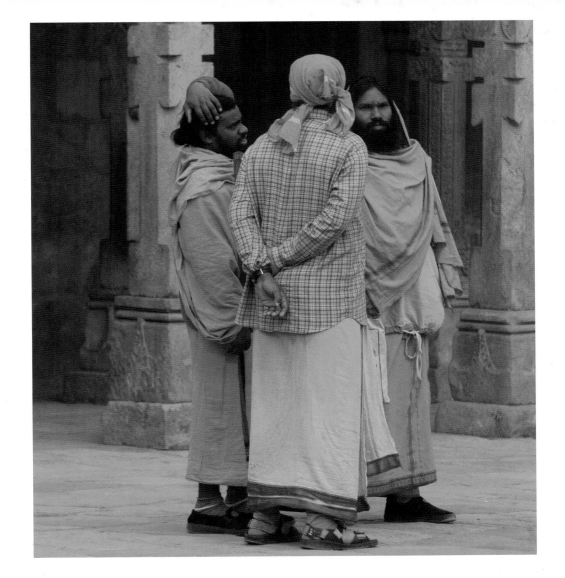

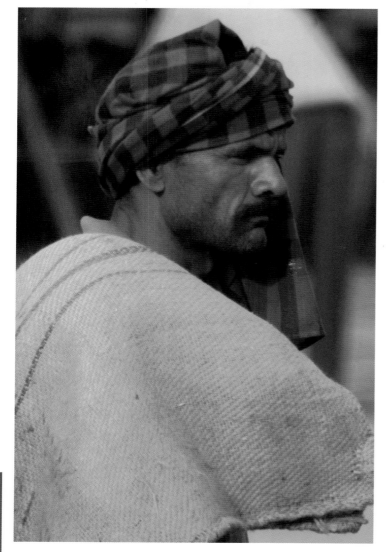
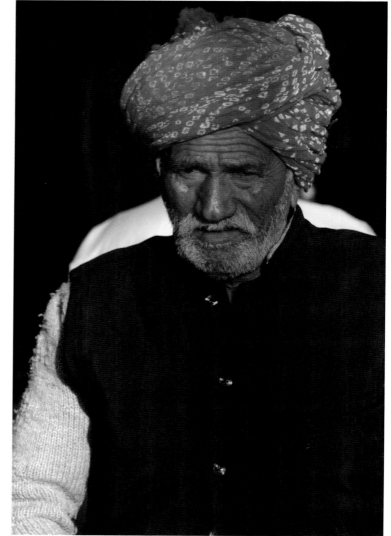

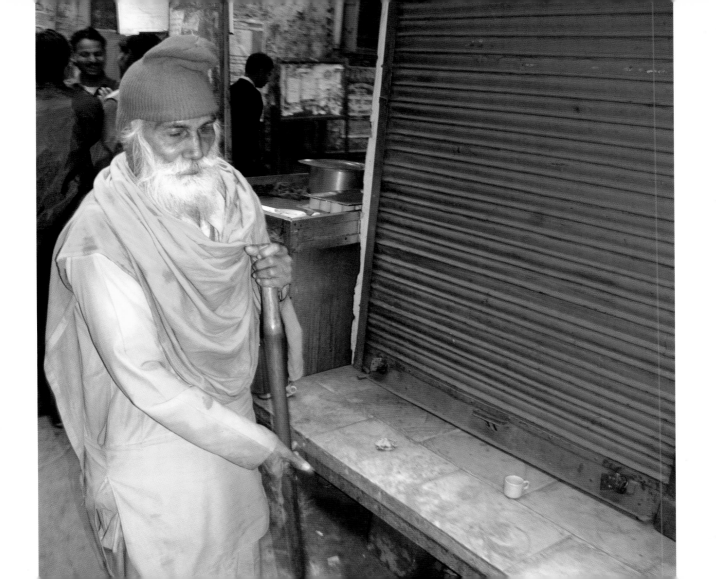

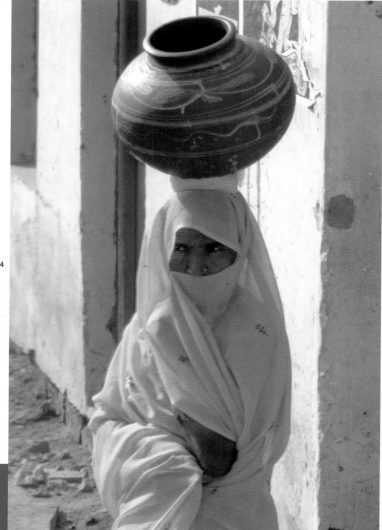

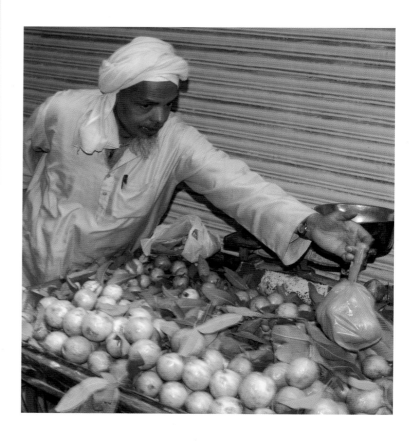

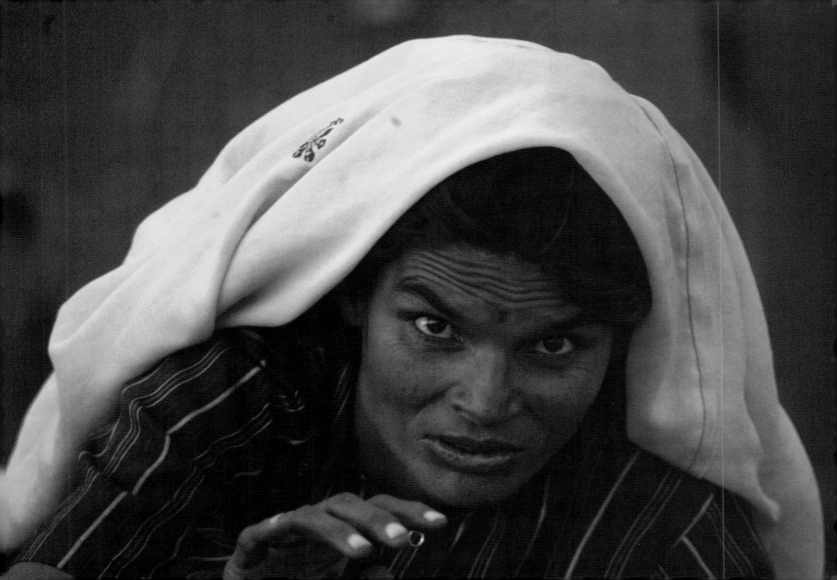

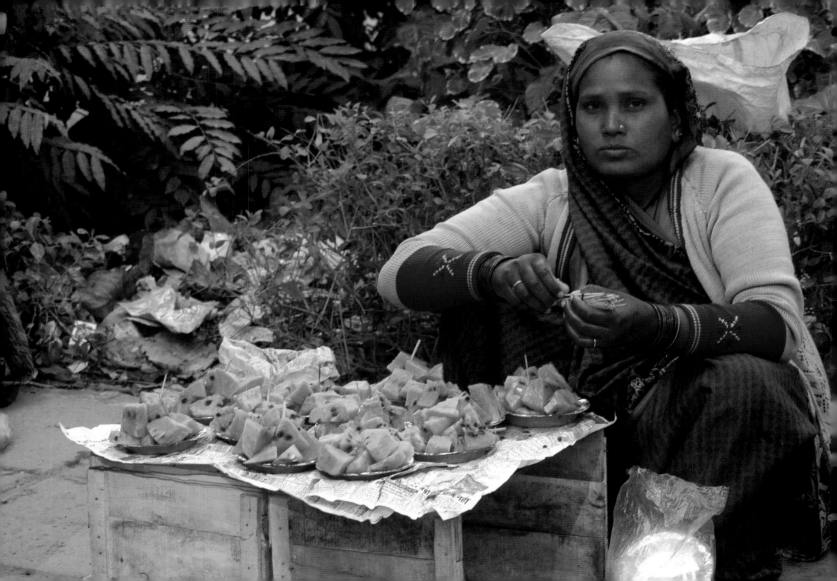

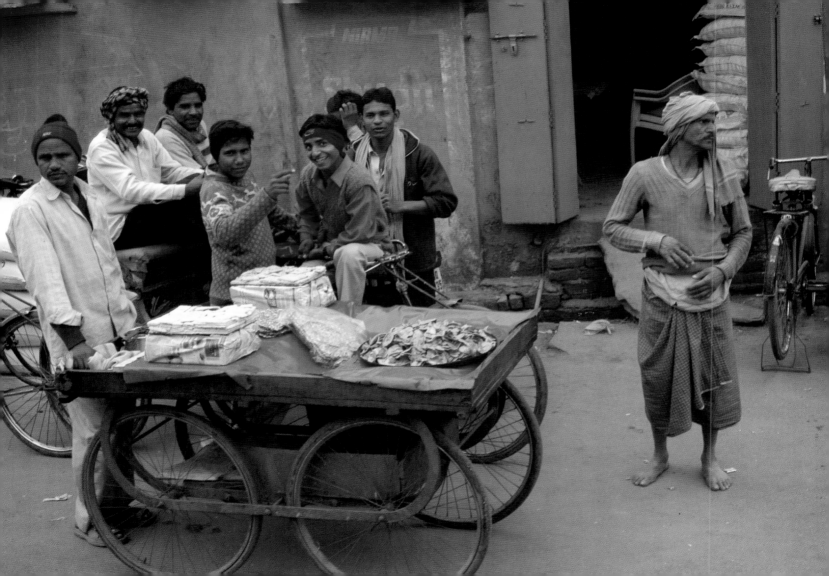

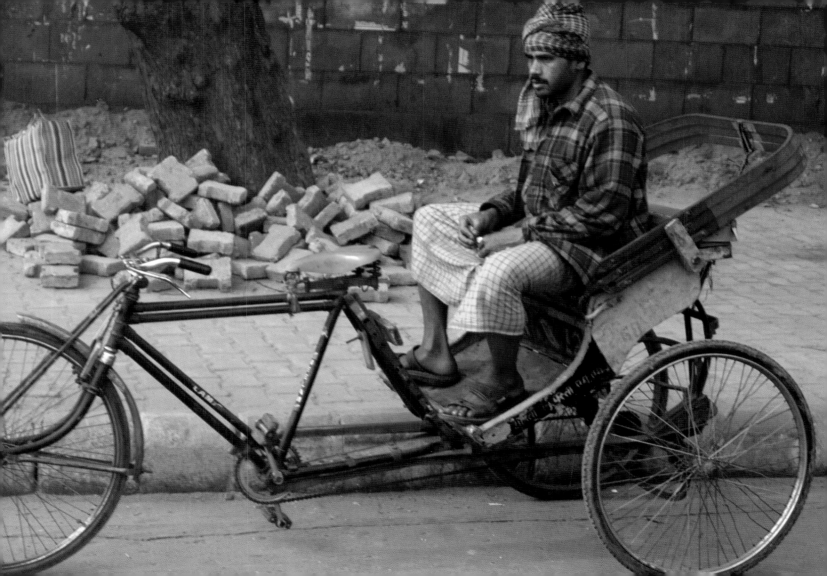

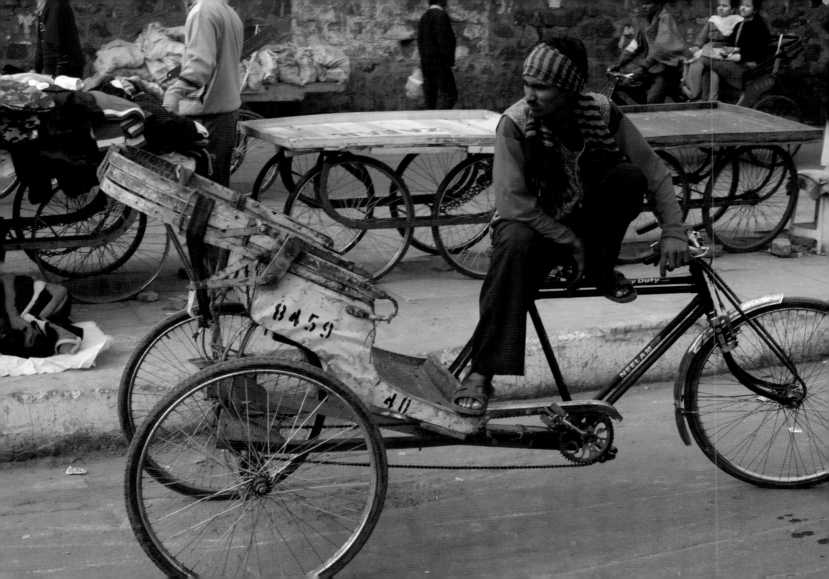

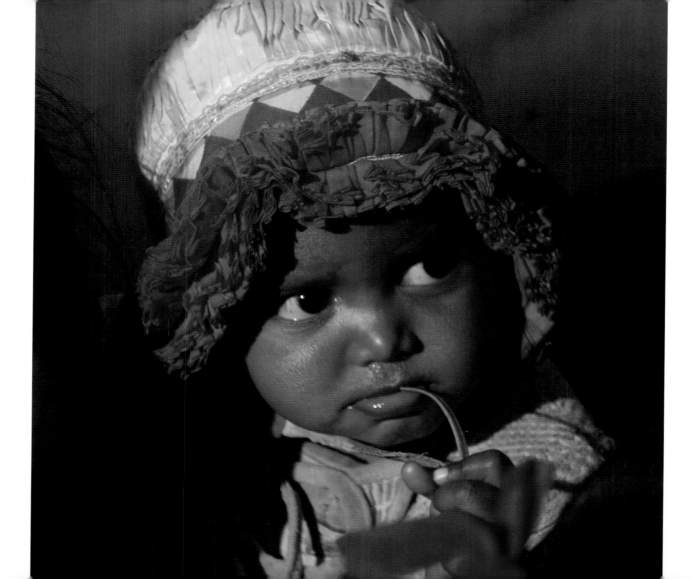

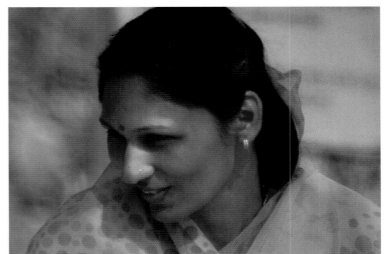

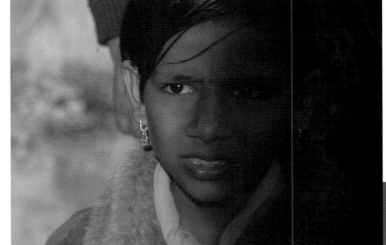

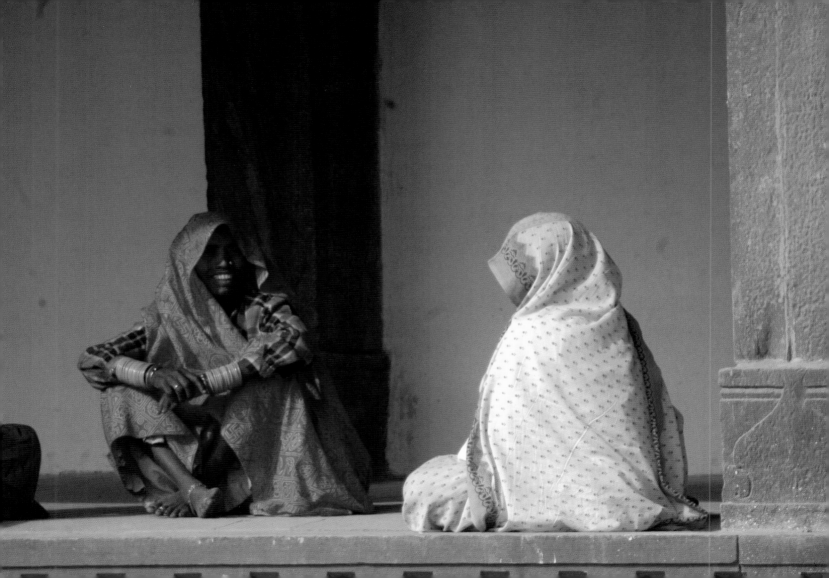

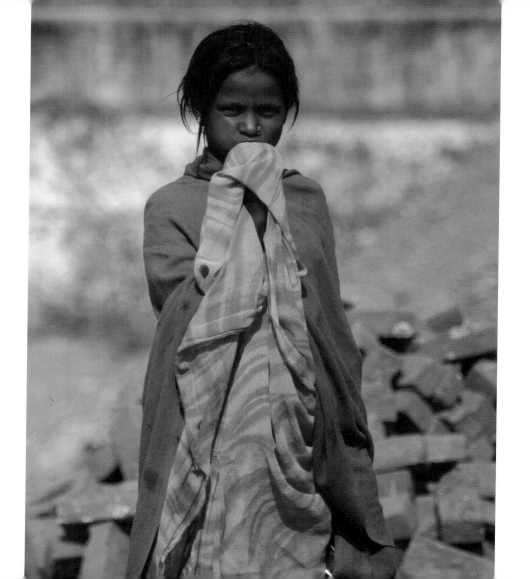

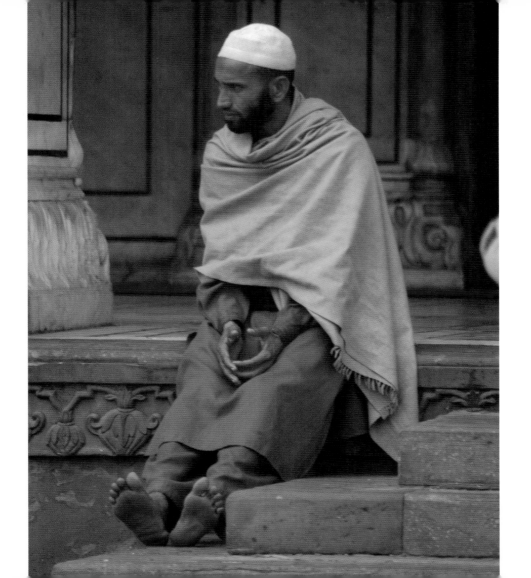

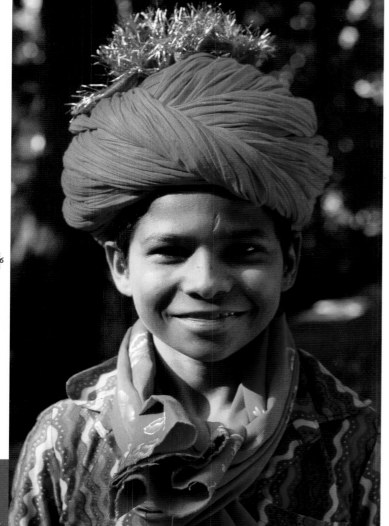
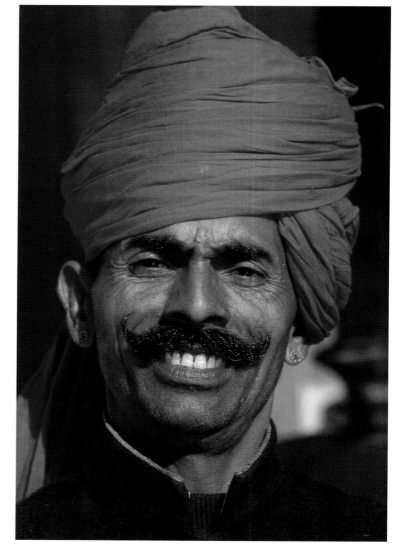

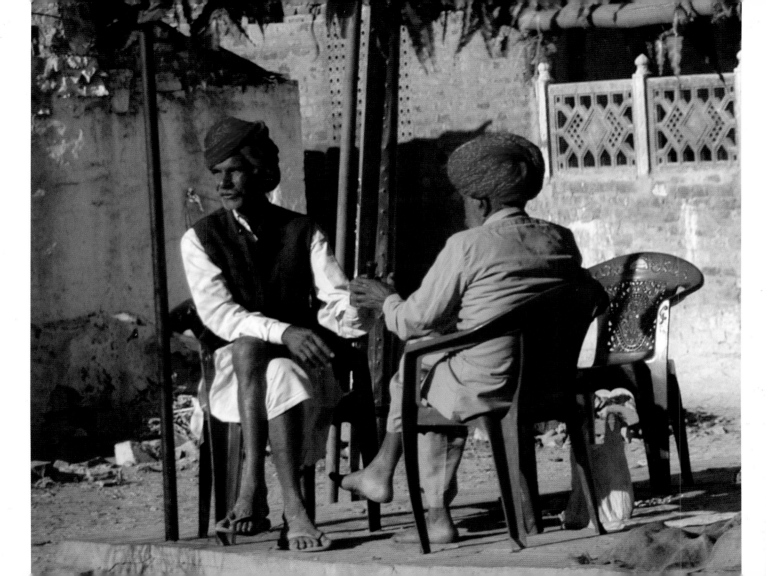

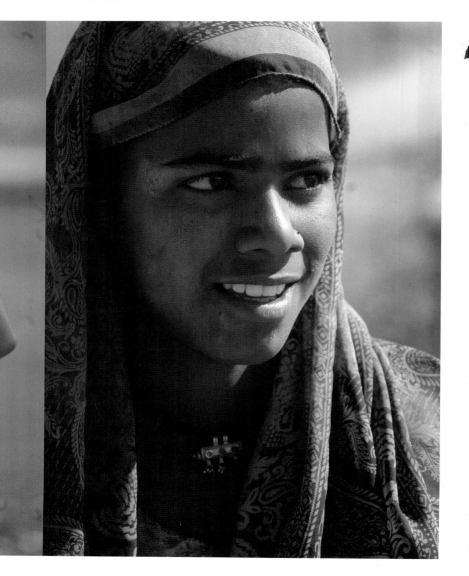

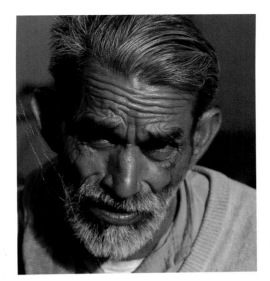

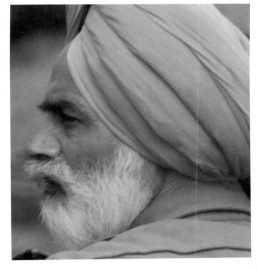
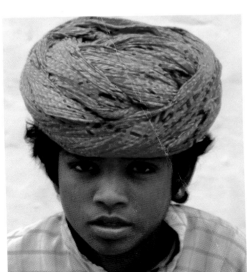
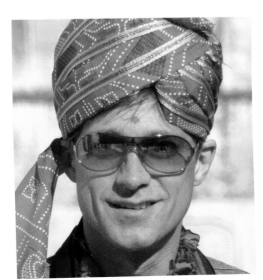
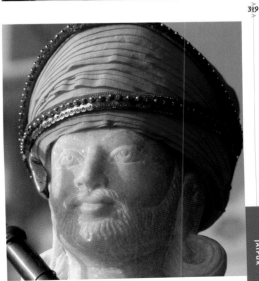

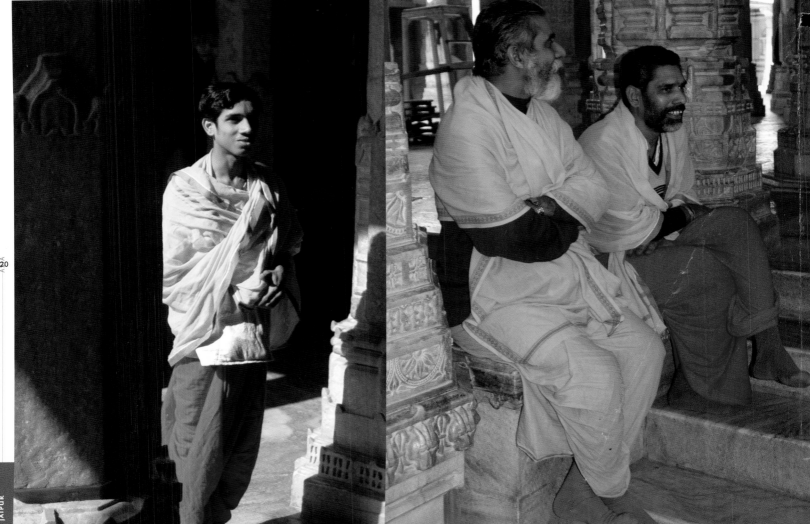

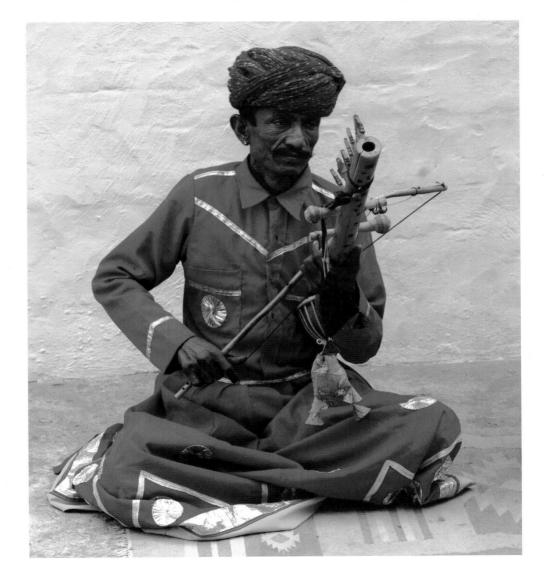

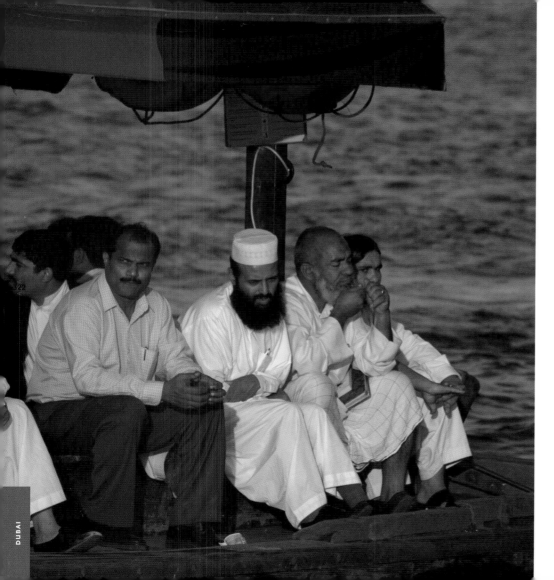

UNITED ARAB EMIRATES

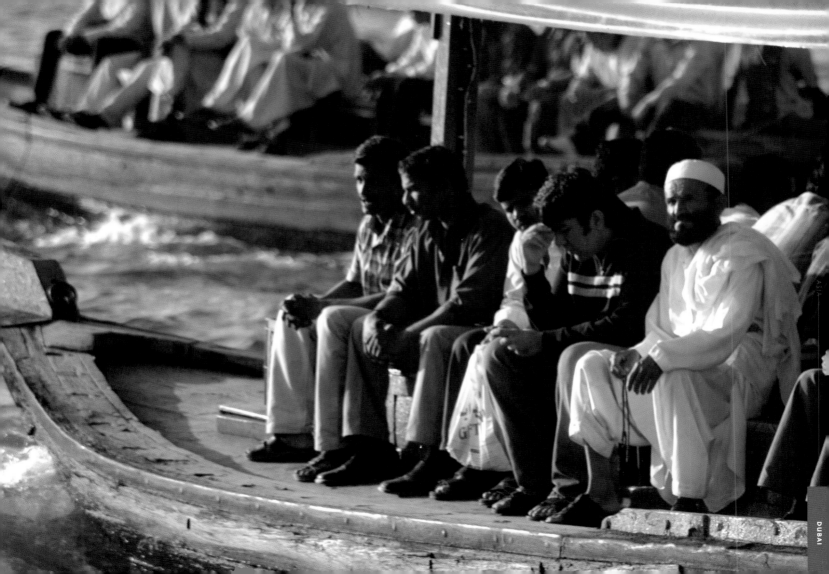

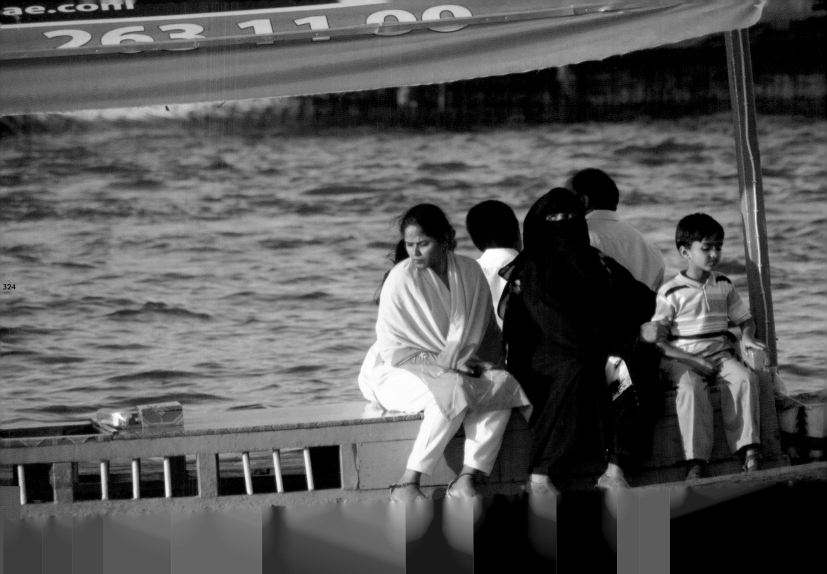

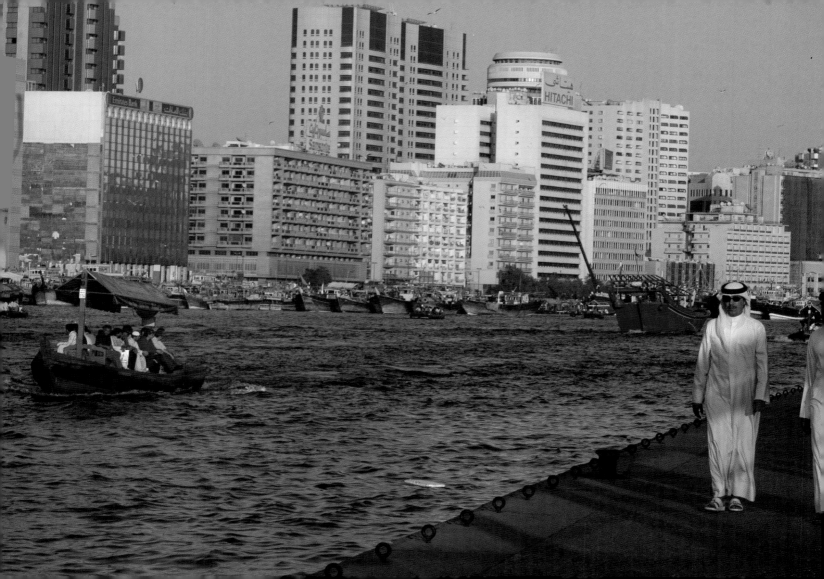

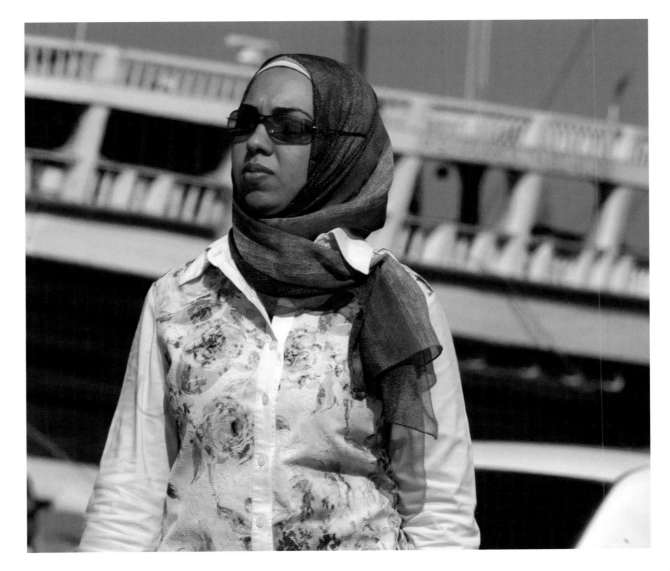

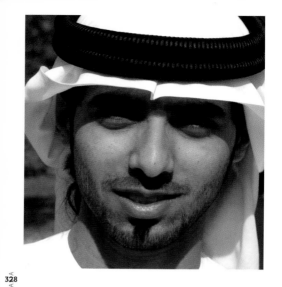
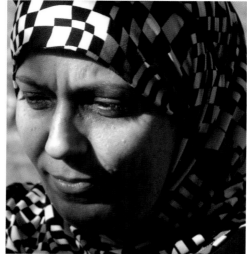
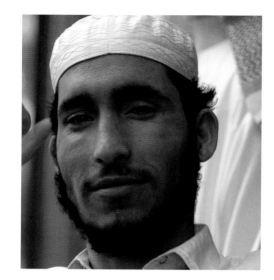
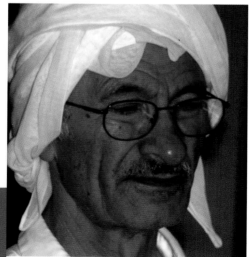
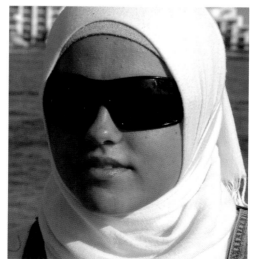
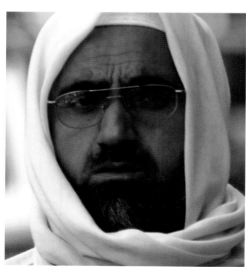

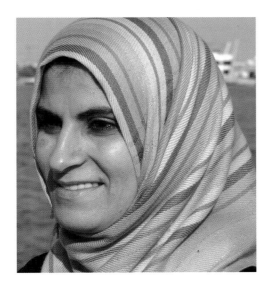
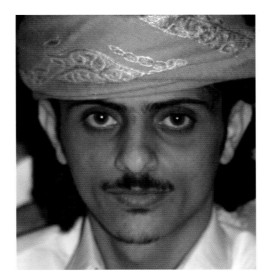
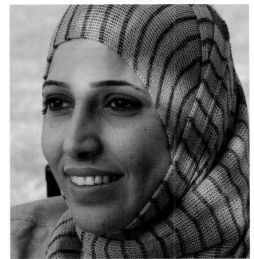
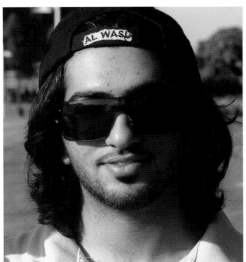
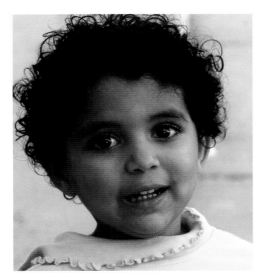
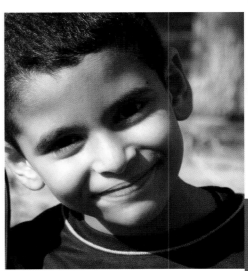

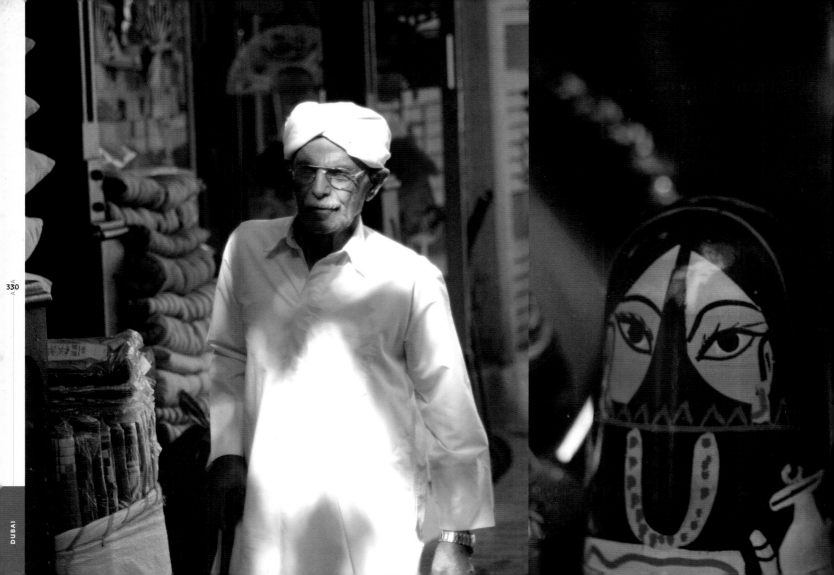

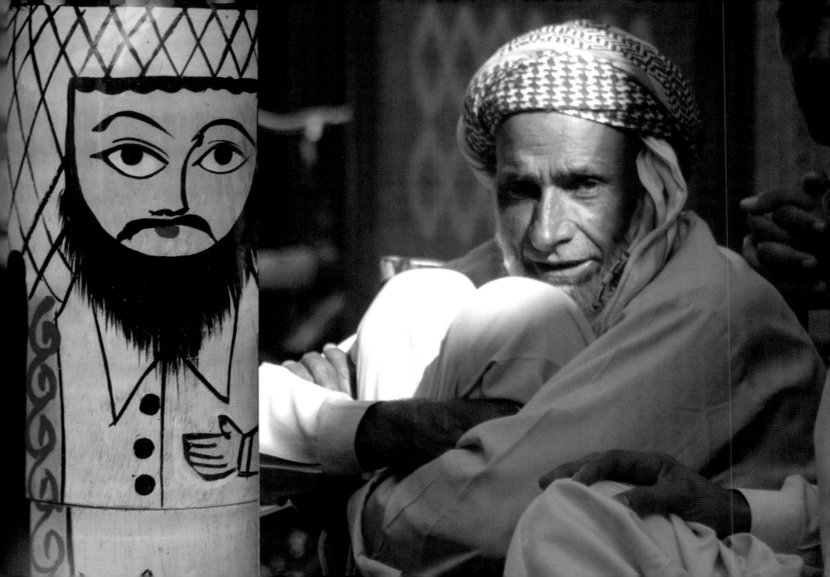

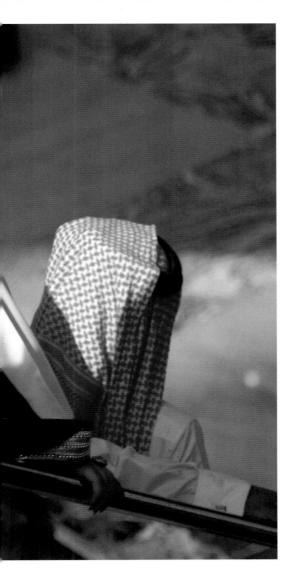
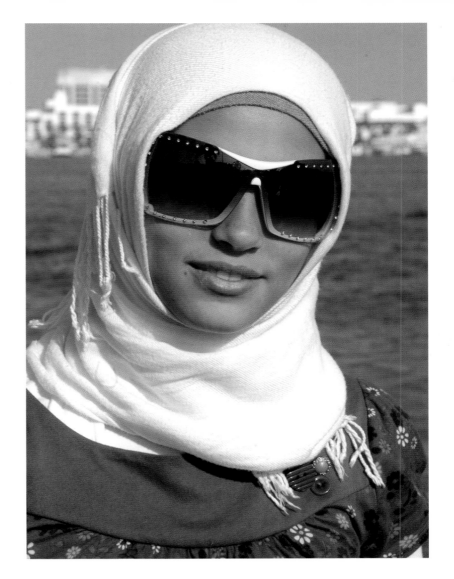

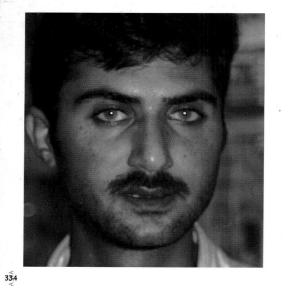
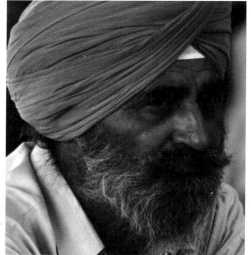
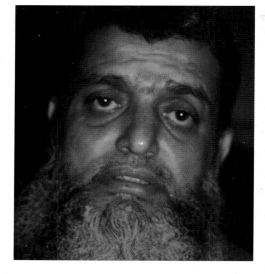
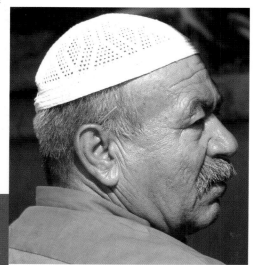
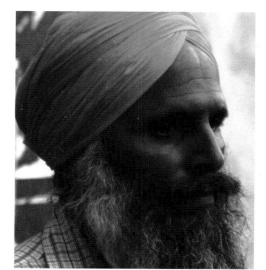
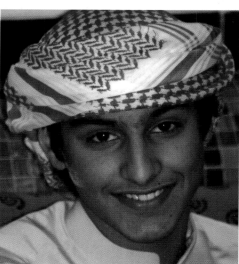

ANTARCTIC BASE STATIONS

Aboa / Finland
Akademik Vernadsky Station / Ukraine
Almirante Brown Antarctic Base / Argentina
Amundsen-Scott South Pole Station / United States
Asuka Station / Japan
Belgrano II / Argentina
Bellingshausen Station / Russia
Bernardo O'Higgins Station / Chile
Casey Station / Australia
Comandante Ferraz Station / Brazil
Concordia Station / France & Italy
Davis Station / Australia
Dome Fuji Station / Japan
Dumont d'Urville Station / France
Frei Montalva and Villa Las Estrellas / Chile
Esperanza Base / Argentina
Gabriel de Castilla Spanish Antarctic Station / Spain
General Artigas Station / Uruguay

Neumayer Station / Germany
Great Wall Station / China
Halley Research Station / United Kingdom
Henryk Arctowski Polish Antarctic Station / Poland
Jinnah Antarctic Station / Pakistan
Juan Carlos I Spanish Antarctic Station / Spain
Jubany / Argentina
King Sejong Station / South Korea
Law-Racovita Station / Romania
Machu Picchu Research Station / Peru
Macquarie Base / Australia
Maitri Station / India
Marambio Base / Argentina
Mario Zucchelli Station / Italy
Mawson Station / Australia
McMurdo Station / United States
Mendel Polar Station / Czech Republic
Mirny Station / Russia
Mizuho Station / Japan
Molodezhnaya Station / Russia

Neumayer Station / Germany
Novolazarevskaya Station / Russia
Orcadas Base / Argentina
Palmer Station / United States
Captain Arturo Prat Base / Chile
Professor Julio Escudero Base / Chile
Progress Station / Russia
Rothera Research Station / United Kingdom
San Martín Station / Argentina
SANAE (South African National Antarctic Expeditions) / South Africa
St. Kliment Ohridski Base / Bulgaria
Scott Base / New Zealand
Showa Station / Japan
Svea / Sweden
Troll Station / Norway
Wasa Station / Sweden
Vostok Station / Russia
Zhongshan (Sun Yet-Sen) Station / China

ANTARCTICA

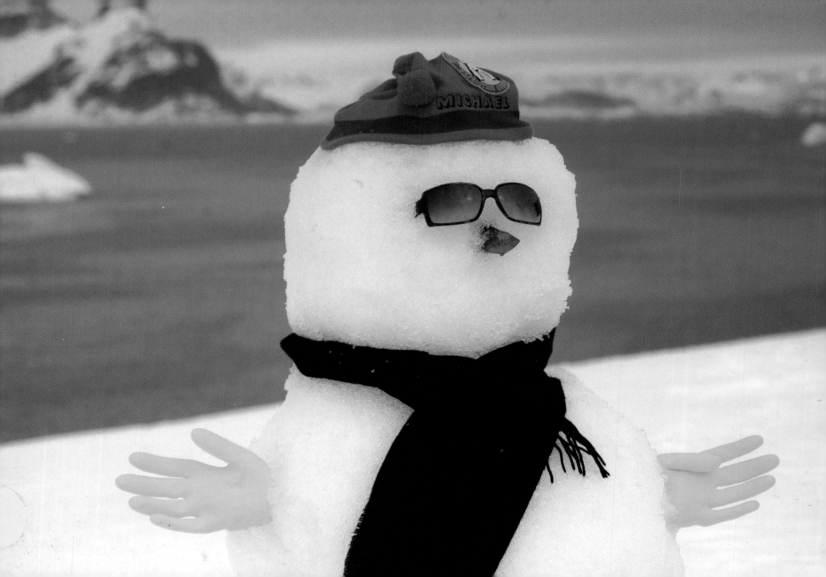

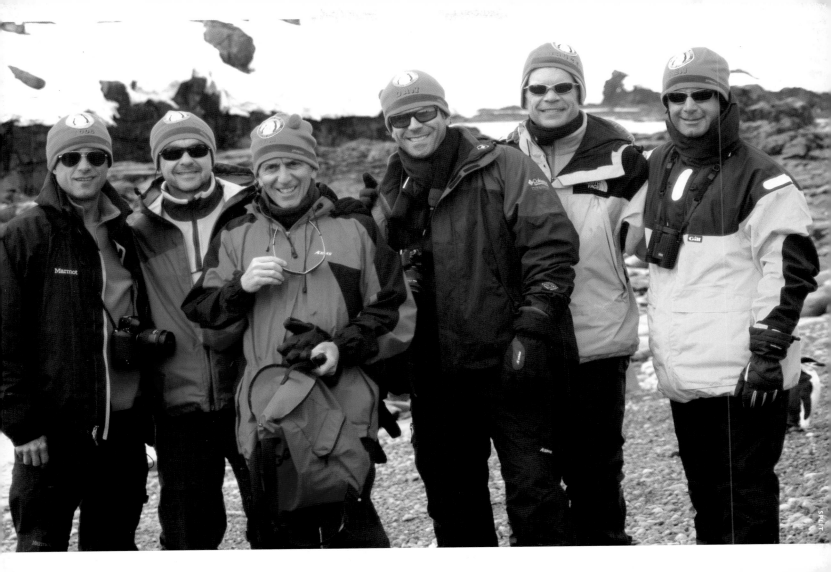

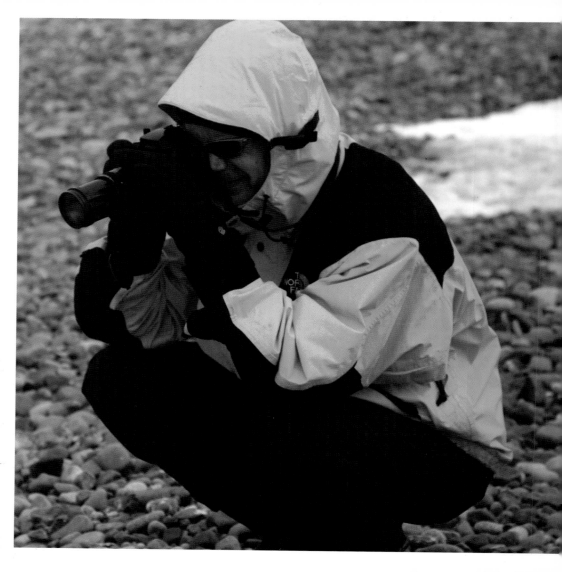

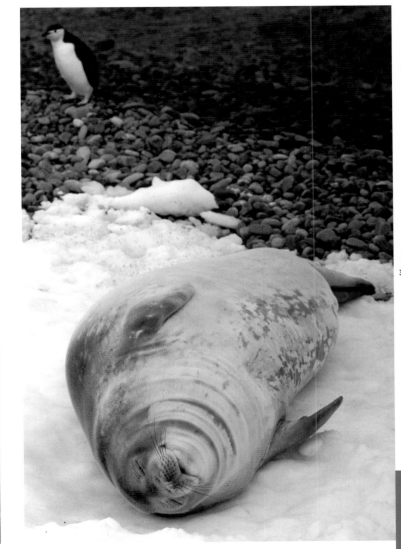

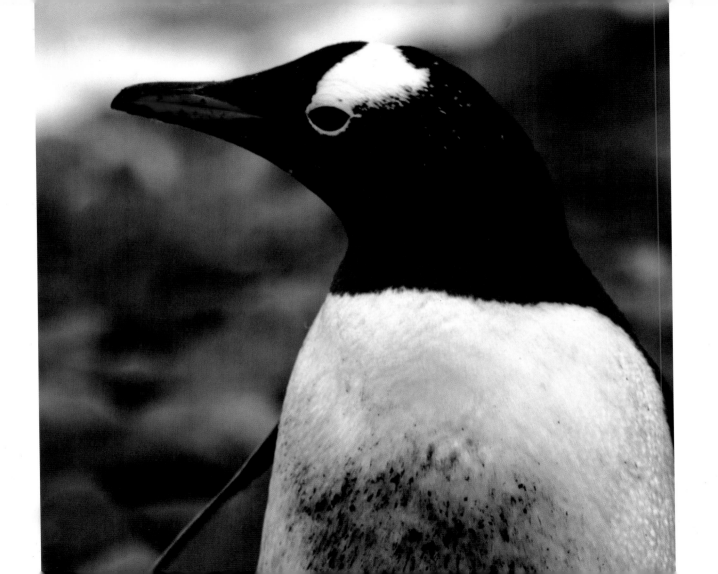

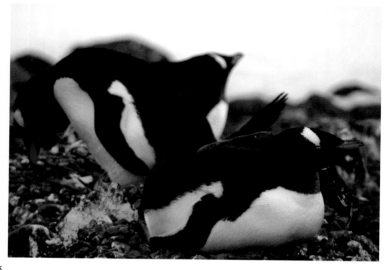
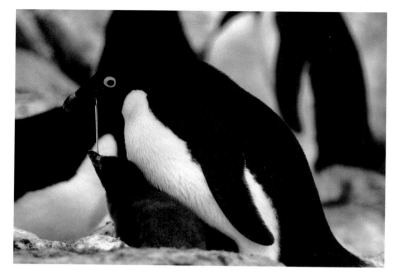
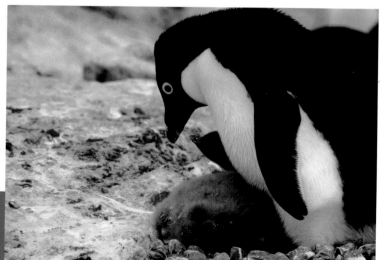
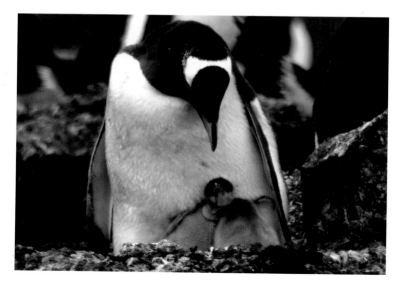

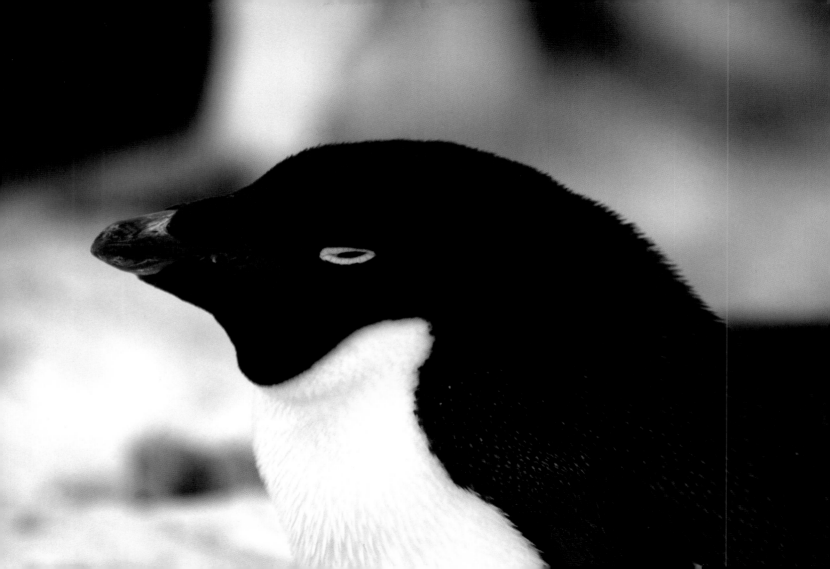

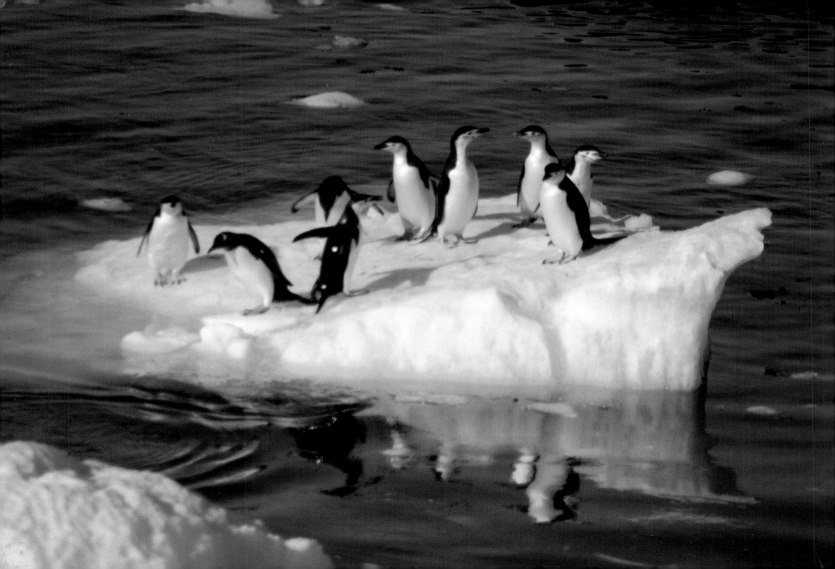

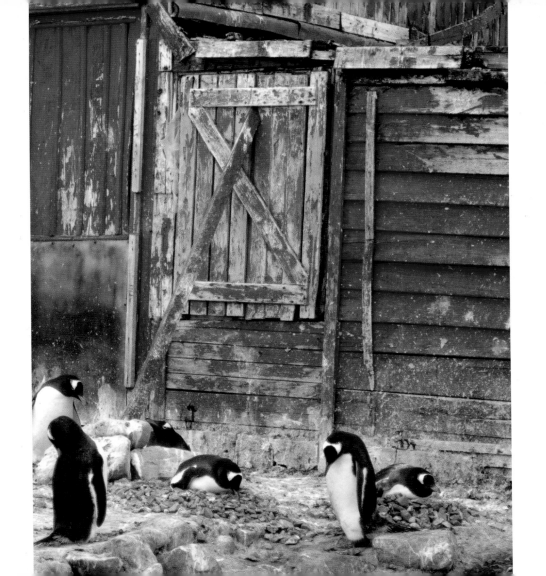

ACKNOWLEDGMENTS

First and foremost, a special thank you to the formidable Marta Hallett for her unwavering support and enthusiasm for this project, to Karen Engelmann for her unique creative guidance, and to Kristen Schilo for keeping us all on schedule.

Thanks to David Granger for giving me the idea to pursue interesting faces, as I travel the world, and to my fellow travelers, Tom DeVincentis, Frank Valentini, Cap Sparling, Mary Rolland, Pamela Fiori, Deb Shriver, and Martha McCully, who also collect countries with great gusto.

I have much appreciation for my family, who support my passion for travel and photography, especially Nancy Clinton, Joe and Kathy Clinton, Kate, Matthew and Debbie Clinton, Chris Evans, Joe, Stephenie, Peg and Bob Pardini, Shannon and Andy, Clint, Sean, Luke, Paul, Molly, David, Bobby, Nicolas, and Janet Clinton. I am also grateful to the entire Wenslovas and Dimson families.

Finally, I'd like to express sincere gratitude to Cathie Black, Judith Bookbinder, Francine Crane, Jack Kliger, Penny and Jay Lieberman, Todd Marsh, Polly Summar, David Turner, Dan Tyler, and my many colleagues at Hearst Magazines.

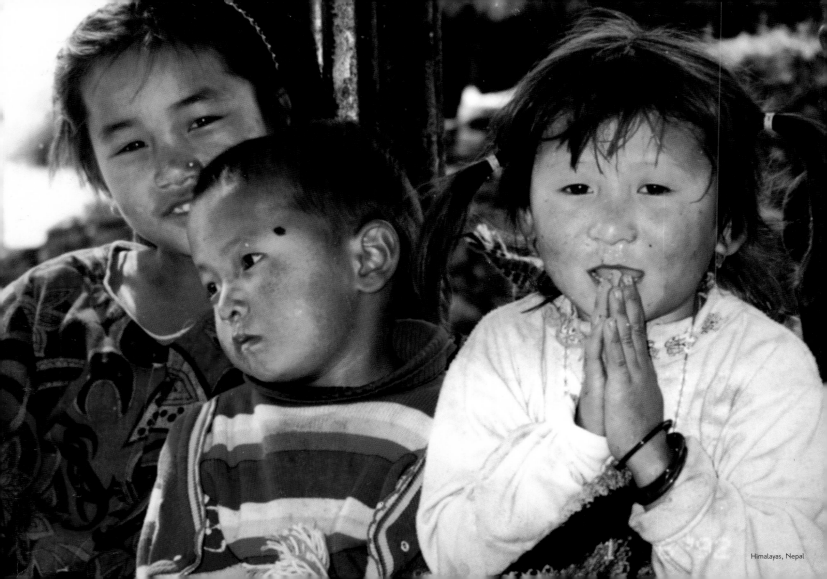

Himalayas, Nepal

ABOUT THE AUTHOR

MICHAEL CLINTON is a publisher, photographer, and world traveler. He has been to 115 countries and all seven continents, in search of new experiences and photographs.

He is the Executive Vice-President/ Publishing Director of Hearst Magazines, where he oversees sixteen publications, including *Harper's Bazaar* and *Esquire*.

Clinton is also the author of WANDERLUST: 100 Countries (Glitterati, 2004) and GLOBAL SNAPS (Glitterati, 2005), and has had photography shows in New York, Miami, New Orleans, and Chicago. He lives in New York City and Southampton, New York.

The author in Mykonos, Greece.
Photo by Frank Valentini